TEXAS
INGENUITY

TEXAS
INGENUITY

★

Lone Star Inventions,
Inventors & Innovators

ALAN C. ELLIOTT

THE
History
PRESS

Published by The History Press
Charleston, SC
www.historypress.net

Copyright © 2010 by Alan C. Elliott
The History Press edition © 2016

Manufactured in the United States

ISBN 978-0-7385-0356-1

Library of Congress Control Number: 2016948308

In memory of
Terry D. Bilhartz

CONTENTS

Contents

PREFACE

There's a lot to know about the great state of Texas. It's too much for one person to know about or write about. If it were possible to write all of the interesting stories of Texas legends that *should* have been written, I'd have to use a Ford F-350 pickup to haul the book around. It'd be so big that getting it into a Barnes & Noble bookstore would be a piece of work. Knowing this bit of reality, I selected a sampling of Texas stories to include in this book and relied on a number of friendly Texas folks to help me check out the numerous facts and fancies.

ACKNOWLEDGEMENTS

Those who provided valuable input and suggestions include former lieutenant governor Bill Hobby, restaurateurs Bob and Carole Bogart, restaurateur Mariano Martinez, Sandra Lord of Discover Houston Tours, Whitney Deann Green, Don O'Neal, the late Tom Young, Lynne Deel, Bill Kittles, Betty Gore, Craig Hopkins, Larry Gillreath, Gayla Brooks, Joan Reisch, Linda Hynan, Frank Liberto of Rico Products, Charles R. Townsend (author of *San Antonio Rose: The Life and Music of Bob Wills* [Urbana: University of Illinois Press]), Cheryl Lindsay and Ritchie Eris of the Conrad N. Hilton Memorial Park and Community Center, Ed Spencer, James Gaskin, Jan Winebrenner, Terry R. Hauck, Robert Deevey, Amanda Raspberry (Dublin Dr Pepper), Emily Wynne of the Van Cliburn Foundation and the helpful folks at the Gladys City Boomtown Museum and Texas Energy Museum. There are probably some I've neglected to include in this list; I thank all who contributed to this project.

A special word of thanks to Patsy Summey for her numerous comments and suggestions. This project would not have been possible without the valuable help and support of my gracious and patient wife, E'Lynne Elliott.

INTRODUCTION

Texas Ingenuity is a collection of informative and sometimes quirky stories about Lone Star inventions, inventors and innovators. Each story emphasizes a Texas connection and shows how Texas innovation, determination or sheer dumb luck made the person or product famous and successful. Every Texan and Texas visitor hankering for a chuckle and an interesting bit of history will enjoy reading *Texas Ingenuity*.

Before I delve too far into these stories, and before you get too excited thinking that the story about your Uncle Joe's invention that changed the world is included in this book, I'll have to apologize. There is no way on God's green earth that this volume could cover all of the incredible stories of Texas smarts. Let's face it: folks in the Lone Star State have an over-abundance of cleverness.

During the writing of this book, I tried to contact someone in every Texas county to locate as many stories as possible and got a few good ideas. However, when you discover that I left out your Uncle Joe's story, you can either forgive the blunder or shoot me an e-mail. Maybe your idea will appear in some future version. To keep up with ever-expanding Texas ideas, inventions, innovations and legends, visit the www.alanelliott.com/legends website and share your stories.

That said, the stories that made it into *Texas Ingenuity* paint a colorful picture of how Texas pioneers put their minds to the task at hand and came up with resourceful ideas that influenced Texas and the world.

INTRODUCTION

Texas Legends contains four major sections: "The 'I's' of Texas: Inventions, Inventors and Innovators," "Tasty Texas: From Cattle Drive to Casual Dining," "Texas Entertainment: Big Stars from the Lone Star" and "Texas Sports: Ready, Set, Innovate!" Pull up an easy chair, get yourself a frosty glass of Dr Pepper and learn about the ingenious and imaginative legends who made the Lone Star State the best place to live this side of heaven.

THE "I's" OF TEXAS

INVENTIONS, INVENTORS AND INNOVATORS

Texas enjoys a worldwide mystique. Travel anywhere in this whole wide world and tell someone you are from any other state in the United States and there will be little reaction. Tell them you are from Texas and an image appears in their head: cowboys, horses, oil fields, high fashion, big business and vast prairies. Hollywood may have enhanced and embellished the image of Texans as being big-thinking, straight-shooting and bull-headed, but the bigger-than-life Texas reputation didn't come about by chance, and it didn't happen overnight. The Texas mystique traces its heritage back to real-life pioneers with pluck and courage who transformed a loose-knit people living in an early frontier outpost into a people with a history like no other place in the United States.

The "I's" of Texas are the innovators, inventors and inventions that have made Texas an exciting, progressive and forward-looking place since the 1830s. There have been many of these determined and insightful men and women, and this book selects a few to illustrate how Texas and the world benefited from their lives and talents.

SAM HOUSTON AND THE GENESIS OF TEXAS

The names of the early Lone Star pioneers are written on county courthouses, city parks, public schools and monuments throughout the state. They are names like Austin, Houston, Bowie, Crockett, De Zavala, Fannin, Travis, Deaf Smith and many others. These were not saints. Some of these patriots were at times counted as scoundrels and ne'er-do-wells. Some came to Texas to escape failed marriages, to outwit the law or to flee from debts. Saints and sinners alike came together in this untamed territory. They found new life in an era and in a place where they would be required to prove their honor and courage in a fight for personal and mutual freedom.

One man stood out among them all. At times when others gave up hope, he held the ragtag assemblage of Texas pioneers together. An imperfect man with a history of promising successes and debilitating failures, he steered the fledgling Texas ship of state from certain disaster into a safe port. His story reflects a life of innovation, originality, resourcefulness, courage and honor that defines what it means to be a true Texan today. In many ways, the image of Texas that is prevalent around the world came about because of the near-legendary life of one man: Sam Houston.

Born in 1793, at a time when many Americans still recalled the Revolution against the British, Sam lost his father when he was thirteen and moved with his mother and eight siblings from Virginia to a rural area of Tennessee. Not happy with the farming life, he ran away from home at the age of sixteen to live with a nearby tribe of friendly Cherokees. After

a year with the Cherokees, this tall, handsome boy gained favor and was adopted by Chief Oo-Loo-Te-Ka and given the name "The Raven."

Over the next few years, young Sam traveled back and forth between the two cultures. At the age of twenty, he joined the U.S. Army. His leadership abilities were soon discovered, and within the year, he rose to the rank of third lieutenant. During the War of 1812, Houston served under the command of General Andrew Jackson. At the Battle of Horseshoe Bend, Houston exhibited extreme bravery (suffering a near-mortal wound that would bother him

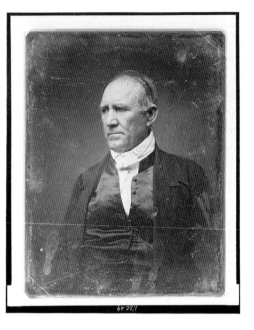

A photograph of Sam Houston taken by Mathew Brady about 1861. *Courtesy of Library of Congress, LC-USZ62-110029.*

the rest of his life) and caught the attention and admiration of Jackson, who raised him to the rank of second lieutenant. The army made use of Houston's skills in communicating with Native Americans, and in 1817, he achieved the rank of first lieutenant. However, his representation of Indian causes in Washington (and the fact that he dressed like an Indian) led to a reprimand.

Hotheaded is too mild a word to describe Sam Houston. His firebrand temper landed him in more than one fracas. In 1826, he accepted a duel (which was illegal) and wounded his adversary, regretting the incident immediately after it happened. In 1829, weeks after marrying Eliza Allen, the couple permanently separated over a domestic quarrel. The reason rests in obscurity, but it depressed Houston so much that he resigned as governor (1827–29) and left Tennessee to live with the Cherokees. From a high and promising career in public service, Houston plummeted immediately into scandal, ridicule and political ruin.

WITH EYES ON TEXAS

The Raven remained isolated in Indian country for a year until he emerged as a representative of the Cherokees to Washington, where President Jackson received his old friend with open arms. Most of Washington turned up their noses at the defamed Houston. They were appalled that he dared show his face again in civilized society. Weaker men would have cowered at such a discourteous reception, but Houston proved that his political currency still held considerable clout. He conferred with Jackson and discussed (among other issues) the future of the Mexican territory of Texas. Jackson wanted Texas, and Houston agreed to keep an eye on developments.

Andrew Jackson believed in a destiny of the United States to stretch from the Atlantic to the Pacific Ocean. To accomplish this, the land from Texas to California would have to be secured from Mexican claim. The United States made attempts to purchase Texas from Mexico, but to no avail. Some U.S. officials proposed taking Texas by force, but there was a red-hot political issue preventing any action to secure Texas: slavery. Allowing Texas into the Union as a slave state would seriously damage the fragile 1820 Missouri Compromise between northern non-slave and southern slaveholding states. Nevertheless, Jackson and his followers were determined that Texas (as well as California and the land between) would join the Union.

Officially a part of Mexico, the area known as Texas stood at the western border of the United States. This rich and promising land became a magnet to Americans seeking a new start in life. The Mexican government wanted settlers to come to Texas to stabilize the region. In 1823, they made arrangements with an *empresario* named Stephen F. Austin (actually with his father, Moses Austin, who died before he could carry out the contract) to allow three hundred families of good report to immigrate to Texas with the promise of land and opportunity. These families, although required to be Roman Catholic and swear allegiance to Mexico, were Americans accustomed to the protections of a free and democratic government.

Along with the upstanding families brought to Texas by Austin, other less virtuous Americans also flooded into Texas. In fact, the Texas frontier attracted a rough cut of man who wanted to escape from a marriage, a criminal record or poverty. The common stamp "GTT" found on U.S. census records of the era shows how many men escaped former lives and had "Gone to Texas."

To all the American immigrants, Austin became the *de facto* leader, settling disputes and serving as head of both the civil and military law. For

example, to protect his new arrivals, Austin supported a law to prevent judgments by U.S. courts from being collected in Texas. Although he made little money in the venture, Austin served diligently as the go-between for both the Mexican government and the Americans and tried to iron out the growing distrust between the two groups.

As more and more Americans came to Texas, the Mexican government started worrying about losing control, and as a result, it imposed increasingly difficult and unfair laws against the immigrants. The Mexican government finally closed Texas to immigration in 1830. It did little to stop Americans from flooding over the border. Eventually, the Mexican army took stronger steps to stop the flow by imposing military laws against the Americans. Independent-thinking Americans reacted to these harassments by staging a general uprising. To further protect themselves, the Texans called conventions in 1832 and 1833 to adopt petitions and present demands to the Mexican government.

These events did not escape the attention of either President Andrew Jackson or his protégé Sam Houston. In 1830, Houston left Washington, returned to the frontier (in the area now known as Oklahoma) and married a Cherokee named Tiana Rogers. He continued to carry on business in and around Texas and served as a negotiator for the Indians.

In 1831, his happy Cherokee home was disturbed by news that his mother was dying. He made it to her side shortly before she passed away and decided after her death to try his hand back in "civilized" society.

HOTHEADED HOUSTON

When Houston arrived in Washington, the press and his old enemies in Congress received him again as a political has-been. He attempted to negotiate a contract concerning Indian welfare but was accused of fraud by Congressman William Stanbery of Ohio. Houston did not take the accusation lightly. He had never backed away from a fight, and he looked for an opportunity to confront his accuser. On the evening of April 13, 1832, it happened. Houston met the congressman on the street and promptly gave him a thorough thrashing with his walking cane (which was made of hickory from Andrew Jackson's Tennessee estate, the Hermitage).

Instead of letting the courts hash out a punishment for the assault, Congress decided to try the case against its former member. Houston hired Francis Scott Key (the lawyer who wrote "The Star-Spangled Banner")

as his attorney. The spectacle captured the interest of the newspapers, and they reported a blow-by-blow account of the trial in every newspaper in every state. Colorful stories of the buckskin-clad Houston challenging Congress made good press. In most stories, the eccentric Houston came out as a backwoods hero. However, after a serious talk with his mentor Jackson, who still had plans for his protégé, Houston took a different tack. He changed his appearance from the buckskin outfit to stylish gentleman's attire. He defended himself before Congress with eloquent speeches (printed diligently in the newspapers) in which he claimed to be "willing to be held to my responsibility. All I demand is that my actions may be pursued to the motive which gave them birth." Houston stood not only head and shoulders above the average man of his day; the wit and wisdom of his speech and his powerful presence were already legendary. At the end of his oratories, spectators threw flowers to him from the balcony, and old friends embraced him.

Houston's speeches contained an impassioned warning against the tyranny of government and the sanctity of citizens' rights. These topics, duly reported by the press, resurrected his political image around the nation, and talk of his running for president filled the air. Nevertheless, Congress found him guilty and fined him $500 (which Jackson paid).

HOUSTON FOR TEXAS

When Houston left Washington this time, he carried with him an understanding from the president that Texas must be secured for the Union. Houston's own ambition was to get Texas for the Union or take it as his own personal prize. Clearly Texas stood at the edge of revolution, and Houston intended to rise to the top of the leadership. Once back in Texas, he wasted no time getting involved in politics. In 1833, he served as a delegate from Nacogdoches to the Second Convention at San Felipe, which called for the state of Texas to be separated from the Mexican state of Coahuila, and sent Stephen F. Austin to Mexico City to deliver the message. Austin did not get a warm reception from the Mexican government and was jailed for his efforts.

In the meantime, Houston secured the title of major general of the Texas army and purchased a suitable uniform in New Orleans. He knew enough about people and politics to see what the future held for Texas. As Houston must have expected, when Austin returned from his confinement in Mexico City, he had one message: "War is our only recourse."

Texas Ingenuity

Mexican dictator Antonio Lopez de Santa Anna figured he could easily put down the rebellion by the ill-prepared Texans. In some ways, he was right. The structure of the Texas army was loose and undependable. Although brave and confident, most of the Texas army officers were inexperienced and independent-minded. For example, when Houston sent James "Jim" Bowie (a well-known adventurer and creator of the famed Bowie knife) to San Antonio with instructions to blow up the Alamo to prevent the Mexican army from getting the stronghold, Bowie instead joined with several other small groups of men to defend it.

On March 2, 1836, Texas declared its independence.

Texas Massacres

The war went badly. On March 6, the Alamo fell with the loss of 189 Texas heroes, including James Bowie, Davy Crockett (a former Tennessee congressman) and William Barrett Travis (the Alamo commander). Although the fall of the Alamo was a devastating blow, it rallied the people of Texas behind the revolution and became one of the most celebrated battles of all time.

Fearing another similar loss, Houston ordered Colonel James W. Fannin Jr. to retreat from Goliad. Fannin delayed. His troops were disorganized. Before he could pull them together to escape, they were attacked. On March 20, 1836, they were captured by the Mexican army, and on March 27, they were massacred by order of Santa Anna.

The only force of any size left in Texas was under Houston's direct command. Almost everyone in the fledgling Texas government demanded that Houston attack Santa Anna. Houston was not swayed by these hysterical voices. Instead, he retreated. For over thirty days, General Houston moved his men away from the Mexican forces. Some of his troops deserted, and his officers repeatedly questioned his tactics. In the meantime, the patient Houston studied maps and waited. His zigzagging retreat led Santa Anna to a place called San Jacinto.

Finally, Houston saw the chance he had waited for.

At four o'clock in the afternoon on April 21, 1836, when the Mexican troops were least expecting it, Houston ordered his men to attack. To the cries of "Remember the Alamo," "Remember Goliad" and "God is with us," the outnumbered Texas army routed Santa Anna's troops. In the heat of battle, Houston's horse, Saracen, was shot out from under him. Houston's

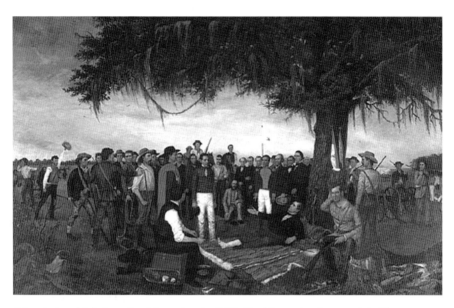

Oil painting titled *Surrender of Santa Anna* by W.H. Huddle, 1890. *Courtesy of the Texas Preservation Board, Austin, Texas.*

right leg was shattered above the ankle. The battle lasted twenty minutes, and the Texans only lost six men to the six hundred of Santa Anna's troops who were killed.

The badly wounded hero of San Jacinto negotiated an armistice with the captured Santa Anna, while his fellow soldiers (including future Texas president and then colonel Mirabeau B. Lamar) pressed for the dictator to be executed in revenge of the Alamo and Goliad. Again, Houston's good judgment prevailed over the emotion of the moment. He knew that for the sake of Texas, Santa Anna was more valuable alive than dead.

The frontier doctors held out little hope of recovery for General Houston. He needed more medical help than what was available in Texas. Teetering on the verge of death, the hero was transported to Galveston and then to New Orleans for medical treatment. The trip took seven days. The news of the Texas victory had preceded Houston, and when he arrived at the New Orleans harbor, a cheering crowd greeted him. Gathering all his energy, Houston stood to wave at the crowd and fainted.

Houston Returns

Houston surprised everyone with his recovery. In a month, he returned to a Texas consumed with political chaos and in need of a leader. On September 5, 1836, Houston was elected president of the new Republic of Texas. (Austin, who lost the election, died in December 1836.) Working out of crude buildings and sleeping on cots or on the floor, Houston and a handful of elected and appointed officials invented a new country. They went to work creating a currency, stabilizing the army, making peace with the Indians and winning recognition from the United States. As planned, Houston had secured Texas from Mexico. However, he could not yet fulfill Jackson's desire to bring Texas into the Union.

At the end of his two-year term, Houston could not succeed himself, and Mirabeau B. Lamar took the helm. Although Lamar was keenly devoted to the future of Texas, his ideas and experience differed from those of Houston. He made war against the Indians (which resulted in the death of Houston's friend Chief Bowl), pressed for expansion into New Mexico (with the intention of expanding all the way to California) and spent money so freely (racking up bills for $4,855,213 with only $1,083,661 in income) that the Texas dollar lost 90 percent of its value. On the other hand, Lamar advocated education, set aside land for schools and is remembered as the father of Texas education. He established a new capital in Austin and was responsible for collecting and protecting many of the original documents related to Texas independence.

With Texas under different hands, Houston returned to private life. At the Hermitage in Tennessee, he visited with Andrew Jackson. The two friends continued to believe that Texas should join the Union. The Raven's work was not yet finished.

In 1837, Houston received a divorce from his estranged wife, Eliza Allen, and Tiana Rogers, his Cherokee wife, died in 1838. During his travels through the South, he stopped in Mobile, Alabama, and met a young woman named Margaret Lea who had been on the New Orleans dock when the triumphant but wounded Houston arrived as a hero. Although she was twenty-three years younger than Houston, he courted her for a year, and they married in 1840. With his marriage to Margaret, Houston's personal habits changed. He ceased being known as the "Big Drunk" and devoted himself to abstinence, refrained from profane language, joined a Baptist church and started recommending marriage to his bachelor friends. While others had trouble taming Sam Houston, Margaret proved

herself equal to the task. She created a happy and respectable home that was soon filled with a number of little Houstonites, beginning with Sam Houston Jr., born in 1843.

When Houston returned to Texas politics, he served as a member of the Texas Congress and was reelected president of the republic in 1841. With Texas government again in shambles and Santa Anna threatening to invade, Houston cut expenses to the bone and sent an army to protect the Texas borders. He held the republic together and sought annexation to the United States. Houston believed (and wrote) that "Texas...could exist without the U States but the U States can not, without great hazard... exist without Texas." Although U.S. president John Tyler supported Texas, Congress did not. When Houston's term ended and Anson Jones took office, the hero continued to seek annexation. Finally, with a threat by Texas to align with England, the U.S. Congress acted on March 1, 1845. As a result, in December 1845, Texas joined the United States.

A PROFILE IN COURAGE

Although Houston sought to retire after bringing Texas into the Union, his role in Texas history was not complete. In fact, one of his most celebrated acts in history was yet to come. While serving as a U.S. senator from 1846 to 1859, Houston stood out among southern politicians in his adamant desire to prevent the slave issue from leading to war. At the end of his Senate term, he returned to Texas and took the office of governor, continuing to fight against the growing sentiment of southern states to form a separate country.

When the antislavery candidate Abraham Lincoln won the fragmented 1860 election, the southern cause for separation from the Union gained powerful momentum. Other southern states voted to join the new Confederate States of America, but Houston refused to call the Texas legislature into session. As a result, a popular movement formed a Texas Secession Convention. Before the convention could meet, Houston relented and called a special session of the Texas legislature, where he eloquently and passionately pleaded for Texas not to separate from the Union. "Let me tell you what is coming....Your fathers and husbands, your sons and brothers, will be herded at the point of a bayonet....You may, after the sacrifice of countless millions in treasure and hundreds of thousands of lives, as a bare possibility, win Southern independence...but I doubt it."

Throughout the early years of the Texas Republic, Houston's insight and wisdom had prevented the Texas army from attacking Santa Anna too soon, prevented angry men from killing the Mexican general, brought the chaotic government of the republic under control and steered Texas into the Union. This time, the frenzy for separation proved to be too strong and too emotional even for Houston. Texas voted to join the Confederate States of America. When all state officials were called on to take an oath of loyalty, Houston refused and was removed from his office.

Houston did not see the end of the war he so bitterly opposed. In 1863, with his beloved Margaret at his bedside, Sam Houston, suffering from pneumonia, uttered his final words: "Texas! Texas! Margaret." Vilified as a traitor and a coward during the Civil War, Houston is now remembered as one of the few Texans who stood his ground against that ill-conceived and disastrous conflict.

The Houston Legacy

Sam Houston did not invent Texas alone. The list of Texas heroes is long and varied. However, Houston's legendary character and dogged determination not only freed Texas, but his bigger-than-life personality, toughness in battle, honor in victory and vision for the future exemplified the Texas attitude and grit that became well known throughout the world. This extraordinary Texas reputation remains to this day.

Texas is packed with tributes to its most famous founding father. First and foremost is "the world's tallest statue of an American hero" on Interstate 45 in Huntsville. Standing sixty-seven feet tall, this impressive figure made of steel and concrete was created by artist David Adickes and dedicated in 1994. Nearby at the state university that bears his name, the Sam Houston Memorial Museum contains information about the life of Houston and preserves his Woodland home (where he lived beginning in 1847) and the Steamboat House, where the Houstons lived in 1862. The museum operates Tuesday through Saturday, 9:00 a.m. to 4:30 p.m., and Sunday from noon to 4:30 p.m. Call 936-294-1832 for more information.

Other memorials of Houston include a statue in Hermann Park in the city of Houston, a statue on the campus of Sam Houston State University and his gravestone in Huntsville. Margaret Lea Houston's grave is in the town of Independence because she died of yellow fever in 1867 and was buried the same day. For information about the decisive battle that won

Texas independence, visit the San Jacinto Monument located about twenty miles east of downtown Houston. The museum is open daily from 9:00 a.m. to 6:00 p.m., and admission is free. A film about the battle, *Texas Forever!!*, can be seen for a small charge. For more information, call 281-479-2421 or visit the www.sanjacinto-museum.org website.

References

Fritz, Jean. *Make Way for Sam Houston.* New York: Putnam Publishing Group, 1986.

James, Marquis. *The Raven.* Austin: University of Texas Press, Austin, 1929.

Kennedy, John F. *Profiles in Courage.* New York: Harper and Brothers, 1956.

Oppenheimer, Evelyn. *Heroes of Texas.* Waco: Texian Press, 1964.

Texas Tidbit

Houston's Cherokee wife, Tiana Rogers, was the great-great-great-aunt of popular cowboy comedian Will Rogers.

Texas Tidbit

Sam Houston served as governor and U.S. congressman from two states and is the only president of a "foreign" country to also serve in the U.S. Congress.

Texas Tidbit

The lyrics for the song "Yellow Rose of Texas" come from a story of Emily D. West, a black servant, who, according to legend, became a Texas hero by keeping Santa Anna "busy" (probably not by choice) when Sam Houston launched his deciding attack on the Mexican forces at San Jacinto.

GAIL BORDEN MILKS SUCCESS

The tombstone above Gail Borden Jr.'s grave reads, "I tried and failed, I tried again and again and succeeded." Borden indeed had a knack for failure.

Born in New York State in 1801, his family moved to Kentucky in 1814 and on to Indiana a few years later. At the age of twenty-one, his brother Tom joined the hordes of adventurers who had "Gone to Texas" to seek their fortunes. The untamed Texas frontier didn't appeal to Gail, and he stayed behind and took a teaching job in Mississippi.

A few years into his teaching career, Gail met a sixteen-year-old pupil named Penelope Mercer who stole his heart. They married in 1828. Like his adventurous brother Tom, the Mercer family was enamored of the prospects of a new life in Texas. Borden's new bride had more influence on him than his brother Tom. She soon convinced her young groom to pull up stakes and join her family in a move to the new frontier. Since she was pregnant, Gail and Penelope traveled to Texas by boat, while the rest of the Mercer family took the land route. The Bordens landed on Galveston Island on Christmas Eve 1829. (At that time, there was no city of Galveston, only a harbor and a few buildings.) They traveled the bumpy dirt road to San Felipe by horse-drawn wagon and set up house near Gail's father (who also now lived in Texas). Penelope's family arrived a few weeks later by wagon train.

The immigrant Americans arriving in Texas like the Bordens and Mercers had been promised that the territorial government would operate under democratic laws of Mexico. However, when Santa Anna assumed

the presidency of Mexico, everything changed. The Mexican promises of democratic rule were abandoned. To keep the Texans (and the rest of the world) aware of what was happening, Borden helped launch a newspaper called the *Telegraph and Texas Register.* As the Americans feared, without the legal protection of the old Mexican constitution, the immigrants found themselves subjected to arbitrary, harsh and unfair rules created and enforced by the officials of Santa Anna's government.

True to the American spirit, a group of Texans met in 1833 to insist that Mexico restore their legal protections. Gail Borden represented his town as one of the fifty-five delegates to the convention. In fact, Borden printed the original Texas Declaration of Independence (for which he was never paid). During the Texas revolution, Borden kept printing daily updates about the fighting until the Mexican army overran his business, took his printing press and threw it into a river.

PATRIOT, EDUCATOR, INVENTOR

After the end of the war, in 1837, President Houston appointed Gail Borden as customs collector on Galveston Island. Teaming up with other entrepreneurs on the island, Borden helped establish the city of Galveston, Texas. He and his partners surveyed and sold the original 2,500 land parcels that established Galveston as the largest city in Texas (at least for a while). He also surveyed and laid out the original city streets of the new town of Houston. As a trustee of the Texas Baptist Education Society, in 1845, he participated in founding Baylor University in the town of Independence (making it the oldest university chartered by the Republic of Texas).

Borden built a fine house in Galveston where he and his beloved Penelope raised a brood of four children. But disaster struck in 1844 when an epidemic of yellow fever raced across the island. Borden lost one of his children to the disease, and to add to his horror, it claimed the life of his guiding light, Penelope. Borden fell into a deep depression, had fits of violence and abandoned all his work. His brother Tom found a widow named Augusta Stearns who could move into the house and manage his household and his remaining three children. Eventually, for the sake of propriety, Borden married the widow, although they never appeared to be close.

In time, Borden emerged from his depression. To keep his mind busy, he started inventing things. One of his first efforts was a horse-drawn wagon that doubled as a boat. He called the machine a "terraqueous vehicle"

since it could (in theory) travel on both land and water. However, when he took the town elders of Galveston on a demonstration voyage into the Gulf of Mexico, the contraption didn't work exactly as planned, and he almost drowned them all.

I TRIED AND FAILED

A photograph of Gail Borden Jr. (1801–1874).

Another invention that didn't pan out was the "meat biscuit": dehydrated meat mixed with flour. Although the biscuit won a gold medal in the 1851 London Crystal Palace Exposition, it had no immediate commercial takers. Undaunted by the lack of initial buyers for his biscuit, Borden moved to the East Coast to try to market his new product. After several years of spending all of his money on the project, he ended up penniless. The widow Stearns had had enough of Borden's lame-brained inventions. She left him.

Bitterly accepting the defeat of the meat biscuit, Borden refused to give up. He prayed for inspiration and searched his mind for new ideas. Then it happened. He remembered an incident on his trip back from London in 1851. During the long weeks at sea, four children died from drinking soured milk. This was not an uncommon occurrence. Borden knew that even in the modern city of New York, thousands of children died each year from drinking spoiled milk. Borden decided that he would devise a method to keep milk fresh and safe for longer periods of time. It was a great idea, but he had no idea how to make it happen.

Borden experimented with this and that method of keeping milk fresh (remember that there were no refrigerators back then), but every idea failed miserably. Undaunted, he persisted with a conviction that his idea of creating safe milk was inspired by God. He took as his admonition a verse from the Bible: "Feed my sheep." (John 21:17)

In 1857, while visiting a religious group called the Shakers, Borden found the answer to his prayers. He saw how the Shakers used a vacuum pan to

prepare and preserve fruit juices that would then keep for long periods of time. Inspired by this new idea, Borden hurried back home. He tried out variations of the vacuum pan idea until he had devised a way to evaporate about 60 percent of the water from milk. The resulting milk didn't go bad in a few days like normal milk. To his delight, the milk lasted for weeks and was still safe to drink. Eureka! He christened his new creation with the name "condensed milk."

I TRIED AGAIN AND SUCCEEDED

Although Borden realized he'd discovered something important, he lacked a certain marketing prowess. Like his experience with the meat biscuit, his first attempts to sell condensed milk failed. Fortunately (maybe providentially), he found a partner, Jeremiah Milbank, who knew all about marketing. Using advertising and newspaper articles, Milbank educated the people of New York about the value of Borden's safe, clean and long-lasting milk. Although they didn't realize it at the time, much of what made Borden's milk safer than other milk was his obsession with cleanliness. (Back then, they didn't know about germs.)

During this period of renewed success, Borden met another widow, Emeline Church. They fell in love and married in 1860. Emeline not only cared for Borden's children (and her own two sons), but she also knew plenty about the dairy industry, and that helped Borden in his business.

Shortly after his marriage, the Civil War broke out between the Northern and Southern states. Borden found the war distressing because his sons fought on both sides of the conflict. On the other hand, it was a gold mine for his business. As the war progressed, tens of thousands of Union troops marched away from home and into the Southern battlefields. Whenever and wherever they marched, they drank coffee, and for their coffee, they needed milk. The U.S. Army discovered that Borden's condensed milk could be carried by soldiers onto the battlefield and would remain safe to use for weeks at a time. The army lapped it up as quickly as Borden could deliver it.

The big success of condensed milk would have secured Borden's future, but he had another idea up his sleeve. By adding sugar and canning the milk in a vacuum-sealed can, the milk would last not just weeks, but years. This new version of condensed milk was even better for the soldiers. Since the milk was already sweet, it reduced the need for soldiers to carry sugar. Borden labeled this new sweetened condensed milk "Eagle Brand." Borden

could barely keep up with the demand for orders. Throughout the war, the orders and the money kept pouring in. It made him a rich man.

After the war, the demand for Borden's milk products continued to grow as ordinary people learned how to use it for cooking, baking and feeding infants. From that point on, Borden's milk became known as the purest, cleanest and safest milk available, and it was soon a household brand sold all across the United States.

During the waning years of his life, a wealthy Borden often returned to Texas during the cold New York winters. True to his earlier commitment to Texas, he used his profits to educate Texas farmers in modern dairy techniques; organized a school for African Americans in 1873; built five churches; and provided support for underpaid ministers, missionaries and teachers. Gail Borden's strict demands for cleanliness and efficiency from the dairies where he purchased his milk resulted in a vast improvement in the way dairy farms operated in the 1860s and '70s. For this effort, he became known as the father of the modern dairy industry.

His namesake town, Borden, Texas, is in Colorado County, located on State Highway 90 (I-10) about seventy-five miles west of Houston. Gail Borden served as the town's justice of the peace and set up a meat-canning plant there. A thriving community in the 1870s, its population moved elsewhere once the highways and trains bypassed it. Borden, Texas, has now almost vanished. Only one store remains. Borden died in his town on January 11, 1874, and his body was shipped by private train car to White Plains, New York, for burial.

Miles away from Borden, Texas, are another county and town named after the inventor. Two years after his death, the people of Texas named Borden County in his honor. It is in west Texas on State Highway 180 between Snyder and Lamesa (south of Lubbock). The small town of Gail is the county seat. About seven hundred people live in the county and about two hundred in Gail.

Today, the Borden name can be seen on cans of his original condensed milk, as well as many other dairy products. The Borden brand that evolved from his original company is currently owned by Diversified Foods.

Amazingly, there is no granite monument or museum in Texas that honors this man who gave so much of his life, inventiveness and wealth to the creation of the Republic and State of Texas. However, there is a memorial to him in a state where he never lived. In Elgin, Illinois, you can visit the Gail Borden Public Library. Eighteen years after Gail's death, his stepsons donated the property and building for a new public library with the condition that it be named for Borden.

References

Frantz, Joe B. *Gail Borden: Dairyman to a Nation.* Norman: University of Oklahoma Press, 1951.

Wade, Mary D. *Milk, Meat Biscuits and the Terraqueous Machine.* Austin, TX: Eakin Press, 1987.

Wharton, Clarence R. *Gail Borden, Pioneer.* San Antonio, TX: Naylor, 1941.

Texas Tidbit

Gail Borden drew the first-ever topical map of Texas in 1835.

TEXAS TEA SERVED UP AT SPINDLETOP

Along the banks and in the center of the Paluxy River in Dinosaur Valley State Park near Glen Rose, you can see dinosaur footprints. Right there in the stream. You can make out the big toe of a brontosaurus-like sauropod called a Pleurocoelus and stand in the footprint of a relative of the famed T-rex. Some people wonder what they were doing in that part of prehistoric Texas.

Were they making oil?

Despite the sometimes popular belief that oil comes from dead dinosaurs, it really came from the goop that oozed up between the dinosaur's toes—tiny organisms like algae and diatoms. As billions of these creatures died and decayed, their sludgy remains sank to the bottom of the sea. After a really long time, their remains became deposits of oil. It seems like even back then, these tiny Texas creatures thought big Texas thoughts, because the Texas organisms were mighty productive, giving Texas an abundance of oil deposits just waiting for modern industry to find a need for it.

That need for oil came about during the last part of the nineteenth century. In 1885, an engineer named Gottlieb Daimler worked with another engineer named Wilhelm Maybach to invent a vertical-cylinder gasoline-powered engine with a fuel-injected carburetor for the purpose of powering an automobile. A year later, another German engineer, Karl Benz, received the first patent for a gasoline-fueled car. The Daimler Motor Company started producing automobiles in 1890, and Benz began mass producing cars in 1895. Eventually, these two companies formed Mercedes-Benz.

Not to be outshined by the Europeans, Americans joined these earlier automotive pioneers and immediately fell in love with the automobile. In 1893, the Duryea brothers started building cars in America. Henry Ford introduced his first car in 1896 (he formed Ford Motor Company in 1903), and Ransom Eli Olds produced his first car in 1901. However, for most Americans at the beginning of the twentieth century, the gasoline-powered car was little more than a backyard barn project for blacksmiths and tinkerers. It may have had a slow beginning, but the worldwide love affair with steel and leather was about to take off like a jackrabbit in a field of coyotes.

Gasoline wasn't the first choice to power an automated vehicle. Inventors tried steam, electricity, coal and a number of other substances. In fact, gasoline was first considered an unwanted byproduct from the production of kerosene (used for lamps). It was often thrown out as a useless substance.

However, even before a widespread need for gasoline emerged, people used oil products for heating and lighting (as an alternative to the more costly whale oil). The first notable oil find in America was in Titusville, Pennsylvania. In 1859, a retired railroad conductor struck oil using a wooden rig and steam-powered equipment. The rush to explore the region for more oil started the American oil industry. By 1900, John D. Rockefeller's Standard Oil Company controlled 90 percent of American oil, making him the wealthiest man in the United States.

IS THERE OIL IN TEXAS?

Even though the large oil operations of the day were based in the Northeast, there were signs that oil could be found in Texas. Along the southeast corner of Texas, near Beaumont, there had been signs of oil for decades. Reports told of a place called Sour Springs where gases erupted from the ground and brown liquids oozed into spring water. Nearby, an odd mound rose from the otherwise flat prairie land at a place called Spindletop. Over the years, this strange place had caught the eye of residents, including a battalion of Confederate soldiers who camped nearby during the Civil War in 1862.

After the war, rumors of the oil caused land prices in the area to rise dramatically as speculators bought and sold land around Jefferson County. Oil explorers from the East came to see what all the fuss was about. They found oil all right, but not enough to get excited about. Nevertheless, the search for oil in Texas intensified. Small discoveries were found near San

Antonio and Waco. In 1894, when the City of Corsicana drilled for water, it struck oil instead. Annoyed, it bypassed the oil and drilled deeper until it found artesian water.

However, the entire city of Corsicana wasn't dimwitted. Several residents formed the Corsicana Oil Company and brought in help that could turn the find into a moneymaking proposition. But this moderate discovery in Texas was soon to be overshadowed. Fate would bring together a group of people in Texas who would start a petroleum revolution.

Patillo Higgins was born in Sabine Pass, Texas, at the height of the Civil War, in 1863. His family moved to Beaumont six years later. Bud, as he was nicknamed, grew up in the stormy "carpetbagger" years following the war and earned a reputation as a rough-and-tumble fellow. Still a teenager, he shot and killed a deputy while fleeing from a crime but got off for self-defense. He did, however, lose an arm from the gunshot wound he received in the fight. He continued his hell-bent ways until, in 1885, he attended a revival and found religion. With as much fervor as he had sinned, he now served God, becoming a deacon at the First Baptist Church in Beaumont. Now an upstanding citizen in the brick business, he made a trip to Pennsylvania in 1889 to learn about methods of brick-making when he discovered the oil business. In the following years, he learned more about oil and soon became curious about the signs of oil around Sour Springs Mound. In 1892, he acquired the land around Sour Springs and started the Gladys City Oil, Gas and Manufacturing Company. When he tried to drill on the site, he found only quicksand, which seemed impossible to drill through. After several failed attempts, Higgins tried to sell the property in 1896 to John D. Rockefeller of Standard Oil but was refused. Higgins still believed that the field contained oil, but what he needed was an expert drilling engineer.

Anthony Lucas (née Luchich), born in the Croatian/Roman city of Spalato in 1855, grew up in Austria and studied engineering. At the age of twenty-four, he moved to America, worked at a sawmill and eventually became an American citizen. He traveled the country providing his engineering services in copper and silver mines and married a Georgian lass named Caroline Fitzgerald in 1887. In 1896, he was asked to ply his engineering expertise to help bore a water well in the difficult-to-drill sandy area of the Louisiana coast. Although he only found salt, he gained quite a bit of expertise drilling in sand. Sometime in 1899, Lucas struck up a writing correspondence with Patillo Higgins about the salt dome near Spindletop. Lucas speculated, as did many others, that such an area might also contain a deposit of oil. He and Higgins subsequently met in Beaumont in 1899, and in June of that year, Lucas signed

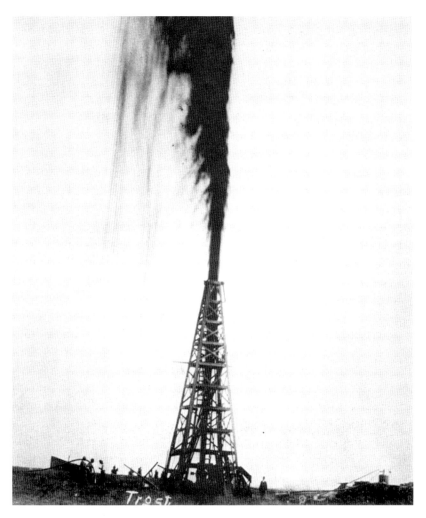

A photograph of Spindletop taken by Frank J. Troust, January 12, 1901. *Courtesy of Texas Energy Museum, Beaumont, Texas.*

a contract to lease (with an option to buy) a 663-acre tract around the mound. He and Higgins formed a tenuous partnership, and Lucas began to drill. At about 255 feet, he hit quicksand. He brought in a new-fangled rotary drill and was able to reach greater depths, but at 575 feet, the hole collapsed. Lucas had sunk his entire fortune into the drilling, and the future looked bleak. He needed someone with an idea. He got three someones.

From the oil field in Corsicana came three brothers: Jim, Curt and Al Hamill. They were introduced to Lucas through a couple of wildcatters

by the names of Guffey and Galey. Together, they persuaded the financier Andrew Mellon to join the project. This provided working capital to continue the search at Spindletop. To drill deeper than Lucas, the Hamill brothers employed a more modern rotary bit and an innovative process of flushing out the hole using mud, which stuck to the sides of the hole and kept it from collapsing. Using this innovative method of drilling, they were able to go deeper than Lucas's previous well.

On January 10, 1901, the well reached a depth of over one thousand feet. The roughnecks lowered the drill bit into the hole to dig even deeper. Suddenly, a gush of mud spewed up from the hole. They backed off the rig, and the mud stopped flowing. When they returned to clean up the mud, it erupted again, but this time with more force. With a blast that could be heard for miles, a gusher of mud spit out of the hole followed by a geyser of oil that spouted two hundred feet into the air. Six tons of four-inch drilling pipes blew into the sky, and the roughnecks scrambled for their lives. Men working in a nearby rice field heard the boom and thought the world was coming to an end. Windows rattled in houses, and the terrifying roar sent animals scurrying for cover. Thick, greasy oil washed over the ground and coated grass and plants for miles around the well, destroying crops on nearby farms. Curiosity seekers converged on the spectacle. Photographer Frank J. Troust took a lucky picture that would become the famous record of the gusher that brought in the age of oil.

Eighty Thousand Barrels a Day

For nine days, about eighty thousand barrels of oil a day spewed uncontrolled out of the well until the crew capped it and stopped the flow.

With the discovery at Spindletop, the economic landscape of Texas changed forever. Texas became a world leader in oil production, and the drilling innovations used at Spindletop were repeated in oil fields all over the globe. The year following Spindletop saw more than 1,500 oil companies chartered. Some of the more notable ones included Gulf Oil, Magnolia Petroleum and the Texas Company (Texaco). Sun Oil also got into the act by moving to the area. Where there is wealth to be made, there are speculators. Beaumont became a boomtown, swelling in population. Land prices shot higher than the oil plume. Businesses and buildings appeared from nowhere. For a brief period in time, all roads led to Beaumont. But it didn't last.

Although Spindletop started a revolution, overproduction in the area soon led to a decline in production to ten thousand barrels a day by 1904. However, from that discovery, a vast army of wildcatters fresh with new oil drilling skills spread all over Texas searching for the next big oil field (and they found several). As a result, Texas soon became the lead producer of cheap fuel for the growing automobile industry and the oil capital of the world.

The real boomtown is long gone, but you can still grab a flavor of the era by visiting Spindletop–Gladys City Boomtown Museum, created in association with Lamar University in Beaumont. This museum helps you get a feel for the era and sense the excitement that filled the area during the Spindletop phenomenon. A walk around the re-created boomtown lets you peek into hotels, barbershops and livery stables of the era; stand under an oil derrick; and stroll along the creaky wooden sidewalks. Take time to watch the film that chronicles the discovery of oil and the personalities of the people involved.

The Gladys City Boomtown Museum is a National Historic Landmark. Since its dedication in 1976, over a half million people have visited Gladys

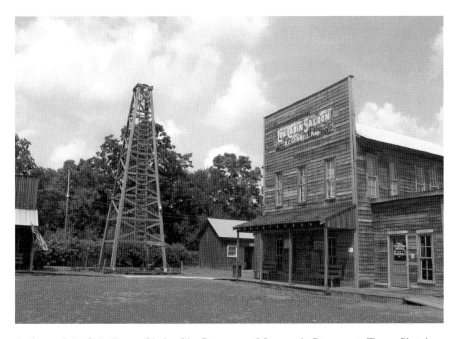

A photo of the Spindletop–Gladys City Boomtown Museum in Beaumont, Texas. *Photo by author.*

City. It provides school tours, adult group tours, teachers' workshops and historical information for researchers, journalists and the general public. The museum is open for self-guided tours Tuesday through Saturday, 10:00 a.m. to 5:00 p.m., and Sunday, 1:00 p.m. to 5:00 p.m. (closed major holidays). Go to www.spindletop.org for more information. Group tours may be arranged in advance by calling 409-835-8023. Gladys City is found at the intersection of University Drive and U.S. Highway 69/96/287 in Beaumont, Texas. Southbound on 287, take the "Highland Ave.–Sulphur Dr." exit; proceed down the service road crossing Highland Avenue. At the first U-turn underpass, turn left and proceed northbound about one-quarter mile to University Drive and Gladys City.

References

Linsley, Judith Walker, Ellen Walker Rienstra and Jo Ann Stiles. *Giant Under the Hill: A History of the Spindletop Oil Discovery at Beaumont, Texas, in 1901.* Austin: Texas State Historical Association, Austin, 2002.

Spindletop/Gladys City Boomtown Museum: A Guide and a History. Beaumont, TX: Lamar University, 1992.

Texas Tidbit

Three major oil companies—Gulf, Texaco and Mobil (now ExxonMobil)—all trace their beginnings back to the Spindletop gusher.

HILTON HOSPITALITY AND STYLE

Conrad Nicholson Hilton, thirty-two years old and fresh from the battlefields of World War I, came to Texas in 1919 to find his fortune. Little could he have realized what an impact this trip to the Lone Star State would have on his life and the world.

Connie (as his family called him) was born in San Antonio, New Mexico, in 1887, the second of seven children of Gus and Mary Hilton. Friends knew Gus (August) as a tall Norwegian who could strike up a conversation with anyone and usually did. He had a keen nose for business and stepped out to take risks when there were profits to be made. Connie's mother, born Mary Laufersweiler, had an opposite personality. Quiet and full of faith, she led her children with a gentle, determined and firm hand.

As a fifteen-dollar-a-month clerk, young Connie cleaned, stocked and ordered supplies for his father's general store. Unlike today's stores where everything is priced, clerks of that era had to negotiate prices with customers. A certain code of ethics existed between the contentious parties where, in the end, each one of them had to think they got a good deal. Connie got good at selling and one day decided to spend some of his hard-earned money on a personal luxury: an L.C. Smith twelve-gauge hammerless shotgun. He placed an order. When his penny-pinching father found out about it, he gave his son a piece of his mind—not because of what he'd ordered, but how. For the twenty-pound shipping charge paid to deliver the rifle, Connie could have shipped one hundred pound of goods: "You threw away an eighty-pound opportunity. You

could have gotten a keg of nails for the same freight charge. You'll never get rich that way."

Although Connie enjoyed his small hometown, he also had ambition. He tried his hand at several different careers, including managing his sisters' singing trio. He also tried politics and won a seat in the New Mexico State Assembly when it became a state. Neither of these careers satisfied him.

Connie tried banking. Raising seed capital from ranchers and farmers he'd sold shovels and sacks of flour to in the past, he sold enough shares to start up the New Mexico State Bank of San Antonio in September 1913. Thinking he had his "own" bank, Connie had a rude awakening when the major stockholders elected Mr. Allaire, a Hilton rival, as the bank president and relegated him to a position with no salary. Connie shot back. He collected proxy votes from all the small stockholders so he could take back his bank. At the next stockholders' meeting, Hilton had the votes to take over. He thought he had won. But Allaire had managed to drain the bank dry before Connie could take office.

"The bank is busted," Allaire announced at the meeting.

Connie thought all his work had been wasted. But Connie's shrewd father, who knew Allaire would be up to no good, had his own surprise. Gus produced two new deposits of $3,000 to save the bank.

Connie became the bank vice-president and started working. Canvassing every dirt farmer, every sheep rancher and every household within riding distance, he increased the bank's assets to $135,000 in two years. By 1916, Connie dreamed of a chain of banks statewide. Instead, World War I got in the way. Like other ambitious young men, he heard the call of patriotism. He joined the army and sold his interest in the bank. This turned out to be a good thing. As an army lieutenant in France, he made lifelong friends who would become instrumental in his future success.

GO TO TEXAS, CONNIE

After World War I and the death of his father, Connie came back to New Mexico. He mulled over what to do with his small nest egg of $5,011. His mother encouraged him, "If you want to launch big ships, go to where there's deep water." The answer to "where" this deep water could be found came on the deathbed of an elderly family friend, Emmett

Vaughey. Connie went to see Vaughey, and when he entered the room, the old man looked at Connie, raised himself up on his pillow and told him as if there was no time to waste, "Go to Texas, Connie."

Something clicked in Connie's mind. "He's right!" He'd heard that Texas was knee deep in oil and ships of fortune were coming in daily. And fortunes meant people needed banks.

With the nest egg sewn into the lining of his jacket, Connie arrived in Wichita Falls. No banks were for sale. He traveled to another oil town, Breckenridge, took one drink of its putrid water and kept going. Arriving in the bustling oil town of Cisco, Connie liked the "feel" of the place. He surveyed the local bank and found that it was indeed for sale for $75,000. But the owner was in Kansas City. Connie counted his assets. His mother would probably pluck down $5,000, and his friends William Keleher and L.M. Drown were probably worth $5,000 each. With that kind of seed money in hand, he felt like he could raise the necessary cash. He sent a telegram to the owner and waited. Things were looking up until the next morning. A telegram arrived from the bank's owner: "THE PRICE IS EIGHTY THOUSAND AND DON'T BOTHER TO HAGGLE."

Connie had learned one thing from his negotiations with farmers, ranchers and businessmen: don't do business with someone who can't stand up to his word. He sent the owner a telegram with his reply: "AMAZED YOUR INDIFFERENCE TO AN ALL-CASH DEAL NO REPLY WANTED." Frustrated, he sat in the lobby of the local Mobley Hotel watching a mob of men trying to get a room. The place was so full that the owner was renting out rooms for eight hours at a time, turning over each room three times a day. A man came over, sat next to Connie and said, "You haven't got a chance to get a room tonight."

Connie stared at him. "Who are you?"

"I own this place."

They began talking, and Connie found out that what the owner really wanted was a chance in the oil fields, but he was stuck with the hotel.

Without hesitation, Connie sealed his future. "You'd sell?" he asked the owner. "What's the price?"

The owner didn't hesitate. "Fifty thousand."

Connie stood up, looking around the crowded lobby. "Let me see the books."

Although he'd never dreamed of owning a hotel before, he was not without experience. During a bleak time in New Mexico, Connie's mother and father had turned the Hilton family home into a five-room hotel, and the entire family had pitched in to make a go of it.

Connie claimed that there were two important lessons he'd learned from his parents. From his father, he learned to work long and hard hours, to make deals and to keep the customer satisfied. From his mother, he learned to pray. Later in life, he said he had learned one more thing: to dream big.

Connie set out working hard to make the deal come true. He called in a business partner, L.M. Drown, and described the Mobley as something between a flophouse and a gold mine. Drown arrived by train, and they went over the books again. He agreed that the hotel was a solid business. Now it was up to Connie to get his best deal. In his own words, Hilton described how he rolled up his sleeves and haggled the deal with Mobley: "It was a first-class bout, and we could both enjoy it because we never let the deal get out of hand. He wanted to sell. I wanted to buy. At $40,000 we shook hands."

With a deal in hand and a week to pay off, Connie and Drown went to work wheeling and dealing with every person they knew who might have some money to throw in the pot. Adding to his original $5,000, his mother pitched in $5,000, and several other friends and business acquaintances joined the deal. With $20,000 raised in four days, Connie went to the local bank to raise the rest.

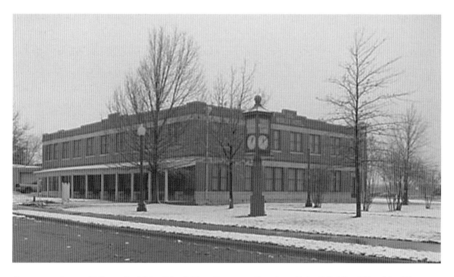

A recent photo of the refurbished building that was the site of the Mobley Hotel in Cisco, Texas. *Courtesy Cheryl Lindsay, Conrad Hilton Community Center.*

Sure the deal would go through, he was met with a curveball he hadn't expected. One of his investor's checks bounced. Now he turned to what he'd learned from his mother: he prayed. In the midst of that prayer, he had an idea.

He went back to the bank and made an offer: "I have a friend in New Mexico who owns a ranch worth $20,000. If you could loan him $5,000, he'd put the money in the deal."

The banker accepted the idea, telegrams were sent back and forth to finalize the transaction and the deal was done.

THE FIRST HILTON HOTEL

Conrad Hilton, the shop manager, the politician, the banker and the army lieutenant, found himself the proprietor of a first-class flophouse hotel in the middle of a West Texas oilfield. The Mobley Hotel in Cisco, Texas, had become the first "Hilton" hotel. That night, the hotel was full, and Connie and his partner slept in the office.

All of Hilton's experiences of the past blended together into a torrent of ideas on how to make his hotel produce more money. What he'd learned from his father's obsession with squeezing every penny out of every square inch of a business led him to take quick steps to improve the cash flow of his new business. He tore out the cafeteria and added more rooms. After all, there were plenty of "hash-houses" in the city. He shortened the reservation counter by half and put in a tobacco and newspaper stand. A corner that housed a large palm tree became a small novelty shop. This became a pattern for future Hilton Hotels. Every bit of space must have a purpose, and every resource must be utilized.

After teasing as much space out of the physical building as possible, Hilton had another idea. He told his idea to Drown: "I know something else that would make us a better hotel—and more money. What we learned in the army: *esprit de corps.*"

"I'm all for it," said Drown. "How do you get it?"

Hilton described his plan to make every employee feel an ownership in the hotel, to make them feel they belonged to the greatest company in the world. He summarized his philosophy in one made-up word: "minimax"—the customer should always get "minimum charge for maximum service." He preached that message to every employee, and it took hold.

TEXAS INGENUITY

The Mobley turned out to be a great training ground to learn the hotel business. It prospered along with the oil boom and within a month had whetted the appetite of the young entrepreneur. He recruited an army buddy, Major Jay C. Powers, to join his enterprise.

"Start in Fort Worth," he told his new partner. "Look for another hotel." Powers searched Cowtown and found the once prominent and now badly blighted sixty-eight-room Melba Hotel. Covered with grime and riddled with years of disrepair, it took a crazed optimist to see anything good in it. In fact, no bank would touch the deal. Connie went to work again raising money from friends and business partners. The deal went through, and Hilton's bucket brigade went to work to bring the shine back to the old place. In three months, the spanking-clean hotel turned a nice profit.

If two was good, three must be better. Thirty miles to the east lay Dallas, and the hotel that caught Hilton's sight was a six-story, 150-room handyman's project, the Waldorf. A young banker, R.L. Thornton, loaned Hilton the start-up money. Hilton spruced up the Waldorf, eliminated wasted space and turned another orphan into a moneymaking enterprise.

THE DALLAS HILTON

A few more hotels later (with one in Wortham, Texas, a complete failure), Hilton tired of the "face-lifting business." He wanted a new hotel designed from the ground up. On a visit to his mother, she caught him doodling.

"Something new, Connie?"

"I'm putting my dream on paper," he told her. The dream was for a high-rise hotel for Dallas, Texas. It would cost over $1 million to build.

"You'd better pray about it."

Connie took his mother's advice. Then he hired an architect. This time, he had a $100,000 nest egg. Hilton played every money card he could find. He saved money on the land by leasing it for ninety-nine years rather than purchasing it outright. Money came in and the construction started, but expenses ran over budget. Living for months on the verge of imminent failure, last-minute funds kept showing up by odd circumstances and from unexpected investors just in the nick of time. Little by little, the building took shape. In August 1925, the last rug was laid and the last doorknob was polished. The Dallas Hilton opened. It was an immediate success.

With breathing room in his life, Connie married Mary Barron and started a family. First living at the Stoneleigh Apartments in Dallas, his first

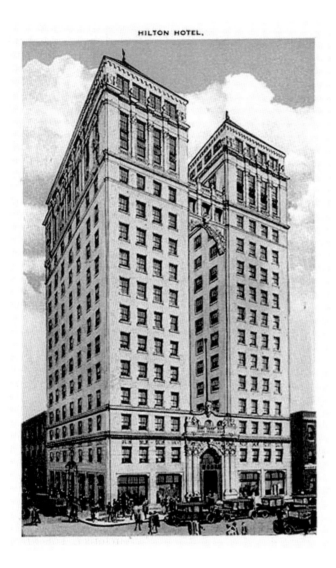

HILTON HOTEL.

Dallas Hilton Hotel
from a postcard
circa 1925.

son, Nick (Conrad Jr.), came along in 1926. In 1927, when son number two, Barron, arrived, the family moved to Lindenwood Street in Highland Park. In 1933, the third son, Eric, arrived.

With the success of the Dallas Hilton, other cities in Texas clamored for a Hilton Hotel. Some cities offered him funds to get the projects rolling. Glad to oblige, Hilton added to his growing collection of hotels in Abilene, Waco, Lubbock, San Angelo, Marlin and Plainview.

Texas Ingenuity

Setbacks

In the fall of 1929, Hilton announced his next grand hotel would be built in El Paso, the gateway to Mexico. It would cost a whopping $1,750,000. Nineteen days after the announcement, the stock market crashed.

The economic impact of this event did not immediately affect Texas, and the plans for the El Paso Hilton went forward. However, by the time it opened its doors, there were no salesmen and no travelers to rent rooms.

Hilton's luck had run out. All across Texas, his hotel rooms sat empty. No matter how many hours he worked, no matter how hard he prayed, his hotel empire crumbled to almost nothing. In a desperate move, he partnered with the Moodys of Galveston, but even then he defaulted on his loans. Over the next few years and in the tense partnership with the hardnosed Oleander City businessmen that resulted, Hilton managed to regain ownership of a few of his hotels.

When the economic crisis lifted, Hilton found that the experience placed him in a position to take advantage of new opportunities. With his miracle method of squeezing the most economy out of each venture, Hilton and his band of loyal partners picked up failed hotels for a pittance.

Applying all the tricks he'd learned in Texas, Hilton used his innovative blend of tight control and management autonomy to get the most profit out of each newly acquired hotel. He demanded from each manager that they use every inch of every building; use mass purchasing where possible; and never waste time, talent or money. At the same time, he allowed managers to make their own decisions as to how to accomplish these goals.

Hilton's Success Philosophy

In his autobiography, *Be My Guest*, Hilton outlined his innovative philosophy with the following points:

1. Hotels must fit the personality of the city and managers must be given the authority to meet the demands of that community.
2. Managers must forecast the needs of the hotel on a day-to-day basis to determine the number of staff and amount of purchasing needed, so that no labor or resources are wasted.

3. Use mass purchasing for as many items as possible—matches, china, bar soap and carpets. Work with manufacturers to design products that meet the hotel's specific needs.

4. Dig for Gold: Like in the experience at the Mobley, find and use all wasted space, turn idle areas into money-making centers.

5. Train good managers with on-the-job training as well as formal schooling.

6. Sell the hotel to the public. Use advertising, promotion, publicity and intelligent booking of parties and conventions.

7. Use an inter-hotel reservation system to book travelers in sister hotels throughout the world.

Using this philosophy, Hilton continued to purchase marginally successful hotels and turn them into spectacular moneymakers, while providing a better experience for his guests. Early acquisitions that experienced Hilton's magic formula included the Sir Francis Drake in San Francisco, the Plaza in New York and the Stevens and Palmer House in Chicago.

A typical story of how Hilton put his own philosophy into action includes how he squeezed profits out of thin air at the Conrad Hilton Hotel in Chicago (formerly the Stevens). Needing more room for conventions, he split a ballroom with a multistory ceiling in half (horizontally) to create two rooms out of the one. In another example, after his acquisition of the Palmer Hotel in Chicago during World War II, he entered the lobby and noticed a mob of guests cluttering the lobby, with a sign above them stating, "Sorry, no rooms without a reservation" (a common practice of the day). Hilton took down the sign. He created a "club" to house the guests (and get them out of the lobby) until his staff could find them accommodations in another hotel. This unheard-of practice soon became commonplace among better hotels and gave Hilton great goodwill among travelers. In the first year of Hilton's ownership of the Palmer, it earned $1.7 million more in revenue than it had in its previous year.

Hilton described his crowning business achievement as his 1949 purchase of "the greatest hotel of them all," the Waldorf Astoria in New York City. Although he was once told that the prestigious hotel was not for sale at any price, he kept a photo of the hotel under the glass on his desk. Every day, that photo reminded him of the goal. With patience and determination, he waited, negotiated and waited more for the time to come. When the door of opportunity opened, he stepped in. The spectacular purchase of the Waldorf Astoria made the world take notice of this upstart Texas hotelier.

Conrad Hilton lived long enough to see his fame make him a household name that ranked him among Hollywood celebrities. The Hilton name meant finery, the best the world had to offer. Divorced from his first wife in 1934, he married the glamorous actress Zsa Zsa Gabor in 1949 and had a daughter named Francesca. In 1950, his son Nick married Elizabeth Taylor. In 1954, his second son, Barron Hilton, became president of the Hilton Corporation.

In his later years, he adopted a new motto and a new passion. As his empire spread around the globe, and as the world feared the proliferation of nuclear weapons and communism, Hilton saw his hotels as places where people from different cultures could meet and make peace. Thus, his new personal and corporate philosophy became "World Peace Through International Trade and Travel."

In 1952, Hilton gave a speech titled "The Battle for Peace," in which he offered a prayer asking, "Be swift to save us, dear God, before the darkness falls." The prayer was printed in numerous national magazines accompanied by a picture of Uncle Sam kneeling in prayer. Within weeks, hundreds of thousands of the posters were sent to Americans requesting a copy.

Texans can experience the beginnings of Hilton hotels by visiting the site of the Mobley Hotel in Cisco and the original Dallas Hilton in downtown Dallas (now the Hotel Indigo). The Mobley, purchased in 1919, remained in the Hilton family until 1931. In 1979, shortly after Conrad Hilton's death, a rehabilitation plan was begun to renovate the old building. The restored building reopened in 1986 and now serves as the city's chamber of commerce office and community center. Two rooms are restored to the original 1919 look, and another room features a historical museum. The Mobley is located just north of I-20 at 309 Conrad Hilton Avenue in Cisco. It is open for tours from 9:00 a.m. to noon and 1:00 p.m. to 5:00 p.m. Monday through Friday. Cisco is located on Interstate 20 between Fort Worth and Abilene. For more information, call 245-442-2537 or visit the www.cityofcisco.com website (look for the chamber of commerce).

For a taste of the first hotel bearing the name "Hilton," visit the Hotel Indigo in downtown Dallas, Texas, on the corner of Main and Harwood. Built in 1925 and renovated in 2006, this hotel was originally described as one of "an exclusive, limited line of upscale luxury hotels only found in a few select cities." The current building is a nationally registered landmark and still glitters with architectural detail and luxury of yesteryear. Much of its original charm as designed by Conrad Hilton remains. In fact, if you sit in the lobby, you might be able to hear the ghost of Connie Hilton laughing

with his partners as he remembers an old joke from the days when they were putting up men at the crowded Mobley: "We can let you have a room with three other gentlemen."

References

Baird, Cathleen. "Conrad N. Hilton: Innkeeper Extraordinary Statesman and Philanthropist, 1887–1979." Conrad N. Hilton Collection, Hospitality Industry Archives and Library, University of Houston, Texas, 2005.

Bolton, Whitney. *The Silver Spade: The Conrad Hilton Story*. New York: Farrar, Straus and Young, 1954.

Comfort, Mildred Houghton. *Conrad N. Hilton, Hotelier*. Minneapolis: T.S. Denison & Company, Inc., 1964.

Hilton, Conrad. *Be My Guest*. New York: Fireside, Simon & Schuster, 1994.

Texas Tidbit

Two top companies that set world standards for sophistication and style started around the corner from each other in Dallas in the 1920s: Hilton Hotels and Neiman-Marcus.

NEIMAN-MARCUS BRINGS FASHION TO DALLAS

The creation of the Neiman-Marcus store was a big mistake. At least that's the story spun by Stanley Marcus when he introduced himself to new employees. As he told it, his father, Herbert, and his aunt Carrie Neiman and her husband, Al, had a good thing going in Atlanta, Georgia.

Earlier in his career, Herbert Marcus had worked for Sanger Brothers and Carrie had worked for A. Harris, the top two retailers in Dallas. But in 1906, as idealistic young people are likely to do, they decided to strike out on their own. They moved to Atlanta and started their own business. What they did—and they did it well—was to help small merchants stage flamboyant sales and attract new customers. In fact, their business was so successful that they were soon presented with two buy-out offers. One suitor offered the franchise for the entire state of Kansas for an up-and-coming soft drink called Coca-Cola. The other offer was for $25,000 in hard cash. Stanley doesn't know why they passed up on the franchise offer, but they did. Instead, these three young entrepreneurs were itching to do retail more than manufacture fizzy drinks. With cash in hand, they made plans to open a Neiman-Marcus specialty store.

Why they moved back to Dallas, no one is sure. But that's where the first Neiman-Marcus store opened on September 10, 1907. Of course, the original store was much smaller than the downtown store today, but the philosophy and commitment to service seen at the opening set the stage for one of the most innovative and successful stores in the world. The *Dallas Morning News* reported the opening of the store as a "New and Exclusive

Shopping Place for Fashionable Women, Devoted to the Selling of Ready-to-Wear Apparel." Ads for the store proclaimed "We have…garments that stand alone as to character and fit.…We will be known as a store of Quality and Superior Value" and "We shall be hypercritical in our selections."

FASHIONABLE INNOVATION

To understand what this commitment meant, you have to understand women's clothes of that era. In the early 1900s, you couldn't go to a store and buy a fashionable dress "off the rack" like you can today. Almost all women's outerwear was made to order (or you made it yourself at home). If you wanted fine clothes, you had no option but to travel to New York or Europe to have them made. Our three new store owners were foresighted enough to see a trend developing. At that time, there were several clothing makers experimenting with ready-to-wear, but the technique of sizing clothes had not been mastered. Carrie Neiman and Moira Cullen went to these manufacturers and worked with them to provide the new store a line of the best ready-made clothes. They were indeed "hypercritical" in their choices. Unlike most retailers, who wanted changes to the merchandise that would lower the price of a dress, Carrie and Moira demanded changes for many of the dresses that would bring them up to standard for the store. When the women of Dallas saw the fashions offered by the new store, they snapped them up.

From the minute its doors opened in 1907, Neiman-Marcus operated as a different kind of store. The philosophy preached by Herbert Marcus was, "There is never a good sale for Neiman-Marcus unless it's a good buy for the customer." Again, you must understand that the usual motto for doing business at the turn of the twentieth century was "let the buyer beware." When you plunked down your hard-earned cash, you purchased what you purchased, as is. No returns. No refunds. No sympathy. The three young idealists who started Neiman-Marcus believed that it was time to operate in a better way. They decided that the Golden Rule, "treat others like you want to be treated," made more sense. And they were right. But this new philosophy proved hard to sell to both employees and customers. The employees didn't understand how Mr. Marcus could allow a woman who had worn an expensive dress for three months to return it for a full replacement. He did, and he explained to the customer how to better care for the delicate lace on her new dress. The store lost $175 by replacing the dress, but the now loyal

customer spent over a half million dollars with Neiman-Marcus in future years. Herbert Marcus repeated his philosophy: "It's never a good sale for Neiman-Marcus unless it's a good buy for the customer."

Legendary Service

The customers' attitudes also had to be changed. In the early days, Herbert, Al or Carrie personally greeted every customer who walked in the door. If they saw a customer about to purchase something they thought didn't fit right, they would immediately kill the sale and offer a better suggestion. Through the years, customers came to appreciate the honest attention given to them at the store. In fact, the Neiman-Marcus quality of service grew to legendary proportions through the years.

One of these stories concerns a young schoolteacher moving to Midland who didn't have a thing to wear. She also had little money but wanted to make a good impression on the men when she stepped off the train. Neiman's provided her with two outfits. She wore one and sent the other one back. It took her months to pay off the one she kept, but twenty years later, she sent her story into the paper, and another saga in the NM legend was added to the list.

Then there was the out-of-town customer who wanted two ducklings delivered to his nephew before Easter. Neiman's agreed and quoted a price. They later discovered that the bus express they had counted on would not deliver the ducks. True to their promise, they hired a chauffeur to make the delivery, which cost three times more than what the customer had been quoted. (Of course, the customer was only billed the original price.) Another example is the customer whose wife and child were coming through Dallas during World War II and needed housing, transportation and milk for the baby. Neiman's provided all three, even though war rationing made it difficult to find fresh milk. And there was the customer in New York who wanted to be taken personally to the fashion houses to select an appropriate dress. Carrie Marcus Neiman took time off from her buyer's duties and showed the customer around. Time and time again, Neiman-Marcus employees went the second mile for its customers. Over the years, this over-the-top personalized effort created a family of loyal customers and many sales.

However, the story of Neiman-Marcus was not all bluebirds and lemonade. On the morning of May 11, 1913, tragedy struck. The entire original store burned to the ground. The family gathered up every penny

they could scrounge, went to New York to buy replacement merchandise and reopened in temporary quarters sixteen days later. The disaster became an opportunity to expand, and a new larger store was built and several new departments were added. It reopened as "twenty-five specialty shops" in one store. With an expanded store, the original threesome had to hire new employees and take on new responsibilities and could not greet each customer personally. This challenged the store's commitment to customer service, but the Golden Rule prevailed and the new expanded service succeeded.

Stanley Marcus (usually called Mr. Stanley to distinguish him from his father, Herbert) joined the company in 1920. He was first apprenticed as a shoe salesman, where he learned the lessons of the store's philosophy, although he did suffer a few faux pas. After graduating from Dallas's Forest Avenue High School (where he'd been voted "Most Popular Boy"), he did a stint at Harvard before returning to the family business. Because of the store's entrenched management that consisted of his father, Uncle Al and Carrie, Stanley felt underused. He struggled to find his place in the company and finally had success by creating a luncheon fashion show at the nearby Baker Hotel during the slow summer months. His event brought new customers to the store, and the idea was copied and used by other fashion stores throughout the country. However, his Uncle Al did not warm up to the youngster's new-fangled Harvard ideas. In 1928, after a series of clashes, Uncle Al opted out of the family business for $250,000. At about the same time, he divorced Carrie. With Al gone, Stanley had to assume a critical role in the company.

MR. STANLEY'S INGENUITY

Mr. Stanley stepped up to the challenge. With his father as mentor, he absorbed the business's customer-centric philosophy and added his own ideas to the mix. These included a stationery shop as well as personalized wrapping. The gift-wrapping was so successful that people from all over the country ordered items from Neiman-Marcus, even though the item was available in their own city, just to have the product delivered in the fancy NM wrapping. Mr. Stanley also added a bridal show and, in a bold move, began advertising in *Vogue* and *Harper's Bazaar* magazines right next to the fashionable New York stores. The fashion bigwigs back east took notice. Dallas, the city in the middle of nowhere, suddenly appeared on the fashion map.

Right: Stanley Marcus: voted "Most Popular
Boy" from 1921 Forest Avenue High School.
Dallas yearbook.

Below: Neiman-Marcus building from a
postcard circa 1920.

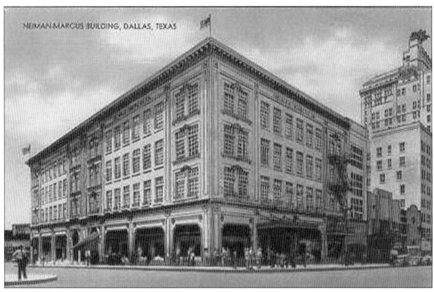

NEIMAN-MARCUS BUILDING, DALLAS, TEXAS

In 1936, the Texas Centennial celebration took place at the State
Fairgrounds in Dallas. To capitalize on the occasion, NM put on an
extravagant fashion show featuring a Southwest motif. The big event
attracted women from all over the state of Texas. Mr. Stanley used the
occasion to invite the editor of *Vogue*, who had never been any farther west
than the Hudson River, to Dallas. To get her to come into the "Wild West,"
he had to go to New York and escort her personally by train. When she

arrived, the glamour of the Neiman-Marcus store and the top-notch fashion show overwhelmed her. There was indeed fashion outside of New York.

With *Vogue* taking the lead, other fashion magazine editors took notice. It was the year "in which the United States discovered Texas." Once the Texas ball started rolling, more and more editors had to visit the Lone Star State, and they, too, were converted to Texas fashion. *Collier's* magazine reported, "At this moment, the eyes and ears of the fashion world are focused not on Paris. Not on New York. Not on Hollywood. But on Dallas." *Fortune* magazine called the city "Dallas in Wonderland." For no other reason than Mr. Stanley and Neiman-Marcus, Dallas became known as the fashion center of the Southwest. This attention to the city not only helped Neiman-Marcus, but it also brought opportunities for growth in the fashion industry to a number of enterprises in North Texas. (To this day, Dallas remains the fashion center of the Southwest. Take a trip on Stemmons Freeway past the World Trade Center, and you will see the impact this designation has had on the economy of Dallas and Texas.)

Over the next decade, the downtown Dallas store expanded again, and Neiman-Marcus continued to wow the fashion industry with innovations, such as the establishment of the Neiman-Marcus Award for Distinguished Service in the Field of Fashion, which drew the elite of the fashion world to Dallas year after year.

In 1950, Herbert Marcus died, leaving Mr. Stanley as company president. Again he proved his worth with more innovations. One of his most successful ideas was a series of "fortnight" promotions. On a 1956 trip to Stockholm, Stanley visited a department store promoting French goods where the entire store transformed into a wonderland of French merchandise, art, music and decorations. He took the idea back to Dallas and sold the concept of how the entire Dallas community could benefit from staging a "French Fortnight" full of cultural activities as well as retail promotions, all on a French theme. His ideas received an enthusiastic response by Dallas community leaders. The Dallas Museum of Fine Arts arranged for an exhibit of Toulouse-Lautrec paintings never before shown in America. The Dallas Municipal Auditorium featured the largest presentation of French tapestries ever seen in the United States. French celebrities and diplomats were invited to speak at civic functions. Nightclubs booked French entertainers. And the *Dallas Times Herald* typeset its paper in a French style.

Neiman-Marcus Brings the World to Dallas

As for letting the world know about the event, Neiman-Marcus arranged for a special section in *Vogue* magazine promoting the French Fortnight and featuring advertising from the best French companies. French artists, diplomats, designers, manufacturers and celebrities were transported to Dallas on a special Air France flight. During the Fortnight, the entire Neiman-Marcus store façade in downtown Dallas was transformed into a French city block.

The reception to the French Fortnight was fantastic. Not only did the event produce astounding publicity for the store and for Dallas, but the sales during the month of the Fortnight increased more than any month in the company's history. In 1958, a British Fortnight was staged; in 1959, it featured a South American theme, and in 1960, a wildly successful Italian Fortnight was presented. With the success of the event, countries from all over the world not only wanted to participate, but they offered to pay for the costs of the event. For many years, the Fortnights became a highlight of every October in Dallas. They continued for a number of years but ended in the 1980s.

That Famous Christmas Catalogue

Another Mr. Stanley innovation continues today. From its earliest years, Neiman-Marcus had a reputation as the place where rich people (mostly oil-rich Texans) bought outrageous gifts. Each year as Christmas approached, Stanley received calls from the national media wanting to know what extravagant purchase had been made that year. There were enough items to keep the media interested, but frankly, Stanley had to make up a few stories. After a few years of Christmas media calls, the idea came to him that he might encourage some newsworthy purchases by offering a few extraordinary gifts in the annual Neiman-Marcus Christmas catalogue. He took the idea to the marketing department, and it came up with "His and Her" gifts. The first was a pair of Beechcraft Airplanes. When the calls came at Christmas, Stanley reported that they had sold one "Her Airplane." The promotion created so much publicity that the following year, the catalogue featured "His and Her" submarines. Within a few years, not only did the media look forward to reporting the annual "His and Her" gifts, but an increasing number of customers from around the world demanded to receive each year's catalogues. The popularity of the catalogue brought publicity and sales.

Decades after the first His and Her gifts, the Christmas catalogues continue to offer a few extravagant gifts. Some of the memorable ones include a wall of fine wine, an Angus steer (either on the hoof or cut into steaks), His and Her robes made of shahtoosh (the most costly cloth in the world), Jaguar roadsters, bathtubs and a Chinese junk. In 2003, His and Her robots sold for $400,000 each. In 2004, the catalogue offered His and Her bowling centers. In 2005, it offered His and Her custom photo booths for $20,000 each, as well as an M400 Skycar for $3,500,000. Today, over two million of the Neiman-Marcus Christmas catalogues are mailed around the world to eager customers.

When you have legendary customer service, an occasional cynic will make up a story that becomes an urban legend. One particular Neiman-Marcus urban legend first appeared in chain mail as far back as 1948 and now makes its round as junk e-mail. In this story, a disgruntled NM customer gets revenge by sending out copies of an expensive Neiman-Marcus cookie recipe. (The same urban legend exists with Mrs. Fields cookies, as well as for Waldorf-Astoria red velvet cake.) The fact that this legend exists is evidence of the aura surrounding the Neiman-Marcus brand name. (No one ever devised such an urban legend for Keebler cookies!) In fact, the recipe that has been circulated all these years is someone's own home cookie recipe. Neiman-Marcus didn't even sell chocolate chip cookies in its restaurants in that era, and its restaurants have always given their recipes freely to customers. Nevertheless, as a public service, Neiman-Marcus created a cookie recipe to give away in response to inquiries about this legend. Here it is, direct from its website at www.neimanmarcus.com:

Neiman-Marcus Chocolate Chip Cookie Recipe

½ cup (1 stick) butter, softened
1 cup light brown sugar
3 tablespoons granulated sugar
1 large egg
2 teaspoons vanilla extract
1¾ cups all-purpose flour
½ teaspoon baking powder
½ teaspoon baking soda
½ teaspoon salt
1½ teaspoons instant espresso coffee powder
1½ cups semi-sweet chocolate chips

Preheat oven to 300 degrees. Cream the butter with the sugars using an electric mixer on medium speed until fluffy (approximately 30 seconds).

Beat in the egg and the vanilla extract for another 30 seconds.

In a mixing bowl, sift together the dry ingredients and beat into the butter mixture at low speed for about 15 seconds. Stir in the espresso coffee powder and chocolate chips.

Using a 1-ounce scoop or a 2-tablespoon measure, drop cookie dough onto a greased cookie sheet about 3 inches apart. Gently press down on the dough with the back of a spoon to spread out into a 2-inch circle. Bake for about 20 minutes or until nicely browned around the edges. Bake a little longer for a crispier cookie.

Yield: 2 dozen cookies

The author, purely for experimental reasons, fixed up a batch of these tasty morsels and found them to be quite spectacular.

Folklore and all, the Neiman-Marcus brand changed the world's perception of Texas, and Dallas in particular. Stanley Marcus promoted the specialty store created by his father, uncle and aunt; created the Texas fashion industry; and promoted Dallas as a sophisticated, world-class city. He stood at the helm of his family store until his retirement in 1975, when he handed over the reins to his son Richard. After his retirement from the store, he continued working in his own company, Stanley Marcus Consultancy. Mr. Stanley passed away on January 22, 2002, at the age of ninety-six.

References

Marcus, Stanley. *Minding the Store*. Boston: Little, Brown, 1974.
———. *Quest for the Best*. New York: Viking Press, 1979.
Tolbert, Francis X. *Neiman-Marcus, Texas: The Story of the Proud Dallas Store*. New York: Holt, 1953.

Texas Tidbit

Stanley Marcus collected rare books. In 2003, Stanley's widow, Linda Marcus, donated her husband's private library to the DeGolyer Library at Southern Methodist University. The Marcus book collection consists of approximately 8,000 books, including his collection of 1,100 miniature books, and is housed in the Stanley Marcus Reading Room.

THE ECCENTRIC HOWARD HUGHES

The Greek philosopher Aristotle once said, "There was never a genius without a tincture of madness." Texan Howard Hughes once said, "I'm not a paranoid deranged millionaire. I'm a damned billionaire." Both of them were right.

On Christmas Eve 1905, Allene (Gano) Hughes and Howard Robard Hughes Sr. (nicknamed Bo) had a son in a little frame house on the east side of downtown Houston. They named the boy Howard Jr. and called him Sonny, although no birth certificate exists. It seems young Howard's entry into the world foreshadowed the mystery that would surround much of his life.

Sonny's dad, Howard Sr., did not seem destined for greatness. Bo dropped out of Harvard, couldn't make it at his father's law practice and spent his early years searching for a quick fortune in silver, zinc and lead mining. When the Spindletop oil gusher made news in 1901, Howard Sr. came to South Texas to search for the black gold that lurked beneath the surface of the earth. Although not a top student, he did have a mind for mechanics and learned from his wildcatting days about the difficulties of drilling through Texas rock. He teamed up with a partner, Walter Sharp, and together they worked on ways to improve drilling techniques. In 1908, they developed a new kind of drill bit, dubbed the Hughes rock bit, that significantly improved the drilling process. How it came about is a mystery. Hughes Sr. claimed he invented it. Sharp's widow claimed they both invented it, and another story contends that Hughes bought the idea from another oilman for $150. The

drill bit consisted of three rotating cones, each with a set of cutting teeth that crushed the rock as the bit rotated.

When Hughes and Sharp tested the first prototype of the bit in 1909, they were able to drill through solid rock at the rate of about a foot an hour, an astonishing feat for the time. The new bit revolutionized the oil business and made both men wealthy. But wealth can't buy long life. Sharp died in 1912, leaving the company in the hands of Howard Sr.

The younger Howard Hughes (Sonny) took after his father when it came to schooling. He had a mediocre record in the Houston public schools, so his father sent him to Fessenden School in Massachusetts at the age of fourteen to get a proper education. Sonny's only accomplishments at the school were learning golf and taking his first plane ride. A year later, his parents hustled him off to another prestigious institution, Thatcher School in California. Sonny's uncle Rupert had made it big in Hollywood as a screenwriter and could look in on him from time to time. In 1922, when Sonny was sixteen, his uncle brought him terrible news. His mother had died unexpectedly.

The older Howard Hughes (Sonny's father) was stricken by Allene's death. He moved to California to escape his memories and soon removed Sonny from the Thatcher School to enroll him (unofficially) in the nearby California Institute of Technology. In 1923, Sonny moved back home to Houston, living in the Hughes family home in Montrose with his aunt Annette Lummis (from his mother's side of the family). His father could not stand to live in the house after Allene died. Instead, he stayed in the Rice Hotel when he visited Houston.

Howard Sr. stayed away from Houston and allowed his competent managers to tend to the day-to-day business of the company. In 1924, less than two years after his wife's death, he died suddenly from a heart attack.

Poor Little Rich Boy

With no living parents, the eighteen-year-old Howard Hughes (along with his uncle Rupert and paternal grandparents) inherited a large portion of Hughes Tool Co. The business was worth millions of dollars. Although he knew nothing about how to run the company, he dropped out of Rice Institute (now Rice University), to the consternation of his family, and announced that he would run the company. A bitter feud erupted, and young Howard bought out all of his family's shares of the tool company. However, as a minor, he couldn't take full control. He used his golfing expertise to develop

Howard Hughes with a Boeing army pursuit plane, circa 1941. *Courtesy of Library of Congress, LC-USZ62-63333.*

a relationship with a local judge who then declared Howard an adult at his nineteenth birthday. Once Sonny gained full control of the company, however, he followed his father's example and left the company in the hands of the managers.

Over the years, Howard developed a preoccupation with health, germs and death; he signed his only will at the young age of nineteen.

The intriguing life of Howard Hughes, his quirks and his eventual hermit lifestyle are well documented in books and on screen. Somehow, in spite of his idiosyncratic foibles and dysfunctional character traits, he is responsible for a number of innovations. In Hollywood, he produced several now classic, industry-changing films, including *Hell's Angels*, *Scarface* and *The Outlaw* (featuring the busty Jane Russell). Nurturing a growing passion for flying, he teamed up with a Cal Tech engineer, Dick Palmer, in 1935 to build a plane called the H-1 that allowed him to set a world speed record at 352 miles an hour. In 1937, he set a new coast-to-coast record, and in 1938, he set an around-the-world flying record, for which he received a ticker-tape parade in New York City. But not all of his airplane experiences

were successful. During World War II, he produced the infamous gigantic troop carrier dubbed the "Spruce Goose" that flew only once. However, the engineering developed for his state-of-the-art planes led to innovations that would earn millions of dollars for him in the future. These include flush riveting (which reduced air drag on the plane) and the variable-pitch propeller.

Other inventions that emerged from the diverse life and mind of Howard Hughes include geosynchronous communications satellites and a half-cup "push-up" bra developed to show off the cleavage of movie star Jane Russell in the 1943 Hughes film *The Outlaw.*

A Web of Intrigue

By the 1950s, the affairs of Hughes were wrapped up in a web of intrigue where he tried (and sometimes succeeded) using his power to influence U.S. politics and world affairs. He filled the ranks of his personal staff with former army officers and CIA operatives, and many of his dealings during the '50s remain shrouded in mystery. It is known that Hughes held secret contracts with the CIA to produce the clandestine Glomar Explorer to search for a lost Soviet nuclear submarine that had sunk in the Pacific. He was also implicated in an unsuccessful attempt to assassinate Fidel Castro. Some reports claim that Richard Nixon's downfall, caused by the burglary at Watergate, came about because of the president's paranoid desire to gather information about Hughes from Larry O'Brien, who was both the head of the Democratic National Committee and a Hughes confidant.

Even Hughes's greatest legacy is controversial. In 1953, he created a philanthropic organization, the Howard Hughes Medical Institute (HHMI), as a tax shelter, with its sole asset being stock in Hughes Aircraft. It paid money to Hughes in the form of lease and loan payments and did little research. When the IRS threatened to nix the scheme, the institute increased its research funding. After Hughes's death, HHMI became a premier research institution in the fields of genetics, immunology and molecular biology. The institute now has more than three hundred locations. Several HHMI locations are in Texas, including Baylor College of Medicine, UT Southwestern Medical School, Texas A&M and UT at Austin. Its innovations have included the identification of genes responsible for cystic fibrosis and muscular dystrophy, the development of a non-invasive test for colon cancer, the creation of a leukemia drug, advancements in AIDS research and progress on cures for neurological injuries. Researchers include seven Nobel

laureates. With a continuing endowment of over $14 billion (as of 2009), its future in creating new innovations in the field of medicine is assured.

On April 5, 1976, an emergency call informed Methodist Hospital in Houston that an ailing Howard Hughes would arrive from Mexico by plane that afternoon. At the time, the public had not seen Hughes for twenty years. The hospital set aside a secured suite under the alias "John T. Conover." A number of hospital staff prepared for the important patient to arrive. However, when the plane landed at the Houston International Airport at 1:50 p.m., Howard Hughes was already dead. At less than one hundred pounds, Hughes was so emaciated from years of cocaine use that his body had to be identified by fingerprints. With no clear will on file, hundreds of "relatives" sought to inherit his estate. The courts eventually split the estate among twenty-two cousins on both his father's and his mother's sides.

Today, the "Spruce Goose" (also known as the Flying Boat) can be seen at the Evergreen Aviation Museum in Oregon. Hughes's H-1 racer is at the Smithsonian Air and Space Museum in Washington, D.C. A large collection of Hughes memorabilia can also be found at the McCarran International Airport's Howard W. Cannon Aviation Museum in Las Vegas. To see the places where Hughes lived and worked, as well as the Hughes family burial plot, take the "Howard Hughes's Houston" tour from Discover Houston Tours. For more information about Hughes, go to www. DiscoverHoustonTours.com, call 713-222-9255 or e-mail owner Sandra Lord at tourhouston@aol.com.

References

Bartlett, Donald L., and James B. Steele. *Howard Hughes: His Life and Madness*. New York: W.W. Norton & Company, 1979.

Brown, Peter H., and Pat H. Broske. *Howard Hughes: The Untold Story*. Cambridge, MA: DaCapo Press, 2004.

Elliott, A.C., P.K. Summey and G.B. Kokel. *Images of America: Oak Cliff*. Charleston, SC: Arcadia Publishing, 2009.

Real, Jack G., and Bill Yenne. *The Asylum of Howard Hughes*. Philadelphia: Xlibris Corporation, 2003.

Texas Tidbit

Howard Hughes moved to Las Vegas in 1966 and rented two floors of the Desert Inn Hotel. When the owners asked him to leave, he instead bought the hotel for about twice what it was worth.

Texas Tidbit

The Texas Theatre, built by Hughes in 1931 and located in the Oak Cliff section of Dallas, was at the time the country's largest suburban theater. It is also where Lee Harvey Oswald fled after the assassination of President John F. Kennedy on November 22, 1963. For more information, visit the www.texastheatre.com or www.oakclifffoundation.org websites.

OVETA CULP HOBBY

The early days of Texas produced a number of independent-minded men and women who made their mark on the world. From one family in Killeen came a baby girl, born in 1905, whose influence would span the entire century from the halls of Texas government to the White House and beyond. Oveta Culp was the second of seven children. She showed early signs that she had an independent streak a mile wide. A story told by her son, former lieutenant governor William "Bill" Hobby Jr., took place sometime between her fifth and sixth birthdays. In those days, her mother and many others supported the popular temperance movement (that tended to go hand in hand with women's rights). One day in church, Oveta heard a Sunday school lesson on temperance, followed by a call to sign a pledge of abstinence. Almost everyone signed it except Oveta. She refused, believing that even though she had no desire to drink liquor, she should not make the pledge until she was sure she could keep it.

Early in life, Oveta developed a mature, logical and common-sense type of thinking beyond most kids of her age. From her mother, Emma, Oveta learned community service, fairness (her mother campaigned for women's suffrage) and the responsibility of the more fortunate to care for neighbors in need. From her father, Ike, Oveta learned the logic of the law and the fickleness of politics. Even while in elementary school, she often sat in her father's law office, listened to discussions about cases and read law books. At the age of ten, she'd read the Congressional Record and, by thirteen, had read the Bible three times. In 1919, Ike Culp won a seat in the state

legislature, and Oveta followed him to sit in on the sessions. After graduating from Temple High School with high honors, she attended Mary Hardin Baylor for two years until 1925, when the Speaker of the Texas House of Representatives requested that she serve as legislative parliamentarian.

In 1928, because Houston was the fastest-growing city in the South, it attracted the National Convention of the Democratic Party (now called the Democratic National Convention). Working with the Houston Chamber of Commerce, Oveta played an important role in planning the event. She went on to serve in the losing campaign for Al Smith but gained practical knowledge about the political process. She also worked on the successful senatorial campaign for Tom Connally, who ousted a Ku Klux Klan candidate. In 1929, she worked for the election of Walter E. Monteith as mayor of Houston and was subsequently appointed to the post of assistant to the city attorney. With her obvious talent for leadership, Democratic Party leaders encouraged her to run for the state legislature in 1930. She lost.

However, politics still played an important role in her future. Years earlier, her parents had supported the election of a family friend, William Pettus Hobby, to governor in 1918. After his term ended, Hobby moved to Houston to serve as president of the *Post-Dispatch* newspaper. His first wife died in 1929. With Oveta active in Houston politics, she and Hobby renewed their friendship. The friendship turned into matrimony in 1931. She was twenty-six and he was fifty-three. After marriage, Oveta moved from her post in the city government to the newspaper business, where her talent for words and organization found a home. At the *Post-Dispatch*, she rose from book editor in 1933 to executive vice-president in 1938.

In those years, she also managed to start a family. In 1932, on her own birthday, January 19, she gave birth to William Pettus Hobby Jr.; five years later to the day, her daughter, Jessica Oveta Hobby, arrived.

Balancing family, business and public service, Oveta served in a number of capacities, including president of the League of Women Voters in Texas and chairperson of a committee on women's participation in the New York World's Fair.

War and WAACS

Her reputation as a powerful woman of superior intelligence and organizational skills soon thrust her into a national position. With war brewing in the world, General David Searles called on her to head the

Women's Interest Section for the War Department Bureau of Public Relations. She refused at first because of family commitments, but her husband encouraged her, and she accepted. When war broke out later that year, she was asked to draw up plans for how women could serve in the army.

Given the rank of major (later colonel), Oveta created the Women's Auxiliary Army Corps (WAACs). Before that time, women had not served in the U.S. military, except as nurses. She soon learned that, although the army wanted and needed women, it also had an entrenched gender bias against women serving in the military. Facing these barriers, Colonel Hobby managed to develop an effective corps of over 100,000 women. For example, she fought the decision that women who became pregnant would be dishonorably discharged by demanding that the fathers also be similarly discharged. She won. However, she didn't win every battle. Her original design for the women's uniform was considered too frivolous and would need to be simplified. When there were complaints about frilly underwear hung

Colonel Oveta Hobby talks with Auxiliary Margaret Peterson and Captain Elizabeth Gilbert at Mitchel Field, 1943. *Courtesy Library of Congress, LC-USZ62-118263.*

out to dry, a change had to be made. In proper army fashion, a conference on undergarments was held in July 1942 to specify the design and color for brassieres, girdles, panties and slips. The WAAC uniform included a visored cap that later became known as the "Hobby Hat."

Even with the internal battles Colonel Hobby had to fight, the WAAC proved to be of critical support during the war effort. She identified 239 different army jobs that women could do short of combat. She found that for a number of jobs, such as folding parachutes, women consistently outperformed men in the same position. Throughout the war, the colonel worked night and day with only short breaks to shower and nap. In July 1945, toward the end of the conflict, she resigned and immediately entered a hospital for treatment of exhaustion. In her tenure, she not only created the WAAC (later the WAC with "Auxiliary" dropped) but also became the first female colonel in the United States Army. She was awarded the Distinguished Service Medal and several other medals from foreign governments.

Following her recovery, she resumed her role at the *Houston Post*. Using her newly acquired perspective of the world and of bigotry, Oveta and her husband used the power of the newspaper to support equal rights for people regardless of race or gender. In 1951, she and Governor Hobby were honored at the National Conference of Christians and Jews for their advancement of human relations. Her impressive service during the war also led to opportunities to serve on worldwide commissions advancing freedom of the press, as well as human equality.

THE BEST MAN IN THE CABINET

In 1952, when General Dwight D. Eisenhower ran for president, the Hobbys jumped on the bandwagon as influential members of the national Democrats for Eisenhower movement. Ike won and selected Oveta Hobby to serve as chairman of the Federal Security Agency. This position developed into a cabinet position for the newly created Department of Health, Education and Welfare. As the second woman ever to hold a cabinet position, she organized an entirely new branch of the federal government. (In 1933, FDR appointed Frances Perkins as secretary of labor, making her the first woman to hold a cabinet position.) During Oveta's tenure, she became a respected member of the cabinet and led reforms concerning health insurance, education and medical research. In addition, she oversaw

A portrait of Oveta Culp Hobby. *Courtesy of Lieutenant Governor William Hobby Jr.*

the distribution of the Salk polio vaccine that eventually led to the eradication of that disease. In 1955, with Governor Hobby ill, she resigned. One of the cabinet members mourned her departure, saying she was "the best man in the cabinet."

She returned to Houston as president of the *Houston Post.* Her husband, Governor William Hobby, died in 1964. Oveta continued to serve in a variety of leadership posts. She sat on the board of directors for the Bank of Texas, as well as on the board of the Eisenhower Birthplace Memorial Park (in Denison), the Advisory Commission for Selective Service, the board of Rice University and many others. The 1960s *Harper's Bazaar* named her one of the "100 American Women of Accomplishment." In 1984, the Texas Women's Hall of Fame inducted Hobby into its prestigious ranks. This brilliant, feisty and ingenious Texas lady died in 1995 and is buried in Glenwood Cemetery in Houston.

Several buildings bear her name. On December 13, 1967, Central Texas College in Killeen dedicated the Oveta Culp Hobby Library, with President Lyndon Johnson performing the honors. In 1995, Colonel Hobby was honored with the dedication of the Oveta Culp Hobby University Center at Fort Hood, Texas. In 1999, Hobby Hall (in memory of Colonel Oveta Culp Hobby) was dedicated at the Soldier/Civilian Support Center at Fort Lee, Virginia. In 2004, the Oveta Culp Hobby Elementary School in Fort Hood opened in her honor.

References

Crawford, Ann Fears. *Women in Texas.* Abilene, TX: State House Press, 1982.

Handbook of Texas Online. "HOBBY, OVETA CULP." www.tsha.utexas. edu/handbook/online/articles/HH/fho86.html. December 9, 2005.

Texas Tidbit

Oveta Hobby's son, William "Bill" Hobby Jr., served as lieutenant governor of Texas from 1973 to 1991, longer than anyone had ever held that office. He held the positions of the Sid Richardson Professor at the LBJ School of Public Affairs in Austin (1991–95) and chancellor of the University of Houston System (1995–97). Hobby currently serves as the Radoslav Tsanoff Professor at Rice University (1997–present).

Texas Tidbit

Hobby Airport in Houston is named for Oveta's husband, former governor of Texas William Pettus Hobby. The Houston airport, first named Carter Field in 1927, changed names in 1937 to the Houston Municipal Airport and, in 1938, to the Howard Hughes Airport. The Hughes designation had to be dropped after a year when someone discovered that federal funds could not be awarded for an airport named after a living person, so it reverted back to the Houston Municipal Airport. In 1967, the City of Houston renamed it the William P. Hobby Airport.

Texas Tidbit

Oveta Culp Hobby and Barbara Jordan were in the inaugural class of twelve inducted into the Texas Women's Hall of Fame in 1984 for the service to Texas and, indeed, the whole United States. The Hall of Fame Museum is located at Texas Woman's University, Hubbard Hall. For more information, visit the www.twu.edu/twhf website.

7-ELEVEN CREATES A CONVENIENT BUSINESS

Back in the olden days, around 1927, few people had that new-fangled appliance called a refrigerator (first introduced in 1913). Instead, most people had something called an icebox: an insulated wooden box with a compartment on top where you placed a block of ice. As the ice melted, the cold water dripped down and kept a bottom compartment fairly cool. In the hot Texas summers, it took a lot of blocks of ice to keep the milk and eggs fresh.

In those years, you went to an icehouse to get your blocks of ice or had it delivered to your door, and icehouses dotted the street corners in almost every neighborhood. One of these stores, Johnny Green's, sat on the corner of Edgefield Avenue and Twelfth Street in the Oak Cliff section of Dallas.

John Jefferson Green, the man who owned this icehouse, had an idea about how he could make more money. Instead of just selling ice, "Uncle Johnny" reasoned that he might collect a little more pocket change if he sold a few other things. At that time, a block of ice sold for a whopping eleven cents. It made sense to him to begin stocking a few grocery items. Remember (if you're that old) that at this time there were no supermarkets. Groceries were purchased at small neighborhood mom-and-pop stores, and these stores often closed early in the evening and on weekends.

What if Cousin Sally had a birthday party coming up and you needed to make your special triple-layer butter cake that night and were out of milk and eggs? Sorry. No can do. That's where Uncle Johnny's idea caught on. He stayed open late—a full sixteen hours a day and on weekends. People

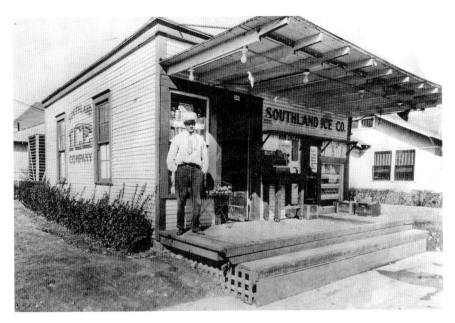

The original 7-Eleven store, originally known as Johnny Green's Ice House, and a Tote'm Store in Dallas, circa 1927.

soon learned that even after the mom-and-pop stores were closed, you could still get a few groceries at the icehouse on Edgefield. Johnny sold quarts of milk for seven cents, a pound of cheese for twenty-four cents and a loaf of bread for nine cents. His customers literally ate it up; they loved being able to pick up a few necessities after hours. Life just became a little more convenient.

It wasn't long before the Southland Ice Company realized that Johnny had a good idea. It bought the idea and opened similar stores all over town. The expanded icehouses were called Tote'm stores since customers "toted" their purchases home. Some stores featured a genuine Alaskan totem pole out front to keep with the theme. Although the icehouse part of the business became less and less necessary as refrigerators become more abundant, the convenience part grew even more popular.

OPEN AT 7, CLOSE AT 11

Since the stores were open from seven o'clock in the morning to eleven o'clock at night (a long time to be open for any business during those years),

in 1946, an advertiser got the bright idea of using that information as the store's name. Thus, the stores were renamed 7-Eleven.

Not only was Johnny's idea good, but it also started a huge trend in retailing. Today, there are convenience stores on street corners, at gas stations, in airports and almost everywhere else people gather or live. If each and every one of them drew up their family trees, then the little icehouse on the corner of Edgefield and Twelfth in Dallas would be listed as each and every one's great-grandpa.

Even a great store can't stay in business with just one great idea, so 7-Eleven came up with a few other "firsts" over the years. It was the first convenience store to operate its store twenty-four hours a day, first to sell fresh-brewed coffee in to-go cups, first to have a self-serve soda fountain and (oh, joy!) first to offer monster-sized drinks (called the Big Gulp). It was also the first convenience store to advertise on television (in 1949), first to sell pre-paid phone cards and first to have a genuinely cool advertising slogan: "Oh, Thank Heaven for 7-Eleven."

That original 7-Eleven store (although rebuilt a few times) remained at the original location in Dallas until 1995. (The building still exists but now serves as an office for the League of United Latin American Citizens, LULAC.)

Today, 7-Eleven stores exist all over the world, including in Japan, Australia, Mexico, Taiwan, Canada and Europe. In fact, 7-Eleven, Inc. is the world's largest operator, franchiser and licenser of convenience stores, with more than twenty-seven thousand units worldwide. The company name was officially changed from the Southland Corporation to 7-Eleven, Inc. in 1999. Its offices are in Dallas just north of downtown on Central Expressway. The next time you get a brain freeze (an officially registered 7-Eleven–owned phrase) sucking down one of the 11.6 million Slurpees (a registered trademark) sold every month, you have Uncle Johnny to thank. For more information, visit the www.alanelliott.com/legends website.

Texas Tidbit

7-Eleven has more sales of these items than any other retailer in the world: *USA Today* newspapers, *Sports Illustrated* magazines, cold beer, cold single-serve bottled water, cold Gatorade, fresh-grilled hot dogs, single-serve chips and money orders. It also has the largest ATM network of any retailer in the United States.

MARY KAY DOES A BEAUTIFUL THING

Charlotte Whitton once said, "Whatever women do they must do twice as well as men to be thought half as good. Luckily, this is not difficult." The grit, imagination and determination of pioneer Texas women transformed this state from a dusty outpost into the finest plot of land on this earth. Early Texas women like Jane Long, one of the first English-speaking women to give birth in the new country, arrived in primitive Galveston in 1821. When her husband died, she was left alone with no resources. She somehow managed to survive and opened a hotel in 1832 in Brazoria, where she helped the fledgling Republic of Texas government take hold. She died at the age of eighty-two, and her gravestone in Richmond reflects her legacy. It simply says, "Jane H. Long, The Mother of Texas." The first female surgeon in Texas, Dr. Sofie D. Herzog, defied popular beliefs against women physicians and set up shop in Brazoria in the 1880s. And there was Governor Miriam Amanda "Ma" Ferguson, who unmasked the Ku Klux Klan in an attempt to free the state from racial hatred, and Barbara Jordan, who broke the color barrier in Texas politics. These and many other Texas women shaped this state and contributed to its greatness. It is not easy to be a pioneer or to break a mold that is long held. In the Texas business world, no one broke the mold like Mary Kay.

Texan Mary Kathlyn Wagner of Hot Wells learned responsibility early. With her mother managing a restaurant and her father an invalid from tuberculosis, Mary had to be the family nursemaid, cook and chief bottle washer from the time she was eight years old. In those years, Mary learned

what it took to get a job done, not only at home, but at school as well. Always a star student, she could have gone to almost any college, but she had no money. Instead, at the age of seventeen, she graduated into marriage.

During the Depression of the 1930s, she worked to earn enough money to help support her growing family. By the time her husband, Ben Rogers, left to serve in World War II, they had three children. She kept the family together during those tough years, and when other wives celebrated the end of the war, it brought disaster into her life. After returning from war, her husband deserted her and left her with those three children to raise on her own.

Mary took a direct sales job with Stanley Home Products. Although she had success in her position, the lack of respect and opportunity for female sales agents frustrated her so much that she left Stanley in 1952 and took a position with World Gift Company. She worked there until retiring in 1963. In her twenty-five years of selling with these companies, she learned all the good and bad involved in training and motivating salespeople. In fact, she ended up training several men who were then put into jobs over her because they "had families to support."

Retirement didn't last long. Within a month, she decided to write a book to help women survive in the male-dominated business world. At her kitchen table, she made two lists; one contained the good things she had seen in companies, and the other featured the things she thought could be improved. When she reviewed the lists, she realized that she had inadvertently created a marketing plan for a successful company. At the same time, she realized that a small local cosmetics company whose products she had used for years would be the perfect vehicle for her company, so she bought the rights to the product.

BEAUTY BY MARY KAY

In July 1963, she married George Hallenbeck, and together they made plans to start Beauty by Mary Kay (changed later to Mary Kay Cosmetics, Inc.). Bottles were filled, labels designed, products boxed and everything looked good. Then disaster struck Mary again. Her husband (and business partner) died suddenly, just one month before the planned opening date for the new business.

Both her attorney and accountant advised that she liquidate the business. Instead, Mary remembered the words her mother told her when she was

young: "You can do it." Despite the grief and shock, Mary Kay plunged forward into business with the help of her twenty-year-old son, Richard Rogers. Mary Kay Cosmetics opened its doors on time on Friday, September 13, 1963.

Using the plan for success she had written down, Mary Kay formed a company based on the Golden Rule as her guiding philosophy. She set as her goal to provide women with an unlimited opportunity for personal and financial success. With a plan designed by a woman, for women, she encouraged her employees and sales force members to prioritize their lives: God first, family second, career third.

Her business operated on a cash basis, so none of her salespeople would get into debt and there would be little need to monitor receivables. She devised sales contests that would challenge her consultants to break their own goals and not to compete against other consultants. In fact, to be a success in Mary Kay, you not only had to support your own sales team, but everyone had to support one another's teams. She often told her salespeople, "You are in business for yourself, but not by yourself." In meetings that were a cross between a Miss America Pageant and a pep rally, Mary Kay inspired loyalty and hard work out of thousands of her sales consultants. Experts in the men's business world said her competitions and sales schemes wouldn't work. But they didn't understand what she was doing. And they didn't know women like Mary Kay knew women. Her company not only worked, it allowed many thousands of women to become financially successful.

Mary Kay married Mel Ash in 1966, and in 1968, her company went public. In 1969, she awarded the first of her famous pink Cadillacs to her top five sales directors. In 1971, she opened her first international office in Australia. In 1976, her first sales consultant passed $1 million in commissions. In 1980, Mel passed away, but Mary Kay kept moving forward. By 1983, sales had reached $300 million, and in 1985, the company repurchased all the outstanding stock to take the company private. By the early 2000s, the company had more than 800,000 independent beauty consultants in twenty-six countries, with more than $1.3 billion in sales and more than 150 consultants earning more than $1 million a year.

Women Can Do It

No one in the world has created as many wealthy and successful women as Mary Kay Ash. When asked how her company became so successful, she

mentions the old adage, "Aerodynamically the bumblebee shouldn't be able to fly, but the bumblebee doesn't know that so it goes on flying anyway." And about people's potential, she says, "Don't limit yourself. Many people limit themselves to what they think they can do. You can go as far as your mind lets you. What you believe, remember, you can achieve," and "God didn't have time to make a nobody, only a somebody. I believe that each of us has God-given talents within us waiting to be brought to fruition."

Mary Kay had every reason to be cynical. She had to care for an invalid father. She lived for decades with discrimination and lost three husbands in the process. Yet with Texas spirit and an undying faith, she plunged forward into one of the most successful business stories in history. Texas and the world are better because of her life. Mary Kay Ash died on November 22, 2001.

The Mary Kay Museum is located at 16251 North Dallas Parkway in Addison (Dallas). In it, you can explore the history of Mary Kay Cosmetics, Inc. and see many of the lavish rewards Mary Kay bestowed on her consultants. These include diamond bumblebee pins, diamond rings, cars and the ultimate prize: the pink Cadillac. Hours of operation are Monday through Friday, 10:00 a.m. to 2:00 p.m. Call 972-687-5720 for more information or visit the www.marykaymuseum.com website.

References

Ash, Mary Kay. *Mary Kay*. New York: Harper and Row, 1981.
———. *Miracles Happen: The Life and Timeless Principles of the Founder of Mary Kay, Inc.* New York: Quill, 2003.
Underwood, Jim. *More than a Pink Cadillac: Mary Kay, Inc.'s Nine Leadership Keys to Success.* New York: McGraw-Hill, 2001.

Texas Tidbit

Fannie Flagg, the author of *Fried Green Tomatoes at the Whistle Stop Café*, was a good friend of Mary Kay Ash. In the movie version of that story, *Fried Green Tomatoes*, Mrs. Threadgoode tells Evelyn Couch that she would be "good with cosmetics," so Evelyn becomes a successful Mary Kay beauty consultant.

LIQUID PAPER AND A MONKEE

Bette Nesmith had a problem. As a secretary in the early 1950s typing away on one of those new-fangled electric typewriters, she occasionally made a mistake. Okay, she wasn't the greatest typist in the world, and back then, a mistake was a big deal. You either had to pull out the sheet of paper and start over again or "X" out the offending word and retype it. Retyping was a lot of work, and marking it out was messy (and usually unacceptable on a business document). On the older-style manual typewriters, it had often been possible to erase mistakes (although sometimes it resulted in an eraser hole in the paper). Those new electric IBM typewriters with carbon-film ribbons were so good at laying down a character on the paper that it was almost impossible to erase. Anyone could see Bette wasn't the only one with this problem; every typist in the world fretted over this predicament. Therein lies the problem—a problem waiting for a solution.

Bette McMurry was born in Dallas in 1924 and married Warren Nesmith at age nineteen. Warren went off to World War II shortly after the wedding. Bette had a son, Michael, while Warren was away, and when he returned (like so many young couples of that era), they got a divorce. (Gee, I wonder if Bette and Mary Kay had a discussion about this?) Bette got a job as a secretary at Texas Bank and Trust in Dallas to support herself and her young son. That's when the problem of the typing errors came up.

However, unlike the many other millions of typists, Bette had a Texas-sized brainstorm. She noticed how window painters often covered up their mistakes by painting over them. As a freelance artist herself, she also knew

how artists often hid mistakes by covering them up with paint. Eureka! Bette had an idea. She used her artistic wiles and worked on a concoction in her kitchen until she had tempera water-based paint that matched the office stationery. Back in the office, she used the paint to cover up mistakes and typed over them. Her boss never noticed the corrections. Success! Another secretary noticed what Bette had done and asked for some of the liquid. Bette put the stuff in a little green bottle and named it "Mistake Out." In short order, more and more secretaries around her began using it.

To meet the demand, Bette produced the liquid in larger quantities. She asked a friend who was a chemistry teacher at St. Mark's School to help her make the liquid quicker-drying, and she found a paint store employee who would show her how to grind and mix the paint. The Nesmith kitchen became her factory, with the Mistake Out liquid taking form in her cake mixer. Her son, Michael, and some high school friends helped fill the bottles. Although the goopy paint seemed popular with secretaries, her first year's sales amounted to only $1,142.71, and her first year expenses were $1,217.35. You can't grow a business with those kinds of numbers, so she tried to find financial partners, but everyone turned down the idea. Finally, she decided she would have to do it on her own.

No Mistake Here

Bette left her full-time job and started the Mistake Out Company. At local business supply stores, she would do a song and dance (not literally) about her invention (now renamed Liquid Paper) and show them how the product worked. Usually, she would talk them into taking twelve sample bottles. The reputation for the magic Texas liquid spread across the nation as stories about it appeared in trade journals. Eventually, her hard work paid off, and orders began pouring in. The first big order, for three hundred bottles (from General Electric), signaled success.

However, like many fledgling entrepreneurs, Bette had limited resources. Marketing meant expenses and times were tough, but Bette was tougher, and she persisted. She married Robert M. Graham in 1962, and together, they hit the road and traveled all around the country promoting the benefits of Liquid Paper. That did the trick. Sales zoomed. About that same time, her son, Michael, moved to Los Angeles to pursue a career in music.

Once the ball was rolling, the Liquid Paper story took off. Bette took out a patent for Liquid Paper in 1975. That same year, she started operations out

of a thirty-five-thousand-square-foot Dallas building cranking out five hundred bottles a minute. Over twenty-five million bottles of Liquid Paper were produced in 1976, and they were shipped to thirty-one countries. By that time, no office anywhere in the world worth its salt would be caught dead without a few bottles of the miraculous Liquid Paper from Texas. Go ahead; check in your office desk. There are probably bottles of Liquid Paper in there right now. (Okay, computers have taken some of its need away, but it still comes in handy.)

Bette used her newfound wealth to set up two foundations to help women in business and art. In 1979, she sold Liquid Paper to the Gillette Company for $47.5 million.

HEY, HEY, IT'S A MONKEE

Bette's son, Michael, also had the success gene. Like his mother, he was full of "if" ideas. In Michael's case, the ideas were musical. Once he'd moved to Los Angeles, he began marketing his tunes. One song called "Different Drum" was picked up by Linda Ronstadt and turned into a hit. In 1966, Michael became part of a new singing group put together to create a television show called *The Monkees*. From that show, his name and face (and wool cap) became known around the country. He began a solo career in 1969, and his songs continue to be played on radio stations throughout the world.

Bette passed away in 1980 at the young age of fifty-six.

References

Blashfield, Jean F. *Women Inventors: Amanda Jones, Mary Anderson, Bette Nesmith Graham, Dr. Ruth Benerito, Becky Schroeder*. Minneapolis: Capstone Short Biographies, 1996.
Massingill, Randi. *Total Control: The Monkees Michael Nesmith Story*. Carlsbad, CA: FLEXquarters, 2005.

Texas Tidbit

Bette Nesmith designed the Liquid Paper Company with the commitment to allow employees to participate in important decision-making processes. She created offices that included a child-care center, a library and a greenbelt to foster communication, comfort—and productivity.

JACK KILBY INVENTS THE FUTURE

Jack St. Clair Kilby reigns as the Thomas Edison and Alexander Graham Bell of Texas all rolled into one. His world-changing invention not only put Texas Instruments Company (TI) on the mega-company map, but it also revolutionized American living as pervasively as Edison's electric lights and Bell's telephone combined.

Look it up; it's patent number 3,138,743. The tiny device, called the integrated circuit (IC) or the microchip, is a Texas invention that controls the pulse of virtually every electronic device today—computers, cellphones, televisions, satellites, automobiles, iPods, iPhones, iPads—any device that thinks, calculates, pulses, beeps or communicates.

It all began during a missed summer vacation. Kilby went to work for the electronics company Texas Instruments in early 1958. At that time, the transistor—created at Bell Labs in 1947—had been in use for about ten years. Although transistors were interesting and powerful when combined in large numbers, they were far too expensive for everyday commercial use. Transistors were basically a glob of semiconductor substance called germanium with several wires sticking out. They were about the size of a pencil eraser and cost more than their weight in gold.

That summer of 1958, when most of the TI scientists went on a two-week July vacation, Kilby had to stay in the lab since he didn't yet qualify for vacation time. He spent that missed vacation period pondering this new and interesting electronic component called a transistor. Fortunately, like Isaac Newton's time in the English countryside when he observed his

legendary falling apple, Kilby's time-alone-experience also produced an idea of considerable gravity. He knew that the current process of hand-soldering several transistors, resistors and capacitors onto a circuit board made every electronic device expensive. But what if there were a simpler, cheaper and more efficient way to combine these three components? It might be possible, he reasoned. After all, the three components—the transistor, the resistor and capacitors—could all be fashioned out of the same semiconductor material. Furthermore, in theory, they could all be created on the same semiconductor chip and could communicate with one another if they were connected with short wires. But would it work?

WHAT DID YOU DO ON *YOUR* VACATION?

With these thoughts in mind, Kilby sketched out his ideas and began working on a prototype. He glued a single slice of germanium about the size of a fingernail to a glass slide. He then fashioned a transistor, three resistors and a capacitor on the same block of semiconductor material. Connecting them with gold wires, he created a simple device that (hopefully) would produce an electronic sine wave. On September 12, 1958, Kilby finished his device and brought his colleagues into his lab to show off his crude-looking contrivance. He connected wires from the glob of material to an oscilloscope, flipped a switch and, to everyone's delight, a sine wave appeared—evidence that his device produced the desired electronic signal.

Just like Bell's first telephone message, "Watson, come in here. I need you!" and Edison's constant glow of the first successful incandescent light, the sine wave appearing on that TI oscilloscope signaled a significant turning point in the history of human progress. In that moment, Kilby's laboratory became the "birthing room" for the modern electronic-dependent world we know today—although no one knew it yet. In a similar lab at the Fairchild Semiconductor Corporation, another inventor named Robert Noyce came up with a similar idea at about the same time. Together, history accepts both Noyce and Kilby as inventors of the integrated circuit. Today, TI and Intel share certain patents related to the IC (and reap lots of royalties).

For several years, the new integrated circuit provided little more than entertainment at scientific conventions. Kilby's IC had to be refined to make mass production easier, and the semiconductor material used became silicon instead of the very expensive germanium. Since silicon is made of sand, microchips made out of it instead of germanium are "dirt-cheap."

The first Integrated Circuit, created by Jack Kilby in 1958. *Courtesy Texas Instruments.*

According to Kilby, no one knew what an amazing revolution they had started. "What we didn't realize then was that the integrated circuit would reduce the cost of electronic functions by *a factor of a million to one*. Nothing had ever done that for anything before."

The U.S. military soon realized the importance of the integrated circuit. In 1962, TI's microchip became the "brains" of the Minuteman Intercontinental Ballistic Missile (ICBM) guidance systems. A few years later, ICs made their way into commercial use. In 1964, TI partnered with Zenith Radio Corporation to produce the first solid-state hearing aid. However, it was too expensive and had limited distribution. But the revolution could not be stopped. That same year, a Japanese firm created a desktop calculator using traditional transistors. It cost $2,500 and weighed fifty-five pounds. TI engineers realized that they could construct a much lighter calculating device using ICs instead of individual transistors. In 1967, three engineers at TI, including Jack Kilby, created a calculator weighing only forty-five ounces and small enough to be carried in one hand. TI went on to produce the handheld calculator commercially, and it became the first mass-marketed consumer product to use the IC. The original consumer version of the resulting Datamath calculator (TI-2500) performed four basic arithmetic functions: addition, subtraction, multiplication and division. This simple calculator (by today's standards) sold for an astounding $119.95 when it hit stores on September 21, 1972. (The original TI Datamath handheld calculator is now displayed in the Smithsonian Institute.)

The success of the handheld calculator (encouraged by cheaper Japanese "cloned" calculators) set the stage for an electronic revolution like the world had never seen. Kilby's invention of the microchip and TI's introduction to

Jack Kilby with some of the inventions he inspired at Texas Instruments. *Courtesy Texas Instruments.*

its use in commercial devices spawned a new industry that filled the shelves of American stores with smaller and progressively cheaper gizmos and gadgets.

At the same time TI's microchips were making headway in the commercial market, Robert Noyce used his version of the IC to start a company named Intel. At Intel, Noyce created a microchip called the 4004 that contained an unbelievable 2,300 transistors on a single silicon wafer. It would become the first in a line of progressively more powerful microprocessor chips, including the 8088 chip (containing a whopping

29,000 transistors) that was used in the history-making first IBM Personal Computer in 1981.

Today, the computer chips inside your home computer may house more than 100 million transistors in a wafer-sized chip. Look around. You'll see ICs in use everywhere. For example, this paragraph was typed into a computer whose "brains" are ICs. The information was transmitted by e-mail over communication devices made possible by ICs. The publisher typeset the book using a machine controlled by ICs. Trucks that delivered the book to the store have engines controlled by ICs. The cash register where you purchased this book is controlled by ICs. The watch that you just glanced at on your wrist is probably controlled by ICs. (Gotcha!) By the mid-2000s, sales of integrated circuits reached over $180 billion.

Edison's and Bell's names may be better known, but this Texan's invention led to a faster and more pervasive explosion of electronic devices into the modern world than any previous invention in human history. Next time you browse around the electronics department of your favorite superstore, think about how each one of the devices traces its genealogy back to Texas Instruments and Jack Kilby's missed summer vacation. Jack Kilby died on June 21, 2005, at the age of eighty-one.

For more information about early handheld calculators, check out the Datamath Calculator Museum at the www.datamath.org website. Information about this and other Texas Inventions and Innovations can be found at the Bob Bullock Texas State History Museum in Austin (www.thestoryoftexas.com).

Reference

Reid, T.R. *The Chip: How Two Americans Invented the Microchip and Launched a Revolution*. New York: Random House Trade Paperbacks, 2001.

Texas Tidbit

Among his many honors, Jack St. Clair Kilby received two of America's most prestigious honors in science and engineering. In 1970, he received the National Medal of Science. In 1982, he was inducted into the National Inventors Hall of Fame (which includes members such as Henry Ford, Thomas Edison and the Wright brothers). In addition, he received the Nobel Prize in physics in 2000 for his part in the invention of the integrated circuit.

BARBARA JORDAN, GOD'S VOICE FROM TEXAS

In 1974, President Richard Nixon resigned the office of president of the United States. The Watergate scandal tested the resilience of the United States Constitution and inaugurated an era of distrust and accusation between political parties that remains to this day. A few politicians have managed to rise above the fray. One was Barbara Jordan. Called upon to give the keynote speech at the 1976 Democratic Convention, she set aside the political rancor of the day and urged the country to come together in unity.

If any person could have contemptuously recited the woes of the disenfranchised, of the down and out, of those who did not share in the American dream, it would have been Barbara Jordan. Instead, this first African American woman ever to deliver the keynote address at a major political convention chose to give a speech of hope that would "fulfill our national purpose, to create and sustain a society in which all of us are equal." Barbara Jordan spoke not only with conviction, intelligence and persuasion; she spoke with a powerful voice that rang with authority and compassion. This woman from Texas captured the imagination of Americans.

The Jordan family lived in Houston's Fifth Ward area just east of downtown. Primarily settled by former slaves after the Civil War, by the 1930s, this area's residents were the working poor who could walk from their homes to jobs at the Southern Pacific Railroad or the Houston Ship Channel. Others in the ward commuted by bus to work as domestics for wealthy Houstonites. During the first half of the twentieth century, this

neighborhood remained a world apart. Unable to legally participate in many of the "whites only" activities of the city, the blacks of the Fifth Ward existed in their own impoverished and protective cocoon, where most streets were unpaved, most houses had no running water and many families existed on the edge of starvation. Only a small percentage of the families were able to eke out a reasonable living—notably those few who were professionals, small business owners or who were lucky enough to hold union jobs.

When Benjamin and Arlyne (Patten) Jordan married, they moved in with his parents on one of the few paved streets in the Fifth Ward. The young couple celebrated the birth of their third daughter (and last child), Barbara Charline Jordan, on February 21, 1936. Benjamin worked as a warehouse clerk and part-time Baptist minister, and Arlyne was a domestic worker. Life in that era, and in Houston's Fifth Ward, meant living under the thumb of Jim Crow laws (state and local laws enforcing racial segregation). As a young girl, Barbara worshiped at the Good Hope Baptist Church, attended neighborhood black schools and rarely mixed with the whites of Houston. Her protective father demanded high morals and a disciplined life from his three daughters. From him, Barbara learned that education, determination and disciplined living were required to achieve life goals. From her grandfather John Ed Patten, she learned a different kind of lesson about life. John had been unjustly convicted by an all-white jury early in his life and had spent six years in prison. He taught her to stand up for her convictions, question the norm, think for herself and rise above the crowd.

The lessons from her father and grandfather were well ingrained into Barbara's personality by the time she entered as a freshman at Phyllis Wheatley High School (the Mighty Wildcats). Although she lacked the light skin and slender physique of the most popular kids at her school, she used the determination learned from her father and the pride in herself learned from her grandfather to rise to leadership in her school. She excelled in debating, was a member of the National Honor Society, graduated with honors (in the top 5 percent of her class) and was elected the school's "Girl of the Year" in her senior year, 1952.

A Life Changed Forever

One particular event during high school changed Barbara's life goals. She heard a presentation by a prominent African American attorney named Edith Spurlock (the first African American delegate to the United

Nations and the first black woman elected judge in the United States). Until that time, Barbara had rarely known anything about the world outside the Fifth Ward. Up until that point, she thought that a high aspiration would be to become a teacher or maybe work as a missionary in the church. Then she encountered this black woman who had been all over the world, who had participated in high levels of government and who carried herself with the highest level of dignity and purpose. The speech provided a conversion experience for Barbara. From that moment, she aspired to a career in law.

Most Texas universities in the 1950s were closed to African Americans. Texas State University for Negroes in Houston had been established in 1947 in part to keep blacks out of other Texas universities. (It was given the name Texas Southern University, or TSU, in 1951.) After her high school graduation, Barbara attended TSU and received a bachelor's degree magna cum laude with a double major in history and political science in 1956. While at the university, she continued to excel in debate and won national honors at several tournaments, including debates that matched her against white students from prestigious universities. During this time, Jordan mastered the use of her deep and resonating voice to convey her message with the passion of a preacher, the logic of a lawyer and the common sense of a country farmer.

Instead of choosing to attend law school at TSU, she made the decision to broaden her experience. In the mid-1950s, the United States had entered a new era of hope for blacks with a ruling by the U.S. Supreme Court that schools must be integrated. However, the immediate impact of the ruling was to strengthen segregation laws in Texas. Barbara felt she needed to move away from the comfort (and limitations) of the Fifth Ward in order to become the kind of significant lawyer she had witnessed in the life of Edith Spurlock. Despite the Supreme Court ruling, few high-ranking law schools accepted black students. One exception was Boston University; it had accepted people of all races since its founding by Methodist ministers in 1839. Barbara applied and was accepted. With sacrificial financial help from her father, she took the difficult step into a new world. Her experience in Boston opened her eyes to the limitations she had experienced in Houston. She realized fully the evils of segregation and the challenges of overcoming prejudice. In the lonely and foreign city of Boston, she struggled to match the intellectual level of her fellow white students, realizing that even the best black colleges were far less rigorous than white colleges. The old "separate but equal" argument was a myth.

Barbara struggled and came close to failing but persisted. While in Boston, her life changed in many ways. She learned that education must encompass more than memorizing facts; real education meant learning to think for one's self, imagining new and original possibilities and coming up with unique solutions to difficult problems. She met and befriended white people for the first time in her life. She developed a broader understanding of her religion that changed her view of God from that of a harsh taskmaster to a caring father.

After three years in Boston, she graduated and returned to Houston to open a law practice. Back in familiar territory, her education proved its worth. She flourished. In the 1960 presidential election (Kennedy versus Nixon), she organized black voters and helped produce the largest voter turnout in Harris County history. With the entire country experiencing challenges and changes in the civil rights of minorities, Barbara stepped in to be a part of the movement. She ran for a Texas Statehouse position in 1962 and 1964 but lost both races. Never one to give up, she tried a third time and won an election in 1966 to become the first African American since 1883 (and the first woman) to hold a seat in the Texas Senate.

During her tenure in the Texas Senate, she earned political respect among her Senate colleagues (both liberal and conservative) to the point where her opinion could influence the laws that most impacted her constituents. Although some black leaders wanted her to exercise a more confrontational approach, Barbara stuck to her own conviction that those working within the system had the best opportunity to advance civil rights. Within the Texas Senate, she rose to the highest levels of honor, including serving as president pro tem of the Senate and briefly serving as acting governor, making her the first black woman governor in the United States. Her abilities caught the eye of President Lyndon Johnson, who counseled her to seek higher office. After the 1970 census provided the need to redraw congressional lines in Texas, the Democratic Senate leadership made her vice-chairman of the redistricting committee with the express task of drawing herself a district in Houston where she could win.

In 1972, with the support of former President Johnson and other Texas politicians, Jordan won a congressional seat in the U.S. House of Representatives. With the help of Johnson, she also secured a prestigious seat on the House Judicial Committee. Within her first two years, she had earned respect among the House members as one of the hardest-working, most intelligent freshman representatives. However, it wasn't until 1974 that the public realized the stature of Barbara Jordan.

In that year, President Richard Nixon was accused of involvement in a cover-up of the burglary at the offices of the National Democratic Committee in the Watergate Hotel. (See the previous story on Howard Hughes for another Texas connection to this event.) During congressional hearings that surrounded the Watergate scandal, Jordan's eloquent, powerful and authoritative speaking ability brought her into the national spotlight as she eloquently and thoughtfully called President Nixon to task for his actions. For many days, the national news reported the impact of Jordan's remarks at the House Judiciary Committee for Impeachment. Here are a few words from that speech:

Barbara Jordan giving the keynote address before the 1976 Democratic National Convention in New York City. *Courtesy of Library of Congress, LC-U9-32937-32A/33.*

Earlier today, we heard the beginning of the Preamble to the Constitution of the United States, "We, the people." It is a very eloquent beginning. But when the document was completed on the seventeenth of September 1787, I was not included in that "We, the people." I felt somehow for many years that George Washington and Alexander Hamilton just left me out by mistake. But through the process of amendment, interpretation and court decision I have finally been included in "We, the people."

Today, I am an inquisitor....My faith in the Constitution is whole, it is complete, it is total. I am not going to sit here and be an idle spectator to the diminution, the subversion, the destruction of the Constitution....It is reason, and not passion, which must guide our deliberations, guide our debate, and guide our decision.

Barbara Jordan spoke with a voice of reason at a time that tested the strength of the U.S. Constitution. One senator remarked that her voice and delivery were so much like the voice of God that he looked under the table to see if she was reading from commandments carved in stone tablets. Unlike many other politicians who used the crisis to further their own ideologies

and careers, Jordan chose to take the role of a statesman and to speak to all Americans with a voice of hope for the future and for integrity in government. In fact, her conduct at the hearings (that led to Nixon's resignation) so impressed the public and the leadership of the Democratic Party that they asked her to deliver the keynote speech at the 1976 Democratic National Convention. At one time, President Johnson had told Barbara that she could become president. At this convention, she very well could have taken a giant leap by accepting a nomination for vice president on the ticket with Jimmy Carter. Instead, she chose not to accept the offer.

Illness slowed down the indomitable Barbara. Her hands and feet tingled when she walked. She could not stand for very long. Although she kept the news from the public, she suffered from debilitating multiple sclerosis. With the symptoms increasing, she chose to step down from her stress-filled life in the U.S. Congress and returned to Texas in 1978.

After returning to her home state, Jordan taught at the University of Texas (a school she had not been able to attend because of segregation laws) in the Lyndon Baines Johnson School of Public Affairs. Although no longer in the Washington spotlight, Jordan continued to speak out on important political issues. During her tenure at the university, she mentored many minority students and received honorary degrees from several other universities, including Princeton and Harvard. She received the prestigious Spingarn Medal in 1992 from the National Association for the Advancement of Colored People (NAACP) for service to the African American community. Among her other honors were her induction into the National Women's Hall of Fame in 1990 and a Presidential Medal of Freedom in 1994. She passed away in 1996 and is buried in the Texas State Cemetery in Austin (which is reserved for citizens who have contributed significantly to Texas history, including Stephen F. Austin and Governors Allen Shivers and John Connally).

In 1982, a Barbara Jordan Media Award was established by the Texas Governor's Committee on People with Disabilities to recognize special contributions for increasing public understanding of the abilities of people with disabilities. She was inducted into the Texas Women's Hall of Fame in 1984. Statues of Jordan appear at the Austin-Bergstrom International Airport (dedicated in 2002) and on the University of Texas campus (2009). Other awards have also been established in her name for women's and education issues. There are also a number of schools named after Congresswoman Jordan, including the Barbara Jordan High School for Careers in her hometown of Houston.

Barbara Jordan's intelligence, determination and ingenuity helped her rise above her poverty-filled beginnings and brought her to the pinnacle of power. Not following anyone's party line, she used common sense and righteous conviction to make an important contribution to the goal of life, liberty and the pursuit of happiness for all Americans.

References

Hendrickson, Kenneth E., Michael L. Collins and Michael Cox. *Profiles in Power: Twentieth-Century Texans in Washington.* Austin: University of Texas Press, 2004.

Jones, Nancy Baker, and Ruthe Winegarten. *Capitol Women: Texas Female Legislators, 1923–1999.* Austin: University of Texas Press, 2000.

Jordan, Barbara. *Barbara Jordan: A Self-Portrait.* Garden City, NY: Doubleday, 1979.

Mendelsohn, James. *Barbara Jordan: Getting Things Done.* Brookfield, CT: Millbrook Press, 2000.

Rogers, Mary Beth. *Barbara Jordan: American Hero.* New York: Bantam Books, New York, 1998.

Winegarten, Ruthe. *Black Texas Women: 150 Years of Trial and Triumph.* Austin: University of Texas Press, 2004.

Texas Tidbit

The Barbara Jordan papers are housed at Texas Southern University in Houston, where she graduated magna cum laude in 1956.

SOUTHWEST'S SUCCESS IS NO TALL TEXAS TALE

Texas is a big state. To do business here, you've got to travel around the "Golden Triangle" of Dallas, San Antonio and Houston and to other cities as well. For decades prior to the 1970s, business travelers drove their company cars down many a mile of Texas asphalt (and killed a lot of armadillos along the way). Sure, flying from city to city could save time, but talk about a budget buster! Back in that era, only oilmen, bankers and Stanley Marcus could afford flying from city to city.

In 1966, someone saw the problem and decided to do something about it. Rollin King of San Antonio, the operator of a small commuter air service, had a vision (assisted by his banker John Parker, who complained about expensive airfare between Dallas, San Antonio and Houston). As a result of that epiphany, King paid a visit to a lawyer friend by the name of Herb Kelleher. At that meeting, King drew a sketch of a triangle on a cocktail napkin with each of the three cities at the corners and used the picture to describe the opportunity for creating an inexpensive commuter airline between the major Texas cities. To abbreviate the meeting somewhat, it went like this:

"Herb, let's start an airline."

"Rollin, you're crazy. Let's do it."

Thus began the nuttiest airline in American history. Initially patterning the idea for this fledgling company on the successful Pacific Southwest Airline (PSA) in California, Kelleher filed papers to incorporate Air Southwest Co. (later to become Southwest Airlines) in 1967.

In an ideal world, Rollin and Kelleher only needed some working capital to get their startup off the ground. It turned out that the world isn't so ideal. There were some road bumps on the tarmac. Before the first Southwest Airlines 737 would taxi out for takeoff, it would take a whole lot of time, sweat, perseverance, money and a little assistance from Lady Luck.

After raising initial seed capital, Kelleher started the process to obtain the license for the airline from the Texas Aeronautics Commission (TAC). That's when the plans hit their first speed bump (more like a brick wall). Those good old boys at Braniff and Trans Texas (later Texas International or TI) airlines didn't want anyone muscling in on their territory. They had Texas airways all tied up with their own expensive flights. Kelleher fought a brave battle but lost the first round. The TAC concluded that Texas didn't need another airline.

Down, but not out, Kelleher answered the bell for round two and took the question to the appellate court. He took a hit to the chin and lost again. It seemed that those good old boys had lots of friends in high places.

Kelleher picked up the pieces and tried again. This time, he went to the Texas Supreme Court. This third time was the charm. It took four years from when Rollin and Kelleher had incorporated to get their certificate to fly. However, the legal process had left the company with a measly $142 in the bank and $80,000 in overdue bills.

Southwest Airlines existed, but it had no airplanes, no pilots, no gates and an uncertain future. It needed someone who could come in and put together an airline using little more than hope and excitement. They got that person in Lamar Muse. Having held executive positions at four other airlines, Muse knew what it took to get planes in the air, and he knew that he had to do it without the red-tape bureaucracy that had existed at his previous companies. It would take a lot of American greenbacks to get things started. Throwing in some of his personal fortune, Muse twisted enough Texas arms to raise cash to purchase three Boeing 727-200 jets. To put together a staff that could get those planes in the air, he filled top positions in every area with industry veterans who were willing to take a chance on this crazy scheme and who were tired of airline business as usual.

While Southwest busied itself with its startup plans, its two nemeses waited for a time to pounce on the fledgling airline. Only a few days before Southwest's inaugural flight, it happened. Braniff and TI filed a complaint with the Civil Aeronautics Board (CAB) that Southwest's operation violated an intrastate exclusivity order. They knew that if they could delay the inaugural flight, Southwest would lose major funding and be crippled.

Kelleher flew to Washington with only the suit on his back to convince the CAB to reject the complaint. Just hours before the inaugural flight, the CAB ruled that Southwest could fly. Instantly, Braniff and TI filed another complaint in Texas and received a restraining order to prevent the takeoff. Kelleher sprang into action in Austin and, in an emergency meeting of the Texas Supreme Court, got the order rescinded. For these and other antics against Southwest, Braniff and Texas International were later fined for their actions in connection with trying to stop Southwest from flying.

GETTING OFF THE GROUND

On June 18, 1971, the inaugural Southwest flight taxied onto the runway piloted by Captain Emilio Salazar, and the company took off into aviation history.

With one great initial victory under their belt, Southwest's management took a running leap at another great hurdle: staying alive. With little money to compete against the dominant Braniff and TI Airlines, Southwest faced almost certain doom. However, Southwest did have an advantage. Since it didn't fly across state borders, it didn't have to follow a federal mandate for ticket prices, allowing it to charge less than other airlines.

Nevertheless, its initial flights carried a few measly passengers. Many of the flights cost more than they brought in. With a decision that would soon become characteristic of the Southwest business style, it quickly adjusted the model. It moved its Houston flights from the Intercontinental Airport to Hobby Airport, which was closer to town and more convenient for passengers. Flight loads increased immediately. Southwest learned two lessons: customers wanted convenience, and when some plan isn't working, don't hire a consultant to do a six-month study followed by a twelve-month evaluation—think up a new plan and implement it without delay.

The Houston lesson was soon put to use in Dallas. In 1974, with the new Dallas/Fort Worth Airport (DFW) scheduled to replace the in-town Love Field, Southwest figured that it would have the same problems it had seen with Intercontinental in Houston. As a result, it announced that it had no intention of moving to the new DFW Airport facility. The decision led to another legal battle. This time, not only were the courts involved, but the skirmish also found its way to the U.S. House of Representatives. The courts ruled that Southwest could fly intrastate routes from Love Field, and the Airline Deregulation Act of 1978 opened

Southwest Airlines flight attendants wearing signature hot pants, circa 1971. *Courtesy Southwest Airlines.*

Love Field to unrestricted flights. However, Speaker of the House Jim Wright from Fort Worth led an effort to pass a bill in 1979 (dubbed the Wright Amendment) that limited flights from Love Field to Texas and the five neighboring states. The intention was to limit Southwest's growth at Love Field and pressure it into moving to DFW Airport.

It didn't work. Southwest thrived and expanded in Texas and kept expanding until it had reached from the East Coast to the West, although flights from Love Field remained limited. Over the next few decades, Southwest faced other struggles. To keep the company solvent and growing, managers and employees had to work harder and cheaper than at any other carrier. The struggle became a crusade, and workers at every level of the company joined together with enthusiasm. The people attracted to work at Southwest, and the people whom Southwest wanted to hire, were those with a positive attitude who would tackle every assignment with enthusiasm and face every challenge with a positive attitude. Southwest rewarded its employees with ownership options and more secure jobs than existed at other airline companies. With such a reputation, many people want to work at Southwest, but few are chosen. In 2004, for example, Southwest received 225,895 résumés and hired only 1,706 new employees.

There is an old saying that adversity builds character. In the midst of tough times, the Southwest family built an airline with a lot of pizzazz as well as character and had fun doing it. In fact, fun is Southwest's middle name. There's a good reason why *Fortune* magazine dubbed Kelleher "the high priest of Ha Ha." Laughter makes work fun, and there are few places as fun (and productive) as Southwest Airlines. This brazen startup not only proved that business could be crazy; it showed that crazy was a good thing. With off-the-wall promotions (buy a full-fare ticket and get a free fifth of premium liquor), outrageous uniforms (hot pants), company pride and humor in every aspect of the operation, Southwest thrived. The company evolved into an organization where fun was taken seriously and where a high demand for professionalism was enhanced by the ability to do work with humor and grace. Its corporate mission statement summarizes its commitment: "The mission of Southwest Airlines is dedication to the highest quality Customer Service delivered with a sense of warmth, friendliness, individual pride, and Company Spirit."

FLYING FOR PEANUTS

One often-quoted incident that illustrates Kelleher's unconventional style concerned the use of the advertising slogan "Plane Smart." Another airline, Stevens Airline, claimed ownership of the saying. A normal

Herb Kelleher wrestles for the right to use the phrase "Plane Smart." *Courtesy Southwest Airlines.*

company would fight out the battle in court, but Kelleher suggested an arm-wrestling competition instead—winner gets the slogan. Kelleher lost the match but not the battle. Not only did the event generate goodwill for Southwest, but Stevens even gave Kelleher permission for continued use of the tagline.

To complement its lighthearted internal culture, Southwest has successfully spread its zany image to the public. From its unique spin on advertising with bizarre slogans such as "Austin Auften" and "Phoenix Phrequently"; its signature bags of nuts (fly for peanuts); its no-frill boarding policy (choose door A, B or C); its colorful airplanes, with themes including Shamu the Whale, the Lone Star Flag and Triple Crown One (dedicated to company employees); and its consistent low fares (designed to compete with driving), Southwest is loved by its customers. A flight on Southwest isn't simply a ride from point A to point B. More than any other airline, the Southwest crew works hard to make each flight fun and lighthearted. You are as likely to hear a joke from the captain as a warning to stay in your seats when the seatbelt light is on. Keeping safety as its highest priority, the crew knows how to spice up an otherwise humdrum trip with a little levity and style.

While other airlines sunk in and out of profitability by doing the same old thing year after year, Southwest questioned everything, and when something wasn't working, it tried something else. If one plan failed, it had another in the wings to try. In the end, it hit on more good ideas than it missed.

The bottom line tells the tale. The rate of growth and profitability for Southwest Airlines surpasses all other airlines in modern history. While many other established airlines have dissolved or gone bankrupt (including old nemesis Braniff), Southwest continues to crank out a profit every year, and its numbers are usually far above any other airline. Year-end results for 2014 marked Southwest's forty-second consecutive year of profitability. In September 2015, Southwest made its 156th consecutive quarterly dividend payment to shareholders.

But don't be misled by the quirky nature of this airline. When there is work to do, everyone chips in because everyone has a stake in the company's success. Where other airlines keep planes in the air about eight hours a day, Southwest's planes fly about eleven hours a day (more efficient). When other airlines take thirty minutes to an hour to turn around a plane between flights, Southwest manages to do it in fifteen. When other airlines lay off employees at the drop of a hat, Southwest builds loyalty and camaraderie by avoiding layoffs and keeping employees working and loving every minute of the job.

In 2014, Southwest Airlines flew more than 136 million passengers, with flights from ninety-seven cities every day. It continues to win awards year after year for being on time and having the best baggage handling and fewest complaints. While other startup airlines have tried to duplicate the legends and mystique of this Texas treasure, none has duplicated the success that is Southwest Airlines.

However, success is not without challenge. For over twenty-five years, the fight over the Love Field Wright Amendment restrictions pitted Southwest against another formidable Texas-based airline, American Airlines (as well as with the DFW Airport Board). These two Texas giants—one the most profitable airline and the other the largest domestic airline—squabble like siblings, but both show Texas ingenuity and tenacity. In 2005, Southwest got a Christmas gift from Congress; it voted a change to the Wright Amendment. On December 13, 2005, Southwest inaugurated flights directly from Love Field to Kansas City and St. Louis. These flights lowered the cost of flying from Dallas to these two cities by hundreds of dollars. In 2006, Dallas, Fort Worth, American Airlines and Southwest all agreed to a timetable that ended the restrictions of the Wright Amendment in October 2014.

References

Freiberg, Kevin, and Jackie Freiberg. *Nuts! Southwest's Crazy Recipe for Business and Personal Success*. Austin, TX: Bard Press, 1996.

Gittell, Jody. *The Southwest Airlines Way: Using the Power of Relationships to Achieve High Performance*. New York: McGraw-Hill Trade, 2002.

Texas Tidbit

In 2014, Southwest served more than 100 million peanuts and 45 million pretzels to its customers.

A STOVE THAT DOESN'T BLOW SMOKE

You won't find Texan Don O'Neal's invention in Walmart or the Sears catalogue or even in the His and Her Christmas catalogue gifts from Neiman-Marcus. But it has impacted thousands of lives, saving many families from lives filled with disease and death.

For generations, the rural poor of Guatemala have cooked food in the same way: using a three-stone fire inside their homes. It is easy to use. Take three large stones and place them a small distance apart in a circle, fill the space with firewood and you've got it. There are advantages to this type of fire. It is easy to build, it is free, you can configure it to accept almost any size pot, it can be used inside or outside the home and it provides light and warmth.

There are also problems with this fire. It is inefficient and requires a lot of wood to keep it going. When used inside a house, which is often the case, it produces smoke that is irritating to the eyes and lungs. It is also dangerous and causes burns.

This three-stone type of family fire has been widely used in Guatemala (and many other third-world countries) for generations. In fact, the fire is such a central part of existence that families must spend much of their energy and time collecting sticks and logs to feed the constant flame. This daily need for firewood has caused forests near villages to be stripped bare. As the forests are turned to scrubland, family members have to make long journeys on foot to find more wood. The trip can take an entire day and often results in health problems such as back injuries and hernias. In a

culture dependent on the three-stone fires, there is no time in the day for idleness or creativity, and little productive work can be performed beyond gathering the daily requirement of firewood.

In communities using the three-stone fires, the mother or sister keeps the fire burning during the day to cook tortillas and other food for meals, while other family members search for wood. At night, the fire continues to burn to warm the home. Children sleeping on the ground have too often rolled into the fire. Many children have been mutilated or killed. Even those family members not burned on the outside develop respiratory disease as a result of breathing constant smoke. The very fire that warms the home and cooks the food kills the rural poor of Guatemala.

Into this third-world dilemma steps a dose of good old Texas ingenuity.

Don O'Neal is a retired mechanical engineer who lives in North Texas. He was born in Lampasas County and graduated from Lampasas High School in 1950 and from Texas A&M in 1954. After serving in the military as an aviation instructor at Fort Eustis, Virginia, he helped found a telecommunication company called Intecom in 1979. He retired in 1983 at age fifty and volunteered for relief and development work in Guatemala. On a trip in 1993, he traveled to the jungles of Guatemala as a photographer with a medical mission team for a group called HELPS International. This group sets up MASH-type medical facilities in Guatemalan rural areas and offers free medical service to the local people. That is enough to commend this group, but something happened that went beyond the medical help.

While on the trip, O'Neal and his wife, Lois, noticed a number of children coming into the clinic with burn wounds. Curious about what caused them, they discovered that the burns came from living around an open three-stone fire. Although the medical teams sought to help these children with medicine and plastic surgery, O'Neal wondered if there was a way to nip the problem in the bud.

For a year, O'Neal studied how the Guatemalans used their home fires. Drawing on his engineering expertise, he researched the pros and cons of alternative cooking methods used among the world's poor. Seeing how the Guatemalan poor were harmed from their current fires, he knew there must be a safer and more efficient stove that could be used in place of their primitive fires. However, there were (at least) two challenges. First was to locate an inexpensive, efficient and safe stove, and second was to find a way to embed the new device into a culture with a long history of the three-stone fires.

O'Neal was disappointed that he couldn't find a stove that would meet the needs of the people, so he did what any inventive Texan would do. He

invented one. Using his knowledge of how the Guatemalan families used their current stoves and what materials would be available locally, O'Neal devised an inexpensive and simple stove that could be put together, taken apart and moved when necessary. It also burned wood efficiently and safely and channeled the smoke away from the inside of the home.

O'Neal's stove is made of cast concrete blocks that can be carried in pieces into a home and assembled on the spot. Instead of an open flame like the three-stone fires, the fire in this stove is enclosed in a chamber. The smoke from the fire exits the stove through a pipe and out of the house. The stove is fuel efficient, cutting down the amount of wood required per day by 70 percent, which will also help slow deforestation. The stove is safer than the open-flame three-stone stove since it lifts the fire off the floor, protecting children from devastating burns.

To make sure his new stove would be acceptable, O'Neal thoroughly tested it in a laboratory setting as well as in selected local homes. The new stove proved its worth.

During the development phase, he remembers his first meeting with the women who would be testing the stove in their homes. He had been warned that there would be great reluctance to change from the three-stone fires, and so he tried his best to describe the benefits. He'd been told that when the women lean back in their seats they are listening and if a woman leans forward, she wants to speak. During his talk, one elder lady leaned forward and said, "You don't understand; we are here because we want to change. Our life is hard, and we want more for our children. Show us how to change and we will change." That event remains a high point in O'Neal's memory of getting the stove into the hands of those who needed it the most.

Since 2002, the O'Neal stove has been produced at a factory in Rio Bravo, Guatemala. The factory consists of two open-air sheds where the blocks are formed and cured and a loading dock where they are sent out all over Guatemala. By 2005, well over five thousand had been distributed to families, and many thousands are on order.

This amazing and innovative stove quickly caught the attention of the Ashden Awards for Sustainable Energy committee. In 2004, Don O'Neal was invited to England to receive the prestigious Ashden Award (nicknamed a "Green Oscar") for the development of the "O'Neal Stove."

In the ceremony, the judges stated, "By bringing the sophisticated fuel-efficient stove into the homes of Guatemala's rural poor, HELPS International (www.helpsintl.org) is leading the way in the fight against crippling respiratory disease and horrifying burns, while also helping

Left: Don O'Neal displaying his efficient, lifesaving and ecologically friendly stove. *Courtesy Don O'Neal.*

Below: Don O'Neal receiving the Ashden Award from Prince Charles, 2004. *Courtesy of Don O'Neal.*

conserve the country's dwindling forests." For his contribution, Don was congratulated by Prince Charles of England and Sir David Attenborough and presented with a check for $15,000.

Although this stove was originally designed for the rural poor of Guatemala, this bit of Texas ingenuity can also benefit the rural poor of other countries who suffer from the same types of cruel labor and disease and whose land is ravaged by deforestation. For the latest information on the stove, go to the www.onilstove.com website.

Texas Tidbit

In 2004, Don received a Volvo for Life award from the Volvo car company for his work in creating the safe and efficient stove for the rural peoples of Guatemala.

A NEW WIND BLOWING ACROSS TEXAS

There is more blowing around in West Texas than tumbleweeds. This great state has been known for the production of energy for over one hundred years, mostly in oil and natural gas. However, the ingenious Texas mind doesn't miss out on a good opportunity, and a new opportunity has been blowing around Texas for years: wind power.

As early as 1970, researchers at West Texas State University started exploring commercial prospects for wind energy. In 1977, these researchers formed the Alternative Energy Institute (AEI) with a primary emphasis based on the creation of energy from wind power.

Of course, wind energy is not new. People started using wind energy thousands of years ago to sail across the ocean. Around the year AD 1000, farmers started using wind energy in early versions of windmills as a way to grind grain between rotating stones powered by the wind.

In the early American frontier, windmills were used in mills to grind grain and to pump water for drainage or from wells. Almost every frontier American farm had a windmill, and many ranches and farms still use them today for pumping water. The earliest use of the windmill for the production of electricity was in 1890 (in Denmark), but it never really caught on for commercial use until the folks at West Texas State University helped revive the idea in the 1970s.

With an increase in the price of oil and natural gas energy over the past decades, and with technological advances in wind power production, the time is right for large commercial development of wind energy. By 2007,

wind energy accounted for about 35 percent of all new energy production in the United States. Texas wind farms accounted for over half of that new growth. In fact, Texas leads the country in wind energy, accounting for close to one-third of the nation's total installed wind capacity. By 2007, Texas was producing enough wind energy to power more than one million Texas homes.

How exactly is this energy created from the wind? Wind energy is actually a form of solar energy. The sun heats parts of the earth more than others (because of atmosphere, the earth's uneven surface and the earth's rotation). When warm air rises, cooler air takes its place. High in the atmosphere, the warmer air goes to where the cool air had been. This movement of air is how wind is formed.

A wind turbine works like the blades of a fan—except opposite. A fan turns and creates wind. The turbine's blades turn as a result of the wind. The center shaft of the turbine's blades is attached to an electrical generator. As the shaft turns, the generator makes electricity.

Many years of research went into creating turbines that could efficiently use the wind to turn the blades and thus create electricity. The typical turbine

West Texas wind farm. *Photo by author.*

in West Texas stands twenty stories tall with blades two hundred feet long (two-thirds the length of a football field).

When a number of these turbines are placed in a field, it is called a wind farm. As of 2008, the largest wind farm in the world was located at the Horse Hollow Wind Energy Center in West Texas, consisting of over four hundred turbines. There are also a number of other large wind farms located around Texas.

Next time you are in Lubbock, Texas, visit the American Wind Power Center located at 1701 Canyon Lake Drive, 806-747-8734. Or visit the www.windmill.com website. This museum provides information and exhibits of all types of windmills that are used for water pumping and electricity generation. The museum is open year round on Tuesday through Saturday from 10:00 a.m. to 5:00 p.m. It is also open on Sundays from 2:00 p.m. to 5:00 p.m., May through September, and is always closed on Mondays. Call ahead to check the schedule.

REFERENCE

Walker, Niki. *Generating Wind Power*. New York: Crabtree Publishing Company, 2007.

Texas Tidbit

On December 20, 2015, wind power provided almost 40 percent of Texas's electricity for seventeen hours—some fourteen trillion watts. Overall, wind energy accounted for 9 percent of the electricity generated in Texas in 2014.

TASTY TEXAS

FROM CATTLE DRIVE TO CASUAL DINING

What does a "Cookie" have to do with the enchilada that you had for lunch? Plenty. But put that concept on hold for a minute while we take Professor Emmett Brown's time machine to the year 1866 for a look at some historical origins of Texas cuisine.

In the days after the Civil War, the early Texas cattle industry was growing by leaps and bounds. In fact, from the end of the war until 1880, about ten million cattle made the trek from Texas to trailheads in Kansas and Missouri or beyond. One of the most famous trails was called the Goodnight-Loving Trail.

Oliver Loving came to North Texas in 1845 at the age of thirty-three. Noticing that a large number of cattle roamed free in the Texas wilds, he reasoned that he could make a greenback or two by driving a herd of those cattle from the Shreveport area to New Orleans. After a few successes at this cattle drive, he decided to try for a more lucrative market. In 1858, he drove a herd north to Illinois and started a new era in the saga of the cowboy: the great cattle drives.

The early cattle trails going north (the equivalents of today's interstate highways, except they weren't paved) were named the Chisholm, Shawnee and Western Trails. During the Civil War, the cattle drives were mostly halted while Texas cattlemen provided beef for soldiers. After the war and during Reconstruction, poverty plagued Texas (as it did most of the South), and the cattle industry suffered.

However, a former Texas Ranger named Charles Goodnight decided to try his hand at reviving the cattle drive, but he lacked experience. That's

when he joined forces with Oliver Loving. They formed a partnership and, in June 1866, left Texas with two thousand cattle and eighteen cowboys and headed north. That first trail drive inched through tumbleweed-infested West Texas and north toward Colorado. They didn't make it to their goal. Instead, they stopped short at Fort Sumner in New Mexico, where they sold their cattle for a whopping $12,000 to the U.S. Army. With this success under their belts, they went again. And again. And again. This trail blazed by these two cowboys became known as the Goodnight-Loving. It ran from Young County to the Pecos River, through Fort Sumner, New Mexico, and north to Colorado.

A statue of the famous cattle rancher Charles Goodnight outside the Panhandle-Plains Historical Museum at the West Texas A&M University campus.

That's where we pick up on the story of Cookie.

When you're out in the dusty dry Texas wilderness with twenty men working up a dripping sweat every day, you've got to feed them some grub. Knowing this, Goodnight purchased an old Studebaker horse-drawn wagon from the army and converted it into a kind of portable kitchen. This sturdy wagon had stood up to the punishing travel of army life, so Goodnight figured it would work on the cattle trail.

His innovation was to rig up a box at the rear of the wagon with a hinged lid that folded down to form a work surface. Inside the box, he put Dutch ovens and other cooking paraphernalia for life on the trail. On the side of the wagon, he attached a large barrel that could carry enough drinking water for two days. The wagon also included a place to carry the essentials such as coffee, flour, wood for a fire and maybe a bit of whiskey. The cowboys kept their sleeping rolls and other essentials in the front of the wagon.

The cook on the trail drive was nicknamed "Cookie" (or some say Coosie), and it was up to him to provide meals for a mess of hungry Texas cowboys several times a day. Typical fare consisted of beans, buffalo or beef (of course) and stews spiced with chili peppers, garlic and onion. Cookie also fixed up sourdough bread, quick biscuits and corn bread. If the cowboys were lucky enough to camp close to a stream, they might get a little sautéed catfish. The food served on the trail drives was called the "chuck," and Goodnight's cattle trail wagons, of course, were dubbed chuck wagons.

Cookie sometimes had to be inventive with his meals. He drew inspiration from German, Czech and Mexican traditions, as well as from American fare. One commonly served dish was fixed up by throwing everything in the pot "except the hair, horns and holler" and was called (in polite company) "son-of-a-gun stew." On the range, it went by the more colorful name "SOB stew."

Cookie ruled the chuck wagon like a drill sergeant, and other cowboys had better stay clear. For instance, cowboys were forbidden to eat at the chuck wagon table, and they never, ever rode their horses through the "kitchen." In fact, for their own benefit, they quickly

A chuck wagon on the SMS Ranch near Spur, Texas, circa 1944. *Courtesy Library of Congress, LC-USF34-033327-D.*

learned to ride downwind of the wagon so the trail dust wouldn't blow into the food.

THERE'S NO CHICKEN IN CHICKEN FRIED STEAK

Many traditional Texas dishes came from on-the-trail recipes conjured up or adapted at the chuck wagon kitchen. One of those dishes was something called "chicken fried steak." I don't imagine that any self-respecting Texas restaurant would open its doors today without chicken fried steak on the menu. But pity those poor northerners who don't understand that there is no chicken in chicken fried steak. For my dear readers who don't know, here's how it all came about.

The cuts of meat available to Cookie on the trail tended to be a little tough, and he took pride in his ability to make the cowboy grub as tasty as possible. (Else the trail boss would find another Cookie.) To make a good steak out of mediocre steak, he proceeded to pound the tar out of the meat until it had some semblance of tenderness. He then coated

the steak with egg (sometimes an egg and milk mixture) and covered the sticky steak in flour. The steaks were fried up in grease in a Dutch oven, and the finished product was covered in peppered cream gravy.

If you've ever cooked fried chicken, you'll notice the similarity. Thus, the name "chicken fried" steak. Because Cookie did a good job coming up with this delicacy, it soon made its way to the ordinary Texas table and into restaurants in the early 1950s. Today, the cuts of meat used for chicken fried steak are better than in those olden days. And when you smother that steak in peppered cream gravy, you will experience a little bit of heaven right here in Texas. (By the way, many restaurants now also serve chicken fried chicken, but that is another story.)

Of course, Cookie may not have been as innovative as some think. Some food historians say Cookie simply adapted the idea for chicken fried steak from German Texans who already had something like it called *wiener schnitzel*. Whichever way it came about, it is now officially a true Texan meal. It is estimated (by people who do those sorts of things) that some 800,000 chicken fried steak dinners are served up in Texas every day.

TEXAS CHILI, SPICY AMBROSIA

Another descendant from the trail is Texas chili. Yes, historians trace a spicy stew or soup that some call chili back to earlier origins, but true *Texas* chili evolved on the cattle drive and on Texas ranches. Here's how it happened: Cookie started (typically) with inferior cuts of beef (like with the chicken fried steak) and chopped it into morsels, and just in case it was getting to be a bit past its expiration date, he put it in his Dutch oven with plenty of water, suet, ground-up peppers and chilies and boiled the heck out of it. The resulting spicy beef chili made a right nice meal and, like other dishes from the trail, made its way onto the tables of Texas families and eventually into restaurants.

As a matter of fact, in San Antonio, a whole way of life developed around Texas chili. In places such as Military Plaza and Haymarket Plaza, locals set up stands called "Chili Queens" and served up the spicy Texas chili to eager customers. The stands typically consisted of a deep pot of chili kept hot over an open fire, with tables lit by oil lanterns to provide a place for the customers to eat. The ladies (Queens) dressed up in fancy clothes to attract the soldiers. Family troubadours played Latin rhythms to set a festive mood, and the family ladled up their spicy concoction.

A Chili Queen stand at Haymarket Plaza in San Antonio, circa 1902. *Courtesy UTSA Institute of Texas Cultures.*

Although the stands were first intended to make some money from local soldiers, the general populace soon sniffed out the dish and came in droves. For a nickel or a dime a bowl, it was good food and cheap. The rapturous aroma of chili filled the air with the scent of heaven, and the poor and the rich mingled together on the plaza to get a taste. It was truly an event to behold. For fifty years, San Antonio nights revolved around the community of the Chili Queens. Unfortunately, in the 1940s, the San Antonio Health Department took a dim view of this outdoor food preparation, and the city government shut down the tradition.

Nevertheless, by World War II, chili had earned its way into the hearts of Texans. Joe Cooper (1952) said of the dish, "The aroma of good chili should generate rapture akin to a lover's kiss." One newspaper reporter from Los Angeles dubbed chili "fiery ambrosia."

And let there be no mistake, true chili is a Texas dish—never call it "Mexican food." Even the Mexicans don't claim it. In fact, the *Diccionario de Mejicanismos* (1959) defined chili con carne as a "detestable food passing

itself off as Mexican." The confusion that chili might be Mexican in origin probably comes from the fact that it is spicy and often called "chili con carne," which is Spanish for "chili with meat."

You may have noticed that there are some other dishes in the world claiming to be real chili. To keep the record straight, and so you're not taken in by any kind of fake wannabe chili, here is a good measuring stick. Today's typical Texas chili pretty much follows this recipe made famous by Lady Bird Johnson. During Lyndon's tenure in the White House, Lady Bird received a number of requests for this recipe and eventually had it printed and sent out to thousands of people wanting a real taste of Texas.

Lady Bird Johnson's Pedernales Chili

4 lbs. chili meat (beef chuck ground or cut into ¼ inch dice, coarsely-ground round steak or well-trimmed chuck)
1 large onion, chopped
2 garlic cloves (or ¼ tsp. garlic powder)
1 tsp. dried Mexican oregano
1 tsp. ground cumin
6 tsp. chili powder (or more, to taste)
1 ½ cups canned whole tomatoes and their liquid
2–6 generous dashes of a hot sauce such as Tabasco
2 cups hot water
Salt to taste

Place meat, onion and garlic in a large, heavy pan or Dutch oven. Cook until the meat is light in color. Add oregano, cumin, chili powder, tomatoes, hot pepper sauce, salt and hot water. Bring to a boil. Lower heat and simmer for about an hour. Skim off fat during cooking.

Some true Texans think this is a rather mild chili, so you might want to add more chili powder and more hot sauce. The main difference between this somewhat modern recipe and original Texas chili is that chili recipes over the years gradually included less fat. The original recipes included suet (raw beef fat from kidneys and loins). When President Johnson started having heart problems, that part of the recipe was removed—and a lot of health-minded Texans followed the lead. Some recipes add about

one tablespoon of *masa harina* flour for each pound of meat to thicken the chili a bit; if you choose to do this, mix the masa in the hot water before adding to the mixture. Also, notice that there is not a bean in sight. No beans in real Texas chili, please!

For a more original chili recipe (like what was used on the trail), here is one described by the International Chili Society:

> *Cut up as much meat as you think you will need (any kind will do, but beef is probably best) in pieces about the size of a pecan. Put it in a pot, along with some suet (enough so as the meat won't stick to the sides of the pot), and cook it with about the same amount of wild onions, garlic, oregano, and chilies as you have got meat. Put in some salt. Stir it from time to time and cook it until the meat is as tender as you think it's going to get.*

From the long-running San Antonio Chili Queen tradition came several good chilis that you can sample today. Two authentic Texas chilis you can find at the grocery store (in a can) are Gebhardt's (started in San Antonio) and Wolf Brand (Corsicana). A German immigrant from New Braunfels, William Gebhardt, invented chili powder in 1902, which is essential to the making of true Texas chili (unless you want to grind the peppers yourself). Wolf Brand is the inspiration of Lyman T. Davis of Corsicana. He sold his chili out of the back of a wagon starting in 1895. First called "Lyman's Famous Chili," its name was changed to Wolf Brand Chili in 1921. Its long-running (registered trademark) marketing phrase is, "Neighbor, how long has it been since you've had a big, thick, steaming bowl of Wolf Brand chili? Well, that's too long!"

For freshly made chili, you have to cook it yourself or find a good restaurant that makes it daily from fresh ingredients.

If you want to cook your own chili, you can try one of the recipes above or purchase some Wick Fowler 2-Alarm Chili mix and follow the directions. Wick won the 1967 (first annual) World's Championship Chili Cook-off in Terlingua with this recipe. Any true Texas restaurant worth its salt serves real Texas chili. The restaurant that has chili in its name, the Chili's restaurant chain (started in Dallas in 1975), lives up to its moniker by serving up a tasty bowl of Texas chili. (More about this restaurant later.)

In 1977, the Texas legislature proclaimed chili the official "state food" of Texas. What took it so long?

GIVE ME TEX-MEX AND EVERYONE WILL BE HAPPY

With all this connection to other Texas foods, there is bound to be a link between the trail and Tex-Mex foods. Here it is. In fixin' up gravy on the trail, Cookie sometimes mixed the chili spices into brown gravy to create a spicy "chili gravy" sauce (different from chili con carne) that could be poured over meat and tortilla dishes. A descendant of that spicy sauce is used in many of today's Tex-Mex dishes, particularly enchiladas. And that's the connection to Cookie. Without Cookie and the chuck wagon, there might not be any Tex-Mex food today. What a sad place Texas would be. Half of the restaurants in the state would have to close down!

In fact, the term "Tex-Mex" was originally used as a derogatory term for food that was not authentic Mexican. And that's the truth. You will not find much Tex-Mex in Mexico City; their cuisine is very different. And that's what makes Texas-Mexican food so wonderful—it was home grown to fit Texas tastes. Fortunately, the foods from the trail made it into the Texas food chain, and we get to enjoy them today. (Although Texas-Mexican food had been around for many years, the term "Tex-Mex" first appeared in print in the 1940s.)

Like other trail foods, Cookie's early "Tex-Mex" dishes made their way into homes and restaurants. The closest we can get to the beginnings of today's Tex-Mex-style Mexican restaurants is a place called (conveniently) the Original Mexican Restaurant, which opened in San Antonio in 1899 on Losoya Street near the San Antonio River. The people who started this restaurant got the idea from small family restaurants around San Antonio that served Texas-style Mexican plates—so who knows who started the original, original Tex-Mex restaurant? Nevertheless, we do know that the Original Mexican Restaurant was started by a fellow from Chicago named Otis M. Farnsworth who saw that a number of Anglos liked to go into the Mexican part of town and eat at the small restaurants. But these home-based kitchens tended to be crowded and cramped and would not pass any health department inspection today.

Farnsworth saw an opportunity. He hired the best Mexican chefs of the day and designed a "modern" restaurant built for the Anglo crowd, with cloth napkins and waiters who wore clean white vests. Male customers were required to wear jackets. Sure enough, as health department regulations grew stricter, the old smaller mom-and-pop restaurants closed down (along with the Chili Queens), and the Original became one of

the few remaining purveyors of Texas-Mexican cuisine. The Farnsworth family operated this successful and popular restaurant until 1961.

One of the legacies of the Original Mexican Restaurant is the Tex-Mex combination plate. The 1900 version, called a "Regular Supper" and selling for fifteen cents, consisted of tamales, an enchilada with chili gravy, refried beans, rice and tortillas—sound familiar? Almost every modern Tex-Mex restaurant has such a plate, usually called a "Regular Mexican Dinner" or something similar. Perhaps one of the closest cousins of the Farnsworths' restaurant is the Original Mexican Café located at 1401 Market Street in Galveston. It prides itself on being the oldest continually operating Mexican restaurant on the island (since the 1920s) and remains a popular destination for those seeking real Tex-Mex food.

In fact, every city and town in Texas has similar restaurants that are descendants of the San Antonio original. In San Antonio, Casa Rio has been a fixture on the Riverwalk since 1946. A new version of the Original Mexican Restaurant was recently opened on the Riverwalk (528 Riverwalk) to commemorate the Farnsworths' café. In Houston, Molina's has been around since 1941. In Dallas, El Fenix traces its heritage back to 1918, and in Fort Worth, the Original Mexican Eats Café opened on Bowie Avenue in 1926. Fort Worth's Joe T. Garcia's Mexican Restaurant opened on July 4, 1935, with seats for sixteen customers. Today, the restaurant seats up to one thousand (including outdoor seating), and don't be surprised if you have to wait in line for the famous enchiladas and fajitas. (And bring cash; they don't accept any credit cards.) In Austin, visit Matt's El Rancho, which was started in 1952. Of course, this is a very limited list since there is a Mexican restaurant on almost every business street in Texas.

The best way to find a good restaurant in Texas is to ask someone who's lived in the city for fifty or more years; they know where the locals go for authentic Tex-Mex cooking. If you're not in Texas—good luck!

Sizzling Fajitas: It's a Wrap

Once Tex-Mex became an established part of Texas cuisine, there were bound to be other Tex-Mex-style dishes invented by ingenious Texans. One such recent addition to the Tex-Mex menu is fajitas. This dish is made from marinated, grilled skirt steak wrapped up with sautéed onions and bell peppers and sour cream (and anything else you want) and served in a flour tortilla. The word fajita comes from the Spanish word *faja*, for

"girdle" or "strip," referring to the cut of meat. There are several versions of the story of how fajitas originated (all in Texas). One report says that fajitas were cooked on mesquite coals as far back as the 1930s. Most people believe fajitas came about as a way to make a cheaper flank steak cut of meat more palatable.

It is reported that in 1969, the Roundup Restaurant in Pharr was the first to serve what we now call fajitas on a sizzling platter with warm flour tortillas, guacamole, *pico de gallo* (which, by the way, is translated as "rooster's beak") and grated cheese. That same year, Sonny "Fajita King" Falcon from Austin opened a fajita taco concession stand at a Kyle *diez y seis* celebration. Ninfa Laurenza introduced fajitas under the name *tacos al carbon* at her Ninfa's Restaurant in Houston in 1973. By the 1980s, virtually every Tex-Mex restaurant had fajitas on the menu, and today they are found all over the country in almost every restaurant with a grill.

Unfortunately, because of the success of fajitas, the "cheaper and less desirable" flank steak cut of meat is now much more costly than it was years ago. This led to the evolution of several non-fajita varieties of fajitas, including chicken, shrimp and vegetable. Some fancier "fajitas" are now from a cut of a better meat such as sirloin. I've even seen a Yankee recipe for potato fajitas. Go figure.

Nachos for All the World

Is there no end to the variety of Tex-Mex food? Last year, your humble author visited a pub in Edinburgh, Scotland. Along with fish and chips, the menu included nachos. Texas innovation strikes again. The original nachos were actually invented in 1943 at a club in the town of Piedras Negras just across the Texas-Mexico border from Eagle Pass. Folks from the Fort Duncan Air Force Base frequented the Victory Club. One day, some officers' wives showed up for a snack, and the maitre d', Ignacio Anaya, couldn't find the cook, so he improvised a snack for the ladies. He cut some corn tortillas into triangles, put grated cheese on them and heated them up in the restaurant's Salamander broiler. He sprinkled some sliced jalapeños on top and presented the dish to the hungry wives.

When the wives returned, they asked for the dish again—you know, that snack that "Nacho" (Ignacio's nickname) had created.

More and more people requested Nacho's special dish, and the name was eventually shortened to "nachos." There you have it. Over the next

twenty-five years, nachos appeared on Tex-Mex restaurant menus in South Texas but never much farther north than San Marcos.

But wait. There's more. In 1977, Jerry Jones (no, not the Cowboys' Jerry Jones) was the City of Arlington's vendor at the Texas Rangers Arlington Stadium. With encouragement from some of his employees from South Texas, he started experimenting with selling nachos the way they were made in South Texas restaurants. Although they sold well, the preparation was too labor intensive, and that limited the number of sales and profits. Frank Liberto, the CEO of Ricos Products, which provided supplies to the concession, took notice of the new product. He had a brainstorm. Adding milk to the cheese used for the nachos, he made a cheesy sauce. The mixture was heated up in a Westinghouse Roaster and could be quickly ladled up for each order. The new sauce meant that the nachos could be served up quicker and the concessionaire could make more sales and more profits.

Nachos were a big hit, but Ricos Nachos might have remained a local Texas favorite except for the linguistic exploits of two legendary sports announcers. When *Monday Night Football* visited the Metroplex for a Dallas Cowboys game, announcer Howard Cosell and his sidekick, Dandy Don Meredith (former Dallas Cowboys quarterback), got a taste of this new snack in the press booth before the game. During their play calling that night, they talked about the snack, wondering how to pronounce the word "nacho." When they finally got the correct pronunciation down, they liked saying the word so much that they started using it as an adjective during the play calling. "That was a nacho run!" "And it's a nacho catch for a touchdown!"

After a few of these "nacho"-filled games, the entire country wanted to taste this Texas treat. Ricos products capitalized on the unexpected free publicity, and over the next few years, Ricos Nachos found their way into every sports stadium, movie theater and festival in America. By 2006, Ricos Nachos were sold in forty-seven different countries. This Texas innovation has indeed spread far and wide—even into the pubs of Edinburgh, Scotland.

Barbeque, Texas Style

Another example of a delicacy that has its roots in Texas history is barbeque (also bar-B-Q, BBQ and other spellings). Now BBQ wasn't exactly invented in Texas, but it was perfected here over the past one hundred years. Influences came from Mexican heritage as well as from

Texas Germans and Czechs. (In fact, the word *barbecue* comes from the Spanish word *barbacoa*.) And although back east it is mostly the pig that is q'ed, here in Texas, it is mostly beef.

Another difference in eastern and Texas BBQ is that the eastern variety is often cooked up in big metal pots. When people immigrated to Texas, many of them didn't want to carry these heavy pots and left them behind. That's why Texas BBQ is slow cooked over a fire (smoked) rather than in a pot.

It is believed that the origins of Texas-style BBQ came when local butchers had to do something with lesser cuts of meat that weren't selling (such as brisket). They would set up a smoker, and soon the aroma filled the town and people came looking for a good meal. The butcher served up the smoked brisket on butcher paper (which is still the case at some restaurants). With this beginning, Texas BBQ evolved into a process of cooking meat slowly and patiently.

Today, BBQ is prepared in large cooking pits (chambers) often made of brick (although metal chambers are also common) and fired with native wood (such as mesquite, oak, pecan or hickory). The meat is typically hand-rubbed with spices (pepper, salt, sugar and others) and put in the pit for a long time—often overnight. Beef brisket is the most common choice of meat, slow cooked and sliced.

Of course, BBQ isn't limited to beef; sausage is a popular part of the Texas BBQ culture, as are other meats like pork, mutton, *cabrito* (goat), turkey and chicken. Texas BBQ is typically served with a sauce (usually tomato based and with brown sugar). Sauces differ considerably from place to place in Texas. However, every part of Texas has a family BBQ dynasty, and each is as unique and delicious as the next. With over two thousand BBQ restaurants in Texas, you're sure to have a lip-smacking one right around the corner.

There are a few places you can still get a taste of the original chuck wagon experience in the Lone Star State. In March of each year, the Star of Texas Fair & Rodeo (in Austin) holds an Old West Chuck Wagon Cookoff where you can see how Cookie fixed meals out on the cattle trails (www.rodeoaustin.org).

If you want a real old-time ranch experience in an upscale way, then take a trip to one of the most famous restaurants in Texas: the Perini Ranch Steak House at Buffalo Gap, Texas, located near Abilene. Tom Perini is the owner of the Ranch and a nationally known western chef. *Texas Monthly* called Perini's restaurant the "Best Steakhouse for Real Texas

Food" (www.periniranch.com). For the best examples of Texas chili, attend the Terlingua International Chili Championship, held the first Saturday of every November (www.abowlofred.com).

Since Texas foods are still evolving, I'll write down one of my own favorite Tex-Mex/Bar-B-Que crossover dishes that I call Bar-B-Dilla. Between two flour tortillas, place a mound of chopped barbeque beef (optionally, include some chopped-up sausage) and sprinkle with Monterey Jack cheese. You might add a sprinkle of chopped-up jalapeños or grilled onions. Press down the tortillas in a skillet or grill so the barbeque is evenly spread out between them. Turn it over to grill it a bit on each side. Cut into pie-shaped wedges. Serve warm and with a dollop of sour cream and guacamole. Let's see if this delicacy starts showing up on some menus.

References

Cauble, Bill. *Barbecue, Biscuits, and Beans: Chuckwagon Cooking*. Albany, TX: Bright Sky Press. 2002.

Cooper, Joe. *With or Without Beans: Being a Compendium to Perpetuate the Internationally Famous Bowl of Chili (Texas Style) Which Occupies Such an Important Place in Modern Civilization*. Dallas, TX: W.S. Henson Publishers, 1952.

Hayle, J. Evetts. *Charles Goodnight, Cowman and Plainsman*. Norman: University of Oklahoma, 1981.

Mariani, John F. *Encyclopedia of American Food and Drink*. New York: Lebhar-Friedman, 1999.

Perini, Tom. *Texas Cowboy Cooking*. Alexandria, VA: Time-Life Books, 2000.

Shlachterm, Barry. *Championship Chili: Top Cookoff Winning Recipes*. Fort Worth: Great Texas Line, 2002.

Tolbert, Francis X. *A Bowl of Red*. Garden City, NY: Doubleday, 1972.

Walsh, Robb. *Legends of Texas Barbecue Cookbook: Recipes and Recollections from the Pit Bosses*. San Francisco: Chronicle Books, 2002.

————. *The Tex-Mex Cookbook*. New York: Broadway Books, 2004.

Texas Tidbit

Larry McMurtry's Pulitzer Prize–winning (1985) novel *Lonesome Dove* is loosely based on the lives of Goodnight and Loving and their experiences on the early trail drives.

DR PEPPER, GOOD FOR LIFE

The trouble with chili or Tex-Mex is that it can be hotter than a firecracker on your tongue. Maybe that's why Texas ended up as the birthplace of one of the most refreshing drinks on the planet.

This story begins in Waco, a place that started out as a rough-and-tumble cattle town in 1856. In 1871, when the railroad came through, the town became a center of commerce, supporting a local cotton industry. Transportation also made Waco a travel hub. As a result, several universities settled in Waco, including Baylor (the oldest university, chartered by the Republic of Texas in 1845, started in Independence and moved to Waco in 1887), Texas Christian University (TCU, from 1896 to 1910, moved to Fort Worth) and Paul Quinn College (from 1881 to 1990, moved to Dallas).

The thriving early Waco downtown boasted all the usual emporiums, including one store in particular named Wade Morrison's Old Corner Drug Store. In the 1880s, a young pharmacist who worked in the store, Charles Alderton, took an interest in the sodas served there. At that time, sodas mostly consisted of carbonated water with some fruit flavor added to them. They were popular, but Alderton sensed that the customers wanted something new.

In 1885, by mixing several fruit flavors, Alderton came up with a combination that hit the spot. Customers drank it up by the glassful, and the demand for the pleasing elixir grew rapidly. "Shoot me a Waco" was the way to ask for Alderton's new drink.

The way the actual name for this new drink came about is something of a legend. The romantic version of the story claims that store owner Morrison was in love with a pretty little lass from Virginia whose father was Dr. Charles Pepper. Wanting the hand of his love, he thought it would be helpful to name his new invention after the father, so he called it Dr. Pepper. Unfortunately, Morrison didn't win the hand of the apple of his eye, but he did come up with an incredibly popular soft drink.

The non-romantic version of the story says that Dr. Pepper was an admired friend and colleague of Wade Morrison, and he thought Dr Pepper was a cooler name than "Waco." Whatever the case, the moniker stuck. (Actually, Dr. Pepper made a slight change to its name in the 1950s by removing the period after "Dr." It did this because the particular font it used in its logo made the name look like Di Pepper.)

There had been other soft drinks created before Dr Pepper (Hires Root Beer being the most well known), but since Coca-Cola was invented a year later, Alderton's soda is now the oldest *major* soft drink invented in America. Indeed, this Texas drink can genuinely claim to be the world's most original soft drink.

Once Dr Pepper became popular at Morrison's store, other Waco soda fountains wanted the drink. Alderton and Morrison teamed up to make the syrup for the growing demand, but they weren't prepared to make the volume needed. In a marriage made in heaven, there happened to be a company in Waco called the Circle "A" Ginger Ale Company. The owner of that company, Robert S. Lazenby, liked the new concoction. In 1891, Alderton stepped out of the picture, and a partnership was drawn up between Lazenby and Morrison to produce Dr Pepper.

Although Dr Pepper, known then as the "King of Beverages," continued growing in popularity around Texas, it had yet to break into the big time. That opportunity came in 1904 during the St. Louis World's Fair. During that event, Dr Pepper stepped into the national limelight.

Another successful marketing strategy came in the 1920s, when marketing folks at Dr Pepper read a doctor's claim that sugar helped working people overcome their sense of fatigue during a normal day when consumed at 10:30 a.m., 2:30 p.m. and 4:30 p.m. Advertisements soon advised workers all across America to "Drink a bite to eat at 10, 2 and 4." The popular 10-2-4 slogan stuck around until the 1960s.

The original Dr Pepper didn't contain caffeine, but it was added in the 1920s to help it compete with other popular drinks of the day. One item that

Dr Pepper doesn't include (and never did) is prune juice (which was a rumor for a number of years).

The Dr Pepper corporate headquarters moved to Dallas in 1922, into an Art Deco–style building that for many years was a well-known Dallas landmark at the corner of Mockingbird and Greenville. In the 1980s, Dr Pepper headquarters moved to Plano and then merged with the 7-Up company in 1986. After several tries by local historical groups to save the site, the old Dallas (Mockingbird) plant was torn down in 1997. Although a grocery store now occupies that parcel of land, the familiar Dr Pepper clock sign still graces the corner and there is a tribute to Dr Pepper in the store. As of 2007, Dr Pepper is part of the Dr Pepper Snapple Group that includes 7-Up, IBC Root Beer, Canada Dry and many other beverages.

There are two major historic Dr Pepper sites that you can visit in Texas. The site of the oldest Dr Pepper bottling company in Texas is in Dublin (now no longer bottling). Sam Houston Prim started this company in 1891. Its other claim to fame is that when most other soft drinks began using corn sweeteners instead of cane sugar to sweeten drinks, the feisty owner at the time (Grace Prim Lyon) refused to switch over, so for many years, the Dr Pepper bottled there still contained real cane sugar.

When Mrs. Lyon died in 1991, the plant was passed on to her longtime faithful employee Bill Kloster. Ever a collector of Dr Pepper memorabilia, he not only kept filling the returnable bottles when all others had stopped, but he also turned part of the plant into a walk-through museum (which he delighted to show anyone who would take the tour). During the tour, he'd hand you an icy cold six-and-a-half-ounce bottle of Dr Pepper to wet your whistle. Seeing the rise in tourists at his plant, Kloster also opened Old Doc's Soda Shop, which features an old-fashioned soda fountain and offers Dr Pepper collectables. The beloved Mr. Kloster died in 1999, and a statue of him was erected outside the plant.

The Dublin plant was again passed along to Kloster's only son and two grandsons, who kept the traditions of "Dublin" Dr Pepper alive until 2012, when they lost their franchise because of a legal issue. However, the company continues to bottle its own brand of soda (now as Dublin Bottling Works), and Old Doc's Soda Shop continues to offer tours through the museum and bottling plant. If you want to see (and hear) the old bottling machine in action, call first to find out when they will be bottling.

Old Doc's Soda Shop is located at the old Dr Pepper Bottling Plant at 105 East Elm, Dublin, TX 76446. Its phone number is 888-398-1024. Dublin is located about seventy miles southwest of Fort Worth and eighty

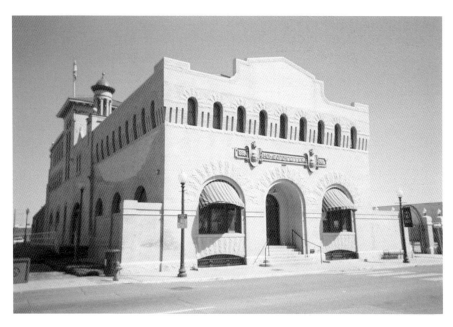

Above: Dr Pepper Museum, Waco. *Photo by author.*

Below: An old-fashioned Dr Pepper delivery truck in front of Doc's Soda Shop in Dublin. *Courtesy Amanda Raspberry, Dublin Dr Pepper.*

miles west of Waco where Highway 377/67 and Highway 6 intersect. Old Doc's Soda Shop is open Tuesday through Saturday, 10:00 a.m. to 5:00 p.m., and Sunday, 1:00 p.m. to 5:00 p.m. Tours depart about every forty-five minutes. Check the dublinbottlingworks.com website for the latest information.

The second place to see Dr Pepper history is in the original Dr Pepper plant (actually it was originally the Artesian Bottling Company plant) in Waco. Although it stopped bottling years ago, the building was renovated in 1991 and turned into a museum. The Dr Pepper Museum and Free Enterprise Institute operates this museum. It contains a re-created version of Old Morrison's Drug Store, complete with a soda fountain where you can order all kinds of Dr Pepper goodies. If it's cold outside, be sure to order a cup of hot (real sugar) Dr Pepper with a slice of orange or lemon in it. Mmmm.

The museum contains an extensive collection of Dr Pepper memorabilia, clips from old Dr Pepper commercials and a shop where you can buy all kinds of Dr Pepper curios. When you visit the museum, be sure to study the building from the outside. You can see where extensive repairs were made to the building after a devastating 1953 Waco tornado.

The hours of operation for the Waco Dr Pepper museum are Monday to Saturday, 10:00 a.m. to 4:00 p.m., and Sunday, 12:00 p.m. to 4:00 p.m. (Hours are extended during peak months.) Admission is eight dollars for adults, seven dollars for seniors and five dollars for students and children. (Check the website at www.drpeppermuseum.com for discount coupons and the latest information on prices and tours.) From IH35, take the Fourth and Fifth Streets exit. Turn west on Fourth Street. Go to Mary Avenue. Turn left on Mary. The museum is on the corner of Fifth Street and Mary. Tours are available for groups. Call for information. The museum is also available for receptions, rehearsal dinners and other events.

References

Rodengen, Jeffrey L., and Karen Nitkin. *The Legend of Dr Pepper/7-Up*. Fort Lauderdale, FL: Write Stuff Enterprise, 1995.
Wright, Karen. *The Road to Dr Pepper, Texas: The Story of Dublin Dr Pepper*. Abilene, TX: State House Press, 2006.

Texas Tidbit

According to Goldie Friede in *The Beatles A to Z,* when the Beatles were developing a new album in 1966, Paul McCartney originally titled it "Dr. Pepper's Lonely Heart's Club Band." The name was changed to "Sgt. Pepper" once he found out that the name "Dr Pepper" was copyrighted. Nevertheless, bottles of Dr Pepper can be seen strewn around in the background in their 1970 movie *Let It Be.*

Texas Tidbit

Another beverage created in Waco is Big Red. In 1937, Grover C. Thomsen and R.H. Roarkin developed a unique drink originally known as Sun Tang Red Cream Soda. Although it remained a strictly Texas treat for many years, Big Red is now marketed (and popular) all over the United States—and is currently based in Waco and Austin.

A cap from an original Big Red (Sun Tang Red Cream Soda). *Courtesy Big Red, Inc.*

THE HAMBURGER

(DO YOU WANT FRIES WITH THAT?)

Texans are a proud folk. When it comes to making a claim about something, we aren't exactly shy. One such claim comes from the East Texas town of Athens and from a fellow named Fletcher Davis. According to Athens's history, "Ole Dave" put a patty of cooked ground beef between two slices of bread sometime in the 1880s and thus invented the hamburger (although it wasn't named that at the time).

This claim deserves a little discussion.

The process of grinding meat (or at least shredding poorer cuts of meat) and cooking it into a palatable dish is ancient. It's said the Mongols fixed it up that way. Russians had something similar they called steak tartare. By the fourteenth century, this idea of cooking minced beef had made its way to Germany. Sailors who visited the port of Hamburg sampled this dish and called it a "Hamburg steak." It wasn't quite what we picture as a hamburger steak today; it was a minced meat, salted and spiced. In about 1850, meat-grinding implements—a tool that would become necessary for grinding hamburger meat like we know today—were first used to make sausage. Hamburger steaks appeared on some American restaurant menus by the 1870s. However, a hamburger steak is still not a "hamburger."

The claim of putting a ground beef patty in a sandwich is held by four American cities. Hamburg, New York, claims that two brothers started selling ground beef on a bun in 1885, but historians have found holes in the story. The Lassen family of New Haven, Connecticut, claims it served the first ground beef patties between two pieces of toast in 1900. Seymour,

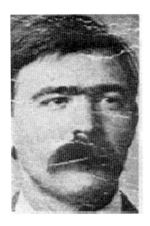

Fletcher Davis, inventor of the hamburger sandwich, Athens, Texas.

Wisconsin, claims that Charles Nagren flattened a meatball in 1885, served it at a local fair and called it a hamburger. However, news stories of that fair do not mention the sandwich. Some accounts claim that a hamburger was served in 1892 at the Summit County Fair in Ohio, although corroboration is hard to come by.

Of all the claims, the one that passes muster by most historians (most notably Texas food historian Frank X. Tolbert) is that of Fletcher Davis (1864–1941) of Athens, Texas. Fletcher (also known as "Ole Dave") was a potter by trade, but when his business slowed down in the 1880s, he opened up a small restaurant at 115 Tyler Street to make some spending money. That's where he started serving a ground beef patty between two slices of bread. Fletcher's sandwich was so popular in Athens that he took it to the 1904 World's Fair in St. Louis. There it caused a culinary sensation, and its fame spread throughout the country. It is said the sandwich got the name "hamburger" at the fair. Even the McDonald's Restaurant research traces the hamburger to Fletcher at the St. Louis World's Fair, according to Tolbert.

Some less authenticated stories tell how Fletcher was also responsible for naming French-fried potatoes. It was said that Fletcher served fried potatoes along with his hamburger sandwich, and when a reporter asked him about it, he said he had learned to fry up potatoes from a friend in Paris. The reporter thought he meant Paris, France, and called them French-fried potatoes. Historians dispute this by pointing out that Thomas Jefferson also mentioned "potatoes fried in the French manner" in 1700. What is more likely is that some Texan invented this particular tall tale.

Of course, Fletcher's hamburger soon became a staple of the Texas diet—and the meal of choice in all of America. Several Texas restaurants have made it big serving up hamburgers. In 1950, Harmon Dobson of Corpus Christi started a restaurant where the hamburger was so big that people exclaimed "what-a-burger!" And that began the successful Whataburger chain that now stretches into ten states and over five hundred locations. Although Dairy Queen and its hamburgers didn't start in Texas, once it got here, it became the restaurant's premier location. With restaurants at almost every highway exit, the familiar red DQ became known as a Texas stop sign.

Reference

Tolbert, Frank X. "The Henderson County Hamburger." http://hamburgerhome.com/tolbert.shtml. March 12, 2010.

Texas Tidbit

It is estimated that restaurants in the United States serve 8.2 billion hamburgers each year.

PIG STANDS EARN FIVE OINKS FOR INNOVATION

In the early 1920s, Texan Jesse G. Kirby observed something interesting about the growing automobile phenomenon: "People with cars are so crazy they don't want to get out of them to eat." Like any good entrepreneur, he put brain to problem and came up with a moneymaking idea. In 1921, he partnered with a doctor named Ruben W. Jackson and opened a restaurant on Chalk Hill Road in the Oak Cliff section of Dallas. But it wasn't an ordinary restaurant. It was the first restaurant to offer curbside service.

Hungry Texans drove up to the curb in their Model Ts and were met by a twelve- or thirteen-year-old boy dressed in a white hat, a white shirt, dark pants and wearing a black bow tie. The boy hopped up on the running board and asked what the driver wanted to eat. After securing the order, the boy ran into the restaurant, placed the order, returned to the car and hopped back onto the running board to deliver the goods. People called these kids "carhops."

The eatery, named the Pig Stand, was the first ever drive-up restaurant. The original Pig Stand was a simple square building with a barbeque pit in the back. It was built close to the street so customers could drive up to the curb for service. As the popularity of Pig Stands grew, the restaurants evolved to include both awning-covered drive-in service (instead of drive-up) and limited counter service.

These later versions were set back from the curb and featured a distinctive red-tiled pagoda-like roofline. In 1921, they displayed what was probably the first neon sign for a restaurant in the United States. The red

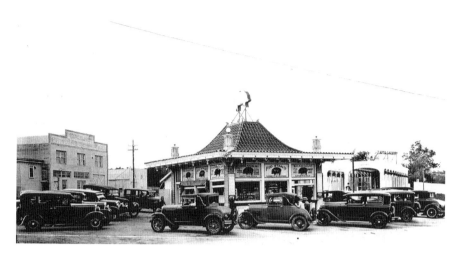

Pig Stand in Dallas, circa 1925.

neon outlined the shape of a pig with the words "Pig Sandwich" filling the interior of the outline. The same logo continues to be used today.

It wasn't only the drive-in service that made the Pig Stands popular. They also served tasty food. Besides hamburgers and sandwiches, they soon became known for their signature Tennessee barbeque pork sandwich called, appropriately, a Pig Sandwich.

Advertising slogans for the restaurants included, "Quick Curb Service," "America's Motor Lunch" and "Eat a Pig Sandwich." A 1927 Dallas newspaper ad claimed that five thousand meals a night were served at Pig Stands in Dallas alone. It encouraged the hungry public to "Join the 5000 and avoid the bother of the evening meal."

As Pig Stands became more and more popular, they grew to over one hundred restaurants. Most were in Texas, but some were as far away as Los Angeles. The innovative carhops and drive-up service would be enough to put Pig Stand in the history books, but Kirby's innovation didn't stop there. Taking a cue from the early success with drive-up and drive-in convenience, Kirby tried something new in 1931: drive-through service. This innovation caught on slower than the drive-in service, but the concept hung on, kept growing and became the lifeblood of the fast-food restaurants of today.

FIRST, FIRST, FIRST

Other "firsts" for the Pig Stand included the first restaurant use of neon signs, the first use of fluorescent lighting (to support nighttime sales) and the first restaurant to use air conditioning—an absolutely essential innovation for scorching Texas summers.

But wait, there's more.

The Pig Stand also altered America's taste palate forever with three more scrumptious innovations. In 1929, a clumsy Pig Stand cook accidentally dropped a ring of onion destined for a hamburger into a bowl of batter. He fished it out, thought for a moment and instinctively plunged it into a nearby vat of hot cooking oil. The result was *mmmmm*, tasty. The battered onion ring became an instant hit and a permanent addition to the Pig Stand menu (as well as to menus all over America).

The second culinary inspiration came twelve years later, in 1941. A man by the name of Royce Hailey, who got his start as a carhop, now ran the Pig Stand Company. At one of the restaurants in Beaumont, Hailey had an inspiration. With the idea of making his toast more substantial, he asked the local Rainbow bakery to make his bread a little thicker. The bread that arrived was *too* thick. It wouldn't fit into the restaurant's toaster. Not to waste anything, the cook suggested slathering the bread with butter and toasting it on the grill. The result was another *mmmmm*, tasty moment. Hailey dubbed the new creation "Texas toast." Another permanent Pig Stand menu item was born, and restaurants all over the world soon picked up on the idea.

A final notable innovation came a few years later when a breaded and fried steak was placed between two bun halves and became the chicken fried steak sandwich. Today, there is hardly any Texas restaurant worth its salt that doesn't have onion rings, Texas toast and a chicken fried steak sandwich on its menu. Unfortunately for Hailey, none of these items was trademarked. However, the Pig Sandwich *was* trademarked and became the object of lawsuits as late as 1992, when the Pig Stand successfully stopped the Hard Rock Café from using the name.

TOUGH TIMES FOR A TENDER PIG

Although there had been more than one hundred Pig Stands from coast to coast in the 1930s, World War II brought an end to the expansion. Over a period of years, the number of Texas Pig Stand Restaurants decreased

significantly. Royce Hailey became sole owner of the company in 1975, and in 1983, his son Richard (who is also the namesake of a popular country swing band, Richard Hailey & the Neon Stars) took over the company. The company went through hard times in 2005, and only a few Pig Stands survived in Beaumont, Houston and San Antonio. But the Stand never could regain its former glory. Continued financial worries eventually caused the entire franchise to close its doors.

When the last of the Pig Stands in San Antonio closed, one person wasn't ready for the end. Mary Ann Hill, who began working at the Stand as a waitress in 1967 at the age of eighteen, bought old Number 29 at 1508 Broadway and reopened it. This Pig Stand had become more than a place to work; it was like an old friend, and her customers were part of a big family.

If you want to experience authentic fast-food history, get yourself over to Number 29 while it's still serving up the Pig Sandwich and onion rings. Tell Mary Ann that Alan sent you.

References

Mercuri, Becky. *American Sandwich: Great Eats from All 50 States*. Layton, UT: Gibbs Smith Publisher, 2004.

Voorhees, Don. *Why Do Donuts Have Holes?: Fascinating Facts about What We Eat and Drink*. New York: Citadel Press, 2002.

Witzel, Michael Karl. *The American Drive-In Restaurant*. St. Paul, MN: Motorbooks International, 2002.

TEXAS SMORGASBORD

SNACK FOODS TO CASUAL DINING

There is no limit to the ingenuity of Texas chefs and restaurateurs. The world is indebted to our fair state for bringing into existence some of the finest, most mouth-watering grub on planet Earth. From snack foods to haute cuisine, Texas people know how to cook. In this section, we'll take a look at some other foods that had their origins in Texas, dreamed up by innovative Texans with an appetite for great food.

Fritos, the Perfect Complement to Texas Chili

Take Fritos, for example. Try a handful. What better partner to Texas chili could there be? And just like that partner, its history is traced back to San Antonio.

Charles Doolin owned an ice cream store in the Alamo City during the Great Depression of the 1930s. When ice cream prices plummeted, Doolin needed a way to make more cash. He looked around for another product to sell and discarded idea after idea. One day at lunch, he saw someone eating something new called a Frito Corn Chip. He traced down the maker and liked what he found. Doolin purchased the product, "lock, stock, and barrel," for $100, borrowing some of the money from his mother. (We don't know the name of the original inventor.) With his newfound product, Doolin and his mother/partner set up a "factory" in her kitchen. The factory consisted of a single potato ricer (a device where you push potatoes or other food

through small holes the width of a grain of rice), and with that gizmo, they turned out about ten pounds of Fritos an hour. The first Fritos sold for five cents a bag (in a brown paper bag).

Convinced that Fritos were the start of something big, Doolin hopped into his Model T Ford and visited hundreds of cities, towns and crossroads where he could find a grocery store or café. He sometimes took part-time jobs as a cook to pay his way. Sure enough, Texas persistence paid off, and sales of the snack took off. In fact, they took off too much. He and his mom had to find a more efficient way to produce the tasty chip. A "hammer" press provided the answer. It could efficiently cut the Frito dough to the desired length and speed up the process. The kitchen moved into a garage, and production increased from ten to one hundred pounds an hour.

The growing company moved to Dallas in 1934, and by 1941, Frito had a division operating as far away as Los Angeles. By the end of World War II, Fritos had become a staple in the Texas diet and, soon, the nation's. In 1945, a Fritos franchise was sold to the H.W. Lay Company of Atlanta, Georgia. In 1961, the two companies merged to form Frito-Lay. In 1965, it became a subsidiary of PepsiCo. As of 2015, the company had about fifty thousand employees with sales in over two hundred countries and territories worldwide.

Fletcher's Not So Corny Corny Dog

Of course, no discussion of Texas food could go far without the mention of Fletcher's Original State Fair Corny Dog. Neil and Carl Fletcher first got a concession stand at the State Fair of Texas in 1938. Some say that in their search for something unique to sell, they made note of another Dallas vendor who cooked a hot dog coated in cornmeal and shaped like an ear of corn. However, his process was cumbersome. They improved on the idea by putting the hot dog on a stick and using the stick to hold the dog while they dipped it into the batter. After frying, the stick made it easy to hold the dog and eat it.

The Fletchers introduced this new mouth-watering treat in 1942. It soon became a perennial favorite. Today, it just isn't a visit to the State Fair without chowing down on at least one (or two) Fletcher's Corny Dogs. Since its introduction, a whopping sixty million of the fried dogs on a stick have been sold. That even impresses Big Tex.

No telling how many gallons of yellow mustard have been squirted onto these dogs!

MMMM, MARGARITA

Are you thirsty? In 2005, the Smithsonian museum in Washington announced that it had acquired for its collection the first frozen margarita machine. The tasty history of this invention goes back to 1971 with restaurateur Mariano Martinez of Mariano's Hacienda Restaurant (6300 Skillman Street) in Dallas, when he modified a soft-serve ice cream machine to produce the popular frozen concoction. Up until then, margaritas had been "handmade" in blenders.

The new process not only saved time but also produced a consistent blended drink. Mariano claims that he was inspired by a 7-Eleven Slurpee machine. The combination of a frozen margarita and Tex-Mex food made a saleable combination, and the invention caught on quickly. The actual invention of the margarita (before the machine version) is more shrouded in mystery, but most think it was in Texas, probably in Galveston. Some say it was invented in Juárez. We'll vote for Texas.

Mariano Martinez at the first frozen margarita machine (now at the Smithsonian). *Courtesy Mariano Martinez.*

Get Comfortable with Casual Dining

As the two-income family increased in Texas in the 1960s, as well as in the rest of the United States, people started eating out more. At the same time, they wanted something more than the fast-food experience. One person saw this need and invented a new kind of restaurant that emphasized "casual dining."

That person was Norman Brinker.

Norman grew up learning how to make money. While only a first grader, young Brinker dreamed of owning a horse. His family couldn't afford one, so Norman earned the money himself by picking cotton, delivering papers, raising rabbits and kenneling dogs. After a stint in the U.S. Navy, he paid his way through college by selling cutlery door to door. Although Norman grew up in various parts of the United States, he soon learned the value of living in the Lone Star State.

With a knack for business already under his belt, he left college for a corporate job at Jack in the Box Restaurants and played an important role in the expansion of the chain into Texas during the 1960s. However, he wanted to be his own boss. With grand aspirations, he opened Brink's Coffee Shop in Dallas, but it failed. Some people stop at failure, but Texans know that it sometimes takes more than one throw to rope a cash cow. Brinker learned from the experience and tried again.

After rethinking and studying the market, he conceived a new plan and opened a restaurant in Dallas in 1966, based on an Olde English theme. Steak & Ale was an instant success; it popularized the concept of a salad bar and defined the "casual dining" industry. After that initial success, Norman

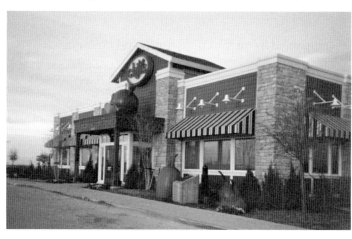

The 1,000th Chili's restaurant, located on Cockrell Hill near Interstate 30, Dallas, 2005. *Photo by author.*

spent some time at Pillsbury (and developed the Bennigan's Restaurant chain), but in 1983, he got the craving for adventure again. This time, he took over the helm of the small Chili's chain of restaurants and made it a household name (while serving up a pretty darn good Texas chili). Other Brinker restaurants that followed include Romano's Macaroni Grill, On the Border Mexican Grill & Cantina, Maggiano's Little Italy, Corner Bakery, Big Bowl Asian Kitchen and Rockfish Seafood Grill. Today, many others have adopted the casual dining paradigm, but Brinker restaurants continue to lead the pack.

When people who have worked for Norman Brinker are asked about him, the word most commonly used is "integrity." Norman took care of his employees so they could take care of the customers. With Texas horse sense and passionate drive, he blended meticulous market understanding with outstanding customer service carried out by a devoted cadre of customer-driven employees, and the formula resulted in success.

SUCCESS IN FORTY-FIVE MINUTES

Brinker's version of the dining experience drove customers back to a restaurant time and time again. In a 1991 interview in the *Memphis Commercial Appeal*, Norman says, "You have about 45 minutes to convince the customer to come again; that's your objective. Your objective, once the customer is there, is to give them such a good experience, they'll want to come again."

Norman suffered a serious injury during a polo match in 1993, leaving him in a coma for three weeks. Physically, he never fully recovered. But he fought hard and came back to work within four months. The second word most commonly used to describe Norman is "fighter." With good humor (accompanied by an infectious smile) and determination, Brinker continued building one of the greatest restaurant empires in the world.

And Brinker's Texas "true grit" extended well beyond his own stable of restaurants. Many successful restaurants were started by Brinker disciples, including Outback Steakhouse and Houston's Restaurant. Norman relished his role as mentor. He often mentioned that he had "probably helped more youngsters pay their way through college than anyone else in the United States." One of his closest friends said of Norman, "He was a shining symbol of what our system of free enterprise is all about. He worked hard and smart—committed to the highest standards of ethics—to become a leader… not just in the casual dining world, but a leader in business…and in life."

Thanks to Norman Brinker, traveling Texans in far-flung cities across the globe can sit down in a comfortable restaurant and grab a bite of Texas flavor and hospitality. And the next time a server comes to your table and says something like, "Hello, my name is John Smith, and I'll be taking care of you tonight," you can think of the innovative Texas restaurateur who inspired an entire new concept of dining.

Norman E. Brinker retired in 2000 as chairman of Brinker International and passed away in 2009. At the time of his death, Brinker International managed more than 1,700 restaurants worldwide. And that's a big Texas legend.

Reference

Brinker, Norman, and Thomas Phillips. *On the Brink: The Life and Leadership of Norman Brinker*. Arlington, TX: Summit Publishing Group, 1996.

Texas Tidbit

Allegedly, the dying words of American frontiersman Kit Carson were, "I wish I had time for just one more bowl of chili."

Texas Tidbit

About the time Norman Brinker took over the reins of Chili's, his wife (at that time), Nancy Brinker, organized the Susan G. Komen Foundation to fund research to eradicate breast cancer. Since 1982, the foundation (named in memory of Nancy's sister) has raised and invested more than $1.8 billion in research for the cure.

TEXAS ENTERTAINMENT

BIG STARS FROM THE LONE STAR

It got lonely among the tumbleweeds of West Texas. In the desert region as well as in the valley and among the pine trees, early Texas settlers whiled away their time with homegrown entertainment. There were no iPods, mp3s, record players, DVDs or Internet. There were a few books, a few fiddles and guitars and precious few pianos. However, songs they had—enough to make tough work a little lighter.

From the beginnings of settlements in Texas, where two or three people gathered together, Texans eked out enough time for a little amusement among the cattle, oil and tumbleweeds of the lone prairie. These next few stories show how this Texas creativity influenced the world of entertainment, including the written word, music, stage and screen.

THE SURPRISING O. HENRY

William Sydney Porter, writing under the name O. Henry, caused a stir in the literary world. Born during the height of the Civil War in 1862 in Greensboro, North Carolina, William lost his mother at the age of three and moved with his father, Dr. Algernon Porter, and brother Shirley (yes, that's the right name) to his grandmother's home. He did well in school and became a licensed pharmacist by the age of nineteen.

For health reasons (people tend to be healthier in Texas), Porter moved from North Carolina to La Salle County, Texas, in 1882, first working as a ranch hand and then going on to Austin to accept a job as a pharmacist at the Morley Brothers Drug Store on East Sixth Street.

William dug into the Austin society, joined the Austin Grays as a lieutenant (a precursor to the National Guard) and organized a singing group known as the Hill City Quartet. In 1887, he married Athol Estes, and in 1889, she gave birth to a daughter, Margaret.

Predating today's popular entertainment magazine of the same name, Porter started an Austin newspaper named *The Rolling Stone* in 1891. Although it reached a circulation of one thousand (in a city of eleven thousand), it was never really profitable, and it lasted only a year. In the meantime, Porter took a job as a teller at the First National Bank. This was either a huge mistake or a very fortunate circumstance (for posterity) because that job ended up birthing the writer who went by the name of O. Henry.

In 1884, Porter was accused of embezzling funds from the bank, a charge he forever denied. Afraid of prosecution, he hightailed it to Honduras.

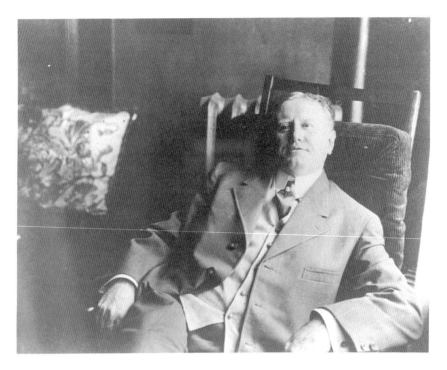

Short story author O. Henry (William Sydney Porter). *Courtesy the UT Center for American History.*

However, he soon learned that his wife was very ill and returned to care for her. Shortly after her death (buried in Oakwood Cemetery), a jury convicted him and sent him to the Ohio State Penitentiary.

With a nine-year-old daughter to support, Porter turned to the only thing he could think of to do in prison: write stories. After a few tries at the craft, he found success when the S.S. McClure Publishing Company bought his short story titled "The Miracle of Lava Canyon." Not wanting his writing associated with the "convict" William Porter, he wrote the story under the name O. Henry.

Porter served three years in prison and left the big house as an up-and-coming short story author known to the world as O. Henry. To pursue his new career in the publishing capital of the world, he moved to New York. However, he still had Texas on his mind. Knowing that readers liked tales of the West, he used his experience on the ranch as the backdrop for many of his stories. Blending that experience with the new experiences of living among the four million people in New York City, O. Henry wrote over

three hundred short stories and became a popular writer with worldwide recognition. His original short story style that made him a master of his craft often included an interesting twist or surprise at the end of the story.

ENDINGS WITH A TWIST

His most famous story, "The Gift of the Magi," concerns a young couple who are short of money but desperately want to buy each other Christmas gifts. (Spoiler alert: don't read this next sentence if you haven't read the story.) She sells her long hair to purchase a watch fob for him, and he pawns off his watch to buy a set of combs for her hair.

His story "The Ransom of Red Chief" concerns a ten-year-old boy who is kidnapped by two men. (Same spoiler warning.) The boy is such a pest that the men end up paying the boy's father to take him back.

When asked where the name "O. Henry" came from, Porter told the story about when he first lived in Austin. He roomed in the home of the Joseph Harrell family and often heard them calling to their family cat, "Oh, Henry." When the time came to choose a pseudonym, O. Henry came to mind. When asked where he got his ideas, he once remarked, "There are stories in everything. I've got some of my best yarns from park benches, lampposts and newspaper stands."

In 1907, O. Henry married Sarah Coleman. The new marriage was not happy, and O. Henry died a short three years later. He is buried in Asheville, North Carolina.

O. Henry (William Sydney Porter) house (now a museum) in Austin. *Photo by author.*

TEXAS INGENUITY

In 1918, a group called the Twilight Club held a dinner at the Hotel McAlpin in New York City to honor O. Henry. Later that year, they established an O. Henry memorial fund, which would award prizes for the best short story writers (sort of like Hollywood's Oscars). The O. Henry Award is now considered the most prestigious award for short stories.

A LITTLE HOUSE WITH A BIG STORY

An O. Henry museum, which opened in 1972, is located in Austin in a quaint Queen Anne–style cottage at 409 East Fifth Street, where Porter lived from 1893 to 1895. Remembering the legacy of the famous Texas author, the museum offers creative writing programs for adults and children. Every year it also holds an annual fundraiser, the O. Henry Pun-Off. The museum is open from 12:00 p.m. to 5:00 p.m., Wednesday through Sunday. It is closed on Monday and Tuesday. Admission is free. For more information, call 512-472-1903.

There is also an O. Henry Room at the General Land Office Building in the Texas State Capitol complex (at 112 East Eleventh Street on the southeast capitol grounds and now operated as a visitors' center). This room commemorates O. Henry's (as William Sydney Porter) service as the General Land Office's most famous draftsman. The exhibit includes information about Porter's life in Texas. A particular spiral staircase in the building was made famous in an O. Henry story called "Murder at the Land Office." The visitors' center (and General Land Office) is open Monday through Saturday from 9:00 a.m. to 5:00 p.m. and on Sunday from noon to 5:00 p.m. For more information, call 512-305-8400.

References

Cerf, Bennett. *The Best Short Stories of O. Henry*. New York: Modern Library, 1994.
O'Quinn, Trueman E. *Time to Write: How William Sidney Porter Became O. Henry*. Austin, TX: Eakin Press, 1986.

Texas Tidbit

A memorial statue to writer O. Henry (William Sydney Porter) is located in the plaza of the First Union Tower complex in Greensboro, North Carolina, on Bellmeade Street, between North Greene and North Elm Streets.

BOB BANNER, MR. TELEVISION

No person has given so much for so long to television as Texan Bob Banner. His penchant for entertainment began in his hometown of Ennis, where he was born Robert James Banner Jr. in 1921. At the age of three, his father took a picture of him sitting at the family upright piano. By the time he was twelve, he could play almost anything by ear and in any key. Bob tickled the ivories (piano and organ) anywhere and everywhere in Ennis they would let him—the Lions Club, school assemblies, the Presbyterian church and the local movie theater. One day in 1937, when he was a sophomore, the high school bandleader, Mr. Granger, called Bob into his office with an urgent request for this star pupil.

"We need a school alma mater by Sunday, Bob. Have you ever written a song?" "No." "You will now—with me. I already have the first eight bars."

Bob went to work helping construct the Ennis alma mater (mostly figuring out chord structure for the band parts), and by late Sunday night, he and Mr. Granger had come up with "Maroon and White." Bob thought it was pretty good. Almost. The last two lines were, "We will always face the conquest with spirits bold, Laurels for Ole Ennis High will be our goal." Those last two words in the last two lines "bold and goal" didn't exactly rhyme. Mr. Granger said they'd fix it later. When he pushed Bob out the door after his high school graduation, Mr. Granger told him not to come back to Ennis until he'd found his fame and fortune in New York or Hollywood.

Never giving "Maroon and White" much more thought, Bob attended Southern Methodist University (SMU) in Dallas, where he arranged music

for the Mustang Band, played trombone and led an eighteen-piece dance band and vocal group called the Varsiteers. In 1942, he staged a musical at SMU's McFarlin Memorial Auditorium called *Sawdust and Sequins*. Much of the music and lyrics were written by Bob. Typical of Bob's generosity of spirit that has lasted for decades, the program included the following acknowledgement concerning Bob's directing style: "The present production could not have run so smoothly and amiably were it not for his [Bob's] patience, understanding and talent for every phase of the show."

At the end of his college days, World War II took center stage, and Bob served for three years on a U.S. Navy destroyer as a lieutenant (jg) assigned to sonar duties.

THE BIRTH OF TELEVISION ENTERTAINMENT

In 1946, Bob moved to Northwestern University to work on a master's degree and then a PhD in theater arts. He taught courses in speech and drama and worked at a local television station, WMAQ, as a production assistant on the children's show *Kukla, Fran, and Ollie*. This television station had fired up its broadcasts on Wednesday, September 1, 1948, placing Bob at the very birth of commercial television. At that time, many established radio and movie producers shied away from television, but Bob embraced the new medium.

The WMAQ television station soon recognized Banner's talent; he became director for the musical variety show *Garroway at Large*, starring Dave Garroway. Although it was a local show, NBC aired it on stations around the country, and Banner received his first national exposure. In December 1949, he was enticed by Fred Waring to produce and direct another new television show, *The Fred Waring Show*, in New York. (Waring, known as the "man who taught America to sing," had already made a household name for himself by hosting several successful radio programs.) The television show featured Waring's musical talents as well as dancing and comedy sketches. Although Banner had not yet finished his PhD, he responded to the call and moved to the Big Apple. While in New York, he also directed Alistair Cooke's *Omnibus*, a series that presented a relaxed reflection on the cultural, historical and artistic heritage of America and became a model for future PBS shows.

Eventually, the lure of Hollywood as the center of the television universe brought Banner to California in 1956, and he produced and directed the

Bob Banner with Loretta Young, accepting an Emmy. *Courtesy Bob Banner.*

Emmy award–winning *Dinah Shore Chevy Show*. ("See the U.S.A. in your Chevrolet.") In 1958, he formed Bob Banner Associates (BBA) and produced *The Garry Moore Show*, which won several Emmys and ran for 218 episodes. This show featured Carol Burnett (a San Antonio native), Durward Kirby, Candid Camera (with Allen Funt) and (my favorite segment) "That Wonderful Year," a nostalgic look back at the songs and memories of a bygone year. Bob placed this popular segment at the end of the show to

entice viewers to stay tuned, just in case one of the other acts in the show didn't exactly turn out as they expected. The song at the end of the segment also served as an opportunity to bring out the entire cast for a musical finale. (Unfortunately, since no one in those days ever thought there would be VCRs and DVDs, these episodes were not well preserved and were almost all lost to history.)

Smile, You're on *Candid Camera*

One of the segments on *The Garry Moore Show* that became a hit in its own right was *Candid Camera* (co-produced by Banner and Alan Funt). The show placed unsuspecting people in unusual circumstances to see how they would react. *Candid Camera* is often called the first television reality show, predating the *Survivor* series by decades.

One of Bob's favorite *Candid Camera* segments was the car without a motor. Bob's crew located several gasoline stations that were at the bottom of a hill so a car without a motor could be released and coast into the station. The crew timed the stunt so there were no other vehicles in the way at the station when the car was released. Petite and innocent-looking Dorothy Collins sat at the wheel.

At one of the stations, she steered the motor-less car into place next to the pump, and the attendant came out to help. She asked for gas and for him to check her oil. (This was during the days when an attendant filled the gas tank and checked under the hood.) The attendant dutifully opened the hood to the car and stared at the motor-less cavity. He turned away for a second and then looked again as if his eyes were playing tricks on him. He looked under the car, looked again at where the motor should be and had a look of disbelief on his face. Finally, he came around to the window where Dorothy was nonchalantly checking her grocery list. "Ma'am, you don't have a motor." It didn't faze her. "Oh, really?" The attendant looked puzzled. "How did you get here?" She replied innocently, "I drove, of course." The attendant went back to look under the hood and stared at the hole. He looked all around the front of the car to see if he could find the motor. Befuddled, he returned to Dorothy. "Ma'am, you don't have a motor." Dorothy (making the reply up on the spot) pleaded with him, holding back tears, "Please don't tell my husband, he'll be so upset."

It was too much for the fellow. He turned and walked into his office, holding his head between his hands, and sat down at his desk. The *Candid*

Camera crew thought the incident had been too much for the poor guy's brain, so they rushed in to console him, turning off the camera. The man was rattled but okay. From that time on, Bob made sure that the crew kept the camera going no matter what happened.

AMAZING TALENT

Banner produced an amazing variety of other shows, including *Salute to Jack Benny at Carnegie Hall* (which saved that treasured venue from demolition) and *Julie and Carol at Carnegie Hall* (which featured Julie Andrews and Carol Burnett and won three Emmy awards). Among the other familiar shows produced by Banner are *The Carol Burnett Show*, *The Jimmy Dean Show*, *The Don Ho Show*, *Almost Anything Goes* (hosted by a young Regis Philbin), *The Kraft Summer Music Hall*, *The Entertainers*, *Star Search* and *Showtime at the Apollo*. His productions also included a slew of Carol Burnett specials and over twenty-five on-site specials from around the world featuring stars such as Julie Andrews, Perry Como, Peggy Fleming, Greer Garson, Liberace, Ginger Rogers, Frank Sinatra and Andy Williams. Other shows and television movies produced by Banner are far too numerous to list.

Even after fifty years, he continued to produce outstanding programming. In 2001, he produced the show *Real Kids, Real Adventures* for the Discovery Channel based on the book series by fellow Texan Deborah Morris. It won an Emmy nomination for Outstanding Children's Series and an Award of Excellence from the L.A. Film Advisory Board.

An incredibly knowledgeable person, Bob shared his experiences and wisdom with countless students by teaching screenwriting and directing courses at Southern Methodist University and Northwestern University (both credit and community courses) for many years.

In 2003, the State of Texas recognized Bob Banner for his outstanding achievements with House Bill Number 519, which read, in part:

> *Though he has spent many years in Hollywood, Mr. Banner has always embraced his Texas roots, which he credits with inspiring and encouraging his appreciation for entertaining, and it is indeed appropriate that he receive special legislative recognition; now, therefore, be it RESOLVED, That the House of Representatives of the 78th Texas Legislature hereby commends Bob Banner on his many achievements in the field of television and extend to him sincere best wishes for continued success and happiness.*

Bob Banner accepted the award in Austin, Texas, along with his wife, Alice, and his niece Susan Bailey. Bob and his shows had been honored with nine Emmy awards, eight Christopher awards, four Peabody awards, five Awards of Excellence, a Golden Rose and many other deserved accolades.

Late in his career, Bob was honored at his alma mater, Ennis High School. He had come back to Ennis just as his old music teacher, Mr. Granger, had encouraged him to do—a success by any Hollywood or New York standard. Unfortunately, Mr. Granger died before he could see how he had changed Bob's life. At the ceremony, the band played the school song, "Maroon and White." Ever the professional, Bob noticed that even after all these years it still contained those last two lines that didn't quite rhyme. Bob Banner passed away on June 15, 2011, at the age of eighty-nine.

References

Gelman, Morrie. "Spotlight: Bob Banner." *Daily Variety*, January 26, 1993, 33+.

Texas Tidbit

Another innovative small-town Texan who hit the entertainment big time is Jamie Foxx, who was born and raised as Eric Marlon Bishop in Terrell. Jamie won an Oscar and a Golden Globe for this portrayal of Ray Charles in the movie *Ray*. He has also won a Grammy and has a star on the Hollywood Walk of Fame. In 2013, Jamie received MTV's Generation Award for his distinguished work in film, music and television.

TEXANS DRAWN TO ANIMATION

Talk about Texas innovation. Okay, don't talk about it; watch it on the big screen. A generation of Americans witnessed Tex Avery's zany humor on celluloid as he defined and redefined the Hollywood cartoon. Besides creating some of the most memorable cartoon characters, including Bugs Bunny, Daffy Duck, Porky Pig and Droopy Dog, he took the cartoon from being kids' eye candy and made it more irreverent and outlandish. From 1935 to 1955, he worked on 136 seven-minute cartoons that changed the way Americans speak ("What's up doc?," "Th-th-th-that's All, Folks," "Be vewy vewy quiet, I'm hunting wabbits," "Silly, isn't it?").

The town of Taylor, Texas, is located thirty-five miles northeast of Austin. With a downtown rich in historic buildings from the nineteenth century, it played host to the birth of Fredrick Bean "Tex" Avery in 1908. (It is also the home of actor Rip Torn, Governor Dan Moody and rodeo superstar Bill Pickett, who invented bulldogging and is described elsewhere in this book.) Avery was kin to Judge Roy Bean, one of the most colorful characters in Texas history, who held court sessions in his saloon along the Rio Grande. Avery also traced his heritage back to the American pioneer Daniel Boone. Perhaps as a result of this heritage, many of his cartoons were based on tall tales from Texas folklore.

The Averys moved to Dallas sometime during Tex's formative years, and he graduated from North Dallas High School in 1926 or '27. Soon after that, he hightailed it up to Illinois, where he learned a few things about drawing at the Chicago Art Institute before moving to Los Angeles.

Like most beginning artists, he had to starve for a while before he found his niche. He worked as a laborer on the docks and slept on the beach while he looked for a way to use his artistic talents. He couldn't sell his comic strip idea to the newspaper, but the cartoons he drew in the beach sand garnered him enough attention to get a job as an in-betweener (painting cartoon cels) in a minor cartoon shop. He went on to work for Walter Lantz (Woody Woodpecker, Andy Panda, Chilly Willy and Wally Walrus) for five years and then to Warner Brothers in 1935. At Warner Brothers, he worked under Leon Schlesinger and became a cartoon director.

What's Up, Tex?

Always a bit of a rascal, Tex was roughhousing with some of the other cartoonists one day when his life changed forever. A paper clip was poked into his eye during a tumble. The damage was severe, and he lost sight in that eye. Tex was devastated. This would mean the end of a career to many artists, but it made Tex more determined than ever to succeed. He developed a driving need to create the best, most popular, most original cartoons the theater had ever seen. (That's when cartoons were shown in movie theaters before the main feature.) To that end, he joined ranks with two other talented cartoonists, Chuck Jones and Bob Clampett, and created a stream of memorable characters that were designed to compete with Disney's popular cartoon characters.

However, unlike the often-sentimental Disney characters, Tex aimed to create irreverent, sarcastic and sexy characters who would be funny to kids while appealing to adult audiences. He constantly came up with new ways to surprise his audience by having cartoon characters comment on the cartoon itself, object to the plot of the cartoon they were in, speak directly to the audience, mock silhouettes of people in the audience coming or leaving (and have the cartoon characters interact with them) and have characters pop out of the credits at the end of the cartoon ("Th-th-th-that's All, Folks").

Red Hot Riding Hood

In 1941, Tex moved to MGM and tried to create some new characters (Screwy Squirrel) that weren't as popular as his earlier progeny. However, his sexy depictions of characters like Red Hot Riding Hood influenced future

cartoon characters like Jessica in *Who Framed Roger Rabbit?* For the soldiers on the field during World War II, Avery created popular cartoons such as the one titled *Swing Shift Cinderella*, where "Rosie the Riveter" during the day became a sexy pin-up girl at night as an entertainer at a local nightclub.

In the 1960s, Avery created another memorable character (for those old enough to remember) called the Frito Bandito ("I love Frito's Corn Chips, I take dem from you"), who was the spokesperson for another Texas original, the Frito corn snack. The character (voiced by Mel Blanc) proved to be very popular and appeared in numerous television ads. When a concern arose that the character was too stereotypical, it was dropped from the campaign, and the Bandito was retired to cartoon heaven.

Tex also ascended into cartoon heaven in 1980. His innovative cartoon style became a legend during his lifetime and influenced the development of many other cartoon characters in subsequent generations. And even though his original seven-minute cartoons were meant to be shown in movie theaters, they found new life on television in the 1960s and continue to be shown every day and every night somewhere in some corner of the globe.

ANIMATION ACCLIMATION

Texas is also the home to several other pioneering animators. Roddy Keitz and Tom Young of Dallas's Keitz & Herndon deserve mention. Keitz was an original partner in the firm, and Young joined the group in 1953. They soon became one of the most respected animation houses in Texas through projects such as developing creative techniques that were used in the original Apollo moon landing animation for American Broadcasting Company (ABC), creation of the first color commercial to air on WFAA-TV for Burleson Honey (which ran for ten years) and creation of the "Frito Kid" (not the Frito Bandito), used as a mascot for the corn chip company for many years.

K&H also produced and directed the *Jot* cartoon series for the Southern Baptist Radio-Television Commission. The *Jot* series was developed by Ruth Byers and Ted Perry, and the characters were designed by Roddy Keitz. It first aired in 1963 and ran for ten years on the Sunday morning program *The Children's Hour* in Dallas. It has been seen in nineteen different countries and has been translated into Arabic, Japanese, Korean and Spanish.

From a technical point of view, Roddy Keitz was the wizard of K&H. He fashioned the first animation stand in Dallas using an old lathe bed

A Jot Cartoon frame. *Courtesy Tom Young.*

mounted upright, with the camera mounted on the lathe table. A few years later, K&H installed the first Oxberry Animation Stand in Dallas. It also had the first computer-controlled animation camera system in the state and held several lead patents in the technology. For its innovation and expertise, K&H became known as the leading animation studio between the East and West Coasts.

K&H LEGACIES

Even though K&H shut down in 1987 when the last partner retired, it left an ongoing legacy. One of its employees was an up-and-coming animator named John Davis. Besides being a cameraman, John worked at the bleeding-edge arena of computer animation. K&H found computer animation too new and too expensive to be profitable. Therefore, when K&H closed its shop, John struck up a friendship with Keith Alcorn and set up a small studio in office space furnished by John's father to pursue the new technology. They named their company DNA Productions. The two grew their new company using 2D and 3D digital animation; they created a number of successful

commercials and animated shorts, including the Emmy-nominated *Olive the Other Reindeer* and *AJ's Time Travelers*. Their *Santa vs. The Snowman* was the first all-3D animated feature made for primetime (ABC) and won a Gold Award from the WorldFest-Houston International Film Festival. Davis created and directed the digitally animated and Oscar-nominated *Jimmy Neutron: Boy Genius* movie in 2001. During the production of *Neutron*, DNA Productions employed 250 people at the Las Colinas Studios.

K&H also provided the launching grounds for Guy Deel, who learned animation from Young and Keitz. He went on to become a visual development artist for both Disney and Don Bluth Studios on such films as *Oliver and Company*, *The Rescuers*, *The Lion King*, *Pocahontas*, *Fantasia 2000* and *Tarzan*. His enormous talent for illustration is evidenced by his illustrations for over 250 book jacket covers for most well-known western writers, as well as many assignments for Reader's Digest Books and the Franklin Mint. He also received several commissions for significant artwork, such as a 130-foot mural at the Gene Autry Western Heritage Museum in Los Angeles (Gene was the singing cowboy from Tioga, Texas) and a 7-foot historical painting in Irving, Texas, commemorating its centennial celebration in 2003.

Also from Dallas is the animator William "Tex" Henson (nicknamed for Tex Avery), who started as an artist for Disney and worked on such films as *Song of the South*, *Pecos Bill*, *Peter and the Wolf* and a number of *Chip and Dale* cartoons. After he left Disney, he worked on projects that included the *Casper the Friendly Ghost* series and the off-the-wall *Rocky & Bullwinkle* cartoons (including *Peabody's Improbable History*, *Dudley Do-Right* and *Fractured Fairy Tales*). For the *Rocky & Bullwinkle* series, he supervised a group of 180 animators in Mexico. He also worked in the Dallas K&H studios for ten years. After retiring, he taught animation for the Dallas Independent School District. Henson died in 2002 at the age of seventy-eight.

Another Texas animator who hit the big time is Mike Judge. Born in Ecuador and raised in New Mexico, he ended up in Texas and at last count lived in Austin. His creations include *Beavis and Butthead* (MTV), for which he voiced most of the characters, and *King of the Hill*, which takes place in Arlen, Texas (sounds like Garland), and tells the story of a conservative God-fearing family as they wrestle with the challenges of modern life. He also wrote and directed *Office Space* (filmed in Las Colinas), in which he played the role of the manager in the Chotchkie's restaurant.

References

Adamson, Joe. *King of Cartoons*. New York: DaCapo Press, 1985.

Canemaker, John. *Tex Avery: The MGM Years (1942–1945)*. Kansas City, MO: Turner Publishing, 1996.

Scott, Keith. *The Moose that Roared*. New York: St. Martin's Griffen, 2001.

Texas Tidbit

A Guy Deel painting hangs in the gallery of the American Adventure pavilion at Walt Disney World Epcot Center, Orlando, Florida.

Texas Tidbit

Don Bluth, animator and creator of *All Dogs Go to Heaven*, *The Secret of NIMH*, *An American Tail* and other full-length animated moves, was born in El Paso in 1937.

TEXAS MUSIC LEGENDS

Few states have enjoyed the diversity of music found in Texas. Fewer still have influenced the world of music as much as the talented offspring of the Lone Star State. For the past hundred years, the cream of the crop from every style of music—including country, swing, rag, jazz, rock and even classical—came from Texas roots. This brief overview highlights the careers of a handful of Texas music masters. Following this tour of Texas music history, several longer biographies explore the careers of seven Texans in seven different musical genres who created or influenced the development of a new style of music that had a national (and sometimes global) impact. These biographies include Bob Wills (western swing), Buddy Holly (rock-and-roll), Willie Nelson (progressive country), Stevie Ray Vaughan (blues), Scott Joplin (ragtime), Selena (Tejano) and Van Cliburn (classical). Before looking at the lives of these seven individuals, a quick look at the development of musical styles in Texas will set the stage for understanding how each of them impacted his or her particular musical field.

Early American folk music arrived in Texas with the settlers of the Austin colony in the 1830s when Stephen F. Austin lured thousands of American settlers into the new Texas territory. When these frontier Americans arrived in the Mexican state of Texas, they found a culture that blended the ruling Spanish old-world heritage with American individualism. This blend of diverse cultures created something new in the world of music. The additional influx of African American slaves brought a third type of music into Texas. As Texas struggled through its brief existence as a republic

and its entry into the United States, other ethnic peoples settled in the state, including a large number of Germans and Czechoslovakians.

From these groups of people came cowboys, and from the cowboys came cowboy songs. The earliest of these songs were adaptations of English, Scottish and Irish melodies. Reborn on the Texas prairie, the subject matter of the music changed to reflect the experiences on the range. These tunes further mixed with slave songs of the South and ethnic folk songs. This new type of music resulted in several nationally popular songs that included "Bury Me Not on the Lone Prairie" and "Home on the Range."

With the advent of radio in the 1920s, specific cowboy singers gained popularity as radio brought cowboy music into homes across America. The first singing cowboy superstar, Gene Autry, was born near Tioga, Texas, in 1907. He bought his first guitar at age twelve from the Sears catalogue and taught himself to play by mimicking the folks on that newfangled radio. In 1927, while Gene practiced his guitar and singing in an Oklahoma telegraph office, Will Rogers overheard him and told him he should be on the radio. He took Rogers's advice and, in 1928, started out on Tulsa's KVOO, billed as "Oklahoma's Yodeling Cowboy." With a little experience and popularity under his belt, he moved on to *That National Barn Dance* on the larger WLS station in Chicago and, from the additional national exposure, landed a role in a Hollywood movie in 1934.

A success both on the screen and as a musician, Gene recorded more than six hundred songs and sold over 100 million records. His most famous recordings (still played today) include "Back in the Saddle Again," "Here Comes Santa Claus" (which was inspired by the Macy's parade), "Tumbling Tumbleweeds" and the wildly successful "Rudolph the Red-Nosed Reindeer" (which he recorded in one take). He appeared in ninety-three movies and on countless television and radio programs. As America's favorite "singing cowboy," he created the early clean-cut, honest-as-the-day-is-long cowpoke stereotype in American culture. A longtime fan of baseball, Autry bought the Los Angeles Angels, the American League franchise in Anaheim, California, in 1960. Some thirty-five years later, he sold the team to the Walt Disney Company. Autry is memorialized at the Gene Autry Oklahoma Museum in Gene Autry, Oklahoma; at the Autry National Center in Los Angeles; and, in 1962, was inducted into the Hall of Great Western Performers of the National Cowboy and Western Heritage Museum in Oklahoma City.

Another early singing cowboy, Tex Ritter (born in 1905), grew up in Nederland. While attending college at the University of Texas in Austin, he learned musical performance from joining the men's glee club (popular back

in those days). After college, he landed a job as a singer at KPRC radio in Houston in 1929, moved to New York in 1931 and (like Gene Autry) used his national exposure as a springboard into Hollywood as a "singing cowboy." He appeared in his first of eighty-five movies, *Song of the Gringo*, in 1936 and became a movie star. Singing more of a raw western folk song than Gene Autry, Ritter's hits included "I'm Wastin' My Tears on You"; "High Noon (Do Not Forsake Me, Oh My Darling)," which received an Oscar for Best Song in 1953 for the movie *High Noon*; "Boll Weevil"; and "Deck of Cards." The Tex Ritter Museum is located within the Texas Country Music Hall of Fame in Carthage. In 1980, he was inducted into the Hall of Great Western Performers of the National Cowboy and Western Heritage Museum in Oklahoma City.

Other early country music stars include Vernon Dalhart (born Marion Try Slaughter the Second) from Jefferson, who recorded 1,600 songs from 1916 to 1939 and coined his stage name from two Texas cities; and Texas transplant Jimmie Rodgers (the Singing Brakeman). This type of country music, popular in Texas in the 1920s, also went by the names hillbilly or string band music. Unlike the fancy singing cowboys in the movies, these performers often dressed in farm overalls and exuded a kind of bumpkin persona.

Not everyone liked that image.

Bob Wills didn't like it at all. He took Texas country music on a new and different path. By blending country with jazz and ethnic sounds and by adding fiddles and drums to the mix, he created a happy, lively, danceable type of music called western swing. (See the upcoming story titled "Bob Wills Swings Texas.")

From elements of Bob Wills's western swing came several new types of Texas music. Honky-tonk music took the lighthearted swing and made it coarser, with harder subjects like drinking, cheating and fighting. Al Dexter's "Pistol Packin' Mama" is an early honky-tonk hit. Other popular Texas honky-tonk musicians included Ray Price, Ernest Tubb, Jim Reeves and Lefty Frizzell.

Price, born near Perryville in 1926, split his time growing up between a father who lived in the country and a mother who lived in Dallas. After a stint in the U.S. Marines, he entered the North Texas Agricultural College (now the University of Texas at Arlington). At night, he started singing in local coffeehouses and met with some success. In 1950, he recorded his first song, which led to a regular spot on *KRLD's Big D Jamboree*. Two of his most popular songs were "Release Me" and "Crazy Arms." He entered the Country Music Hall of Fame in 1996.

Ernest Tubb (known as E.T. to his friends) hailed from Crisp, Texas, in Ellis County, born in 1914. A fan of Jimmie Rodgers, Tubb learned to play the guitar and sing by mimicking his hero. After Rodgers died in 1936, Ernest met his widow, and she offered valuable advice on how to promote his career. By 1940, he was a full-time musician and had his first big-time hit in 1941, "Walking the Floor Over You," considered by some to be the first true honky-tonk song. By 1943, he and his band, the Texas Troubadours, were regulars at the Grand Ole Opry in Nashville, Tennessee. Over the years, Tubb helped promote the careers of other musicians such as Hank Williams, Patsy Cline and Loretta Lynn.

The soothing, warm voice of Jim Reeves was born in Panola County in 1923. After showing an early fascination with music, he learned enough to start singing at local dances by the age of twelve and soon earned enough of a reputation to appear on KRMD radio in nearby Shreveport. He attended the University of Texas in Austin and played minor-league baseball until a leg injury forced him to quit. Falling back on his musical talents, he went back to radio and recorded his first song in 1949. His recording of "He'll Have to Go" in 1959 became his greatest hit. Other hits included "Four Walls" and "Bimbo." Sadly, he died in a plane crash in 1964.

William Orville "Lefty" Frizzell, born in 1928, grew up in Corsicana. Like his contemporaries, he showed an interest in music at an early age and started playing in a band while still in high school. At nineteen, he appeared regularly on a thirty-minute radio show, and within a few years, he had recorded a string of hits, including "If You've Got the Money, Honey," "Always Late" and "Saginaw, Michigan." Often called the definitive honky-tonk singer, Frizzell is credited with bringing that style into the mainstream of American music. A museum dedicated to Frizzell is located in Pioneer Village in Corsicana.

Charlie Frank Pride, born in Sledge, Mississippi, in 1938, currently makes his home in Dallas. He started his career in the Negro Baseball League and successfully transitioned to country music, where he became by far the most celebrated African American country music artist. He had dozens of number-one hits, including "Kiss an Angel Good Morning" and "Is Anybody Goin' to San Antone?"

In a break from the country music of the 1960s, a new style called progressive country got its start in Austin at a club called the Armadillo World Headquarters with Willie Nelson heading up the charge (see the story titled "Smokin' Willie"). This new style of country music included

stars such as Waylon Jennings, Michael Martin Murphy, Kris Kristofferson, Mickey Gilley, Kinky Friedman and others.

Waylon Arnold Jennings started his life in Littlefield in 1937. He found a job as a DJ near his hometown before he hit the teenage years, and by 1958, he had landed a job as a DJ in Lubbock. He teamed up with Buddy Holly and joined the Crickets at the dawn of rock-and-roll. In the 1959 plane crash that killed Holly, Jennings would have died, too, but he had given up his seat to the Big Bopper ("Chantilly Lace"). The shaken Jennings switched to country music after that and moved to Nashville, where he became a successful songwriter and performer. By the early '70s, he'd grown tired of Nashville and looked for a new venue. He joined Willie Nelson in Austin, and his 1976–77 hits "Luckenbach, Texas" and "Mamas Don't Let Your Babies Grow Up to Be Cowboys" catapulted him to national fame.

One of many musicians who grew up in the Oak Cliff part of Dallas, Michael Martin Murphy found a home in Austin's progressive country movement. He first made a name for himself in Nashville as a songwriter cranking out tunes that were recorded by the country capital's elite. A more refined sound than Jennings, Murphy's biggest hit was "Wildfire." Kris Kristofferson grew up in Brownsville, became a Rhodes scholar and wanted to be a novelist but ended up in Nashville instead, writing songs like "Help Me Make It Through the Night." He had a few successful albums in the '70s and then turned to acting. Kinky Friedman existed on the edge of the Austin scene. His often outrageous songs played with his Jewish heritage in songs like "They Aren't Making Jews Like Jesus Anymore." Other contributors to the movement included Ray Wiley Hubbard ("Up Against the Wall, Redneck Mother") Jerry Jeff Walker ("Mr. Bo Jangles"), Billy Joe Shaver, Steve Fromholz, B.W. Stevenson and others.

Sing across Texas with Me

Young country followed the progressive movement with stars that included Kenny Rogers, Barbara Mandrell, the Gatlin Brothers and Tanya Tucker. A Houston native, Rogers led the pack. After singing folk music with the New Christy Minstrels and rock with the First Edition, Rogers turned to country in 1977 with the hit "Lucille." He scored a number of times in the charts and also became notable as an actor. Another Houston product, Barbara Mandrell, presented a sophisticated image to the young country set. Her 1984 hit "I Was Country When Country Wasn't Cool" made her a

household name. Other Texans and adopted Texans who have contributed to young country (and related genres) include Don Williams, Janie Fricke, Lyle Lovett, Johnny Lee and Lee Ann Rimes.

Another branch that evolved from Bob Wills's western swing style was Texas rock-and-roll. Wills's was one of the first bands to include drums and play with a steady dance beat. That concept appealed to a youngster named Buddy Holly in Lubbock, and combining that with the pizzazz of Elvis Presley, Holly came up with a new type of four-man musical group that would influence the fledgling rock-and-roll scene for decades to come. Other early Texas rockers include the Big Bopper (born J.P. Richardson), Roy Orbison ("Pretty Woman"), Johnny Preston ("Running Bear," written by the Big Bopper) and Pat Boone (a descendant of Daniel Boone with hits such as "Love Letters in the Sand" and "April Love"). Following the transition of music after the 1960s Beatles invasion, Texans who continued to score in the rock world included Domingo Samudio, aka Sam the Sham ("Wooly Bully"); Michael Nesmith of the Monkees (whose mother invented Liquid Paper); Steve Miller; the unforgettable (and sometimes incomprehensible) Janis Joplin; and ZZ Top. (See the story "Buddy Holly" for more information on Buddy Holly.)

Port Arthur's Janis Joplin grew up in a nice middle-class home. Some biographies claim that she thought of herself as ugly and, because she didn't fit in with the popular crowd, started hanging around with guys whom your momma would call "the scum at the bottom of the barrel."

After high school, a brief move to California put her in touch with the hippie crowd, and Janis found her niche. She returned to Texas and became a regular and popular singer in Austin bars and nightclubs. In 1964, after a UT prankster dubbed her the "Ugliest Man on Campus," she picked up her guitar and headed back to California. There in the stew-pot of hippie culture, she hooked up with a band called Big Brother and the Holding Company and had become a counterculture rock star by 1967 during the "Summer of Love." Her gruff but enthralling voice along with her music's sex- and drug-filled messages appealed to the counterculture youth of the day and made her a memorable rock icon.

The tentative title for her second album was *Sex, Dope and Cheap Thrills*. The title epitomized Janis's lifestyle but was shortened to *Cheap Thrills* for marketing purposes. Her greatest hits included "Me and Bobby McGee" and "Mercedes Benz," with the oft quoted lyric "Oh, Lord, won't you buy me a Mercedes Benz? My friends all drive Porsches, I must make amends." Frequently associated with the feminist movement of the era, many young

women of the '60s loved how Janis made hippie attire okay to wear (instead of girdles and party dresses). Because of her radical message and lifestyle, she was sometimes called the female Bob Dylan. However, she met a more unfortunate fate, dying from a drug overdose in 1970.

One of the greatest influences on the evolution of country music was the sound of African American music at the turn of the twentieth century. One of the most appealing sounds that early country musicians heard in Texas honky-tonks was ragtime and jazz.

The success and influence of ragtime music is due in large part to the talent and determination of an innovative Texan (born in Texarkana) named Scott Joplin. Although he didn't invent ragtime, Joplin rose to the title of undisputed master of the ragtime art. (See the story "From Rags to Ragtime for Scott Joplin" for more information.) This syncopated music, mostly played by black musicians at the time, led to the creation of New Orleans jazz. Specifically, historians believe that Joplin's ragtime influenced Jelly Roll Morton's "invention" of New Orleans jazz in 1902.

Another African American Texan who influenced an entire music genre is Blind Lemon Jefferson, born in Freestone County about 1897. He started his musical career in East Texas and made his way in 1917 to Dallas's Deep Ellum. His unique singing style led to the emergence of a type of music called the blues. Jefferson recorded over one hundred songs with Paramount Records in the 1920s and '30s, and his popularity opened the way for many other up-and-coming blues artists. Other Texans who contributed to the development of jazz and blues included Leadbelly (King of the Twelve-String Guitar) and four pioneer Texas female jazz singers: Beulah T. (Sippie) Wallace, Victoria R. Spivey, Hociel Thomas and Maggie Jones.

One of Blind Lemon Jefferson's disciples was a young man from Dallas nicknamed T-Bone Walker. Born Aaron Thibeaux Walker in 1917, as a teenager T-Bone (the nickname came from his mother's version of his middle name) was given the job of escorting Jefferson around Dallas. Inspired (as were so many others) by Jefferson, Walker recorded his first album, *Wichita Falls Blues*, in 1929 as Oak Cliff T-Bone Walker. T-Bone's influence came when he switched to electric guitar in 1935. He made blues sing like no one had done before and became known as the "Daddy of the Blues." Another blues guitarist from Oak Cliff, Stevie Ray Vaughan, followed in T-Bone's footsteps some years later and influenced a new generation of blues guitarists. (See the story "Stevie, Rock On!" for more information on SRV.)

Tejano music evolved from Mexican and other folk music blended with a polka rhythm. Sometimes called *conjunto* or "Tex-Mex" music,

early purveyors often pumped out the beat of these toe-tapping tunes on the two-row button accordion. Pioneer Tejano stars included Narciso Martínez, Don Santiago Jimenez Sr. (*El Flaco*, the Skinny One), Tony de la Rosa, Paulino Bernal and Estaban Jordán. Modern Tejano music traces its beginnings to "Little" Joe Hernandez of Temple. However, it wasn't until the life and death of Selena Quintanilla-Perez that Tejano music rocketed into the mainstream of American music history. (See the story "Queen Selena" for more about Selena.)

Other Hispanic artists include Trini Lopez and Freddie Fender. Lopez was born in 1937 in Dallas and recorded with Frank Sinatra's Reprise Records. His hits included "If I Had a Hammer" in 1963 and "Lemon Tree" in 1965. He also appeared in the movie *The Dirty Dozen* in 1967. Fender was born in San Benito in 1938 and had some success in recording Spanish versions of several pop songs. He had his own hit in 1974 with "Before the Next Teardrop Falls" and went on to record other hits, including "Secret Love" and "You'll Lose a Good Thing." He was inducted into the Tejano Music Hall of Fame in 1987.

Classical music is a transplant into Texas. The upcoming story "Bach to Texas" shows how classical and fine arts music has had an influence on Texas and has itself been influenced by Texans, particularly by Van Cliburn.

This brief history of Texas music touches on the highlights of the great music heritage in Texas. From the Czech and German folk songs to inspiring gospel and contemporary Christian music, there are many other branches of Texas music that could be explored. To learn more about other genres of Texas music, please refer to the following references.

The following biographies tell the stories of seven Texas musicians who rocked the music world: Bob Wills, Buddy Holly, Willie Nelson, Stevie Ray Vaughan, Scott Joplin, Selena and Van Cliburn. For more information, check out the www.txstate.edu/ctmh website.

References

Barkley, Roy R., ed. *The Handbook of Texas Music*. Austin: Texas State Historical Association, 2003.

Corcoran, Michael. *All Over the Map: True Heroes of Texas Music*. Austin: University of Texas Press, 2005.

Koster, Rick. *Texas Music*. New York: St. Martin's Press, 2000.

Whitburn, Joel. *Billboard's Top Pop Singles, 1955–2002.* 10th ed. Menomonee Falls, WI: Record Research Inc., 2004.

————. *Joel Whitburn's Pop Hits, 1940–1954: Singles and Albums.* 2nd ed. Menomonee Falls, WI: Record Research Inc., 2002.

Texas Tidbit

The Texas Jazz Festival began in Corpus Christi in 1959 and takes place every October. The North Texas Jazz Festival happens in March each year, sponsored by the University of North Texas.

Texas Tidbit

Waylon Jennings wrote the title song, "Good Ol' Boys," for the TV series *Dukes of Hazzard*, which first aired in 1979. The song rose to number twenty-one on the charts in 1980.

BOB WILLS AND THE TEXAS PLAYBOYS

The music of Bob Wills grew out of the heart of Texas. Born in 1905 and raised in the farmland around Kosse (south of Groesbeck), young James Robert "Jim Rob" Wills was the first of ten children born to John and Emma Wills. Young Wills worked around African Americans in the fields as they sang work songs and ballads. At night, he heard jazz, blues and frontier fiddle music at the local bar. Music of Texans like Scott Joplin, Blind Lemon Jefferson, Bessie Smith and Victoria Spivey filled his head with a luring beat. His father played fiddle, and Jim Rob picked up the craft by the age of ten. Young Jim sometimes substituted at nightclubs when his father was too drunk to play.

By the age of seventeen, Jim Rob sought his fortune in the world. He attended barber college and worked as an insurance salesman, a preacher and a laborer. At night, he looked for places to play music. At the age of twenty-four (and now calling himself Bob Wills), he joined up with Fort Worth guitarist Herman Arnspinger and recorded songs with names like "Gulf Coast Blues" and "Wills Breakdown" on the Brunswick label (now lost to history). Adding a singer and another guitarist (brothers Milton and

Left: Bob Wills. *Courtesy Charles R. Townsend, San Antonio Rose: The Life and Music of Bob Wills (Urbana: University of Illinois Press, 1976).*

Below: Bob Wills and his Texas Playboys. *Courtesy Charles R. Townsend,* San Antonio Rose: The Life and Music of Bob Wills *(Urbana: University of Illinois Press, 1976).*

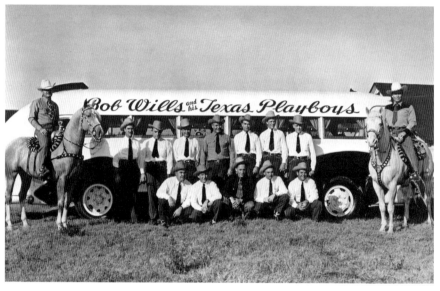

Derwood Brown) to the mix, he formed a group called the Laddies. They were featured on Fort Worth's WBAP radio. After tenor banjoist Sleepy Johnson joined the group in 1930, Burrus Mill executive W. Lee O'Daniel hired the band to promote Light Crust Flour on KFJZ and WBAP radio stations. Thus, the "Lightcrust Doughboys" were born.

Although the Doughboys continue on to this day, Wills left them within a few years to form his own band, the Playboys. They found a home at KVOO in Tulsa, Oklahoma, on a popular daily 12:30 p.m. radio spot, where they soon became the premier band of the Southwest.

Bob had Texas class. While other country players of his day were seen as guitar pickin' farmboy hicks, he wanted to dress up nice and produce a more

sophisticated sound. To that end, he not only dressed up his band, but he also added reeds, horns, drums and an electric guitar, eventually ending up with sixteen members (the number varied year to year). And the band didn't stick with western music; it could play any number of popular styles of the late 1930s. Bob said of his band, "We're hep!" His band recorded under the ARC, Vocalion, OKeh and Columbia labels, hitting the big time with the popular "San Antonio Rose." Somewhere along that time, he also changed the name of the group to the Texas Playboys.

Bob Wills didn't start out to create some new musical genre. He wanted nothing less than to have the best dance band in America. That meant that the music he played had to be happy, toe-tapping and downright danceable. Borrowing from a number of musical styles, Wills pulled together Dixieland jazz, blues, big-band sounds and folk music to create something new. The Bob Wills sound was not the same old music played by a great dance band. Bob Wills created a new form of music that became known as western swing.

For a while, World War II broke up the band, and Bob served a brief hitch as a soldier. After his discharge, he landed in California and started up his band again. The time after the war saw many of the 1930s and '40s era's bands fade from popularity as new sounds took over the market, but Wills kept singing and selling records.

Ah-Ha!

Bob's enthusiasm for his craft drove the Texas Playboys forward through the times when others gave up. Conducting with his fiddle bow, his band played anything and everything that people on the dance floor wanted to hear. Ever the showman, Bob never failed to entertain his audiences. Throughout his concerts, he would call out in a gleeful voice phrases such as "Ah-ha!" and "All right!" These spirited comments became a trademark of his music, and a Bob Wills tune wouldn't be the same without them. Wills often used these cheerful asides on the radio to tell listeners about the band with comments like, "That's Herbie Remington on the steel guitar. All right, Herbie!" His longtime lead singer, Tommy Duncan, provided a smooth voice that became another integral part of the Playboys' success. Together, Tommy and Bob put on a show guaranteed to turn any sourpuss into a purring (and dancing) cat.

In 1945, Bob played at the premier country venue, the Grand Ole Opry. At that time, country bands never had drummers. In Wills's band, the

drummer provided a vital part of the mix. That innovation (which seems natural now) caused enough of an uproar with the folks at the Opry that he was asked to leave the drums out of his act. After some negotiations, they reluctantly agreed that he could use the drums but only if they stayed out of sight behind the back stage curtain. When Bob waltzed out onto the stage, he called out to his drummer, "Move those things out here on stage." Then and there, he created a new sensation in country music. (But he never received another invitation to play at the Opry.)

The legacy of Bob Wills stretches beyond country and western music. His use of drums in his band and his emphasis on dance music with a beat were direct forerunners of rock-and-roll. Chuck Berry's 1955 hit song "Maybelline" is an adaptation of a Wills song called "Ida Red." A young Buddy Holly found inspiration in western swing and created a smaller four-man band (with a drummer) during the early days of rock-and-roll. (Rock-and-roll singers like Elvis didn't have bands at that time.) When Buddy Holly toured England with his innovative four-man band, it inspired a certain pair of young lads named John and Paul to create the Beatles. Other "British Invasion" musicians of the mid-'60s agree that their entire form of music would never have happened had it not been for the influence of Buddy Holly (who had been influenced by Bob Wills).

Bob Wills and his Texas Playboys continued to play throughout the '50s but sputtered in the '60s and finally broke up in 1967. Wills was elected to the Country Music Hall of Fame in 1968. Other than Gene Autry, he is the only person to have also been inducted into the National Cowboy Hall of Fame in Oklahoma City. In 1969, the Texas legislature honored Wills for his contribution to American music. In 1973, Wills won a Grammy award from the National Academy of Recording Arts and Sciences for the album *For the Last Time: Bob Wills and His Texas Playboys*. Bob Wills, the innovator and the "King of Western Swing," died in 1975.

The Bob Wills Legacy

In 1988, the Oklahoma state legislature adopted one of Wills's songs, "Faded Love," as the state's official country and western song. In 1999, Wills's contributions to rock-and-roll were recognized by his induction to the Rock and Roll Hall of Fame, which stated that "rock and roll's freewheeling spirit of stylistic recombination has antecedents in the work of Bob Wills and His

Texas Playboys." An album released in 2000 by Asleep at the Wheel (with fourteen different artists contributing) is titled *A Tribute to the Music of Bob Wills & the Texas Playboys*.

When in Turkey, Texas (southeast of Amarillo), pay a visit to the Bob Wills Museum on Sixth and Lyles Streets. Managed by the Wills family, it contains exhibits and photographs of Bob's career, including family mementos, fiddles, clothes and awards. The museum hours are Monday through Friday, 9:00 a.m. to 11:30 p.m., and 1:00 p.m. to 5:00 p.m. or by special appointment. For more information, call 806-423-1253 or 806-423-1033.

There is also a Bob Wills Day Festival in Turkey every year (in April/May), where you can hear your fill of western swing from a number of bands (often), including some of the musicians who were in Bob's original bands. The celebration is organized by a volunteer organization. For more information, call 806-423-1253.

References

Hurt, H. Ed. *Bob Wills: His Life, Times, Music*. Bloomington, IN: Authorhouse, 2000.

Sheldon, Ruth. *Bob Wills: Hubbin' It*. Nashville, TN: Country Music Foundation, 1995.

Strickland, Al. *My Years with Bob Wills*. Austin, TX: Eakin Press, 1996.

Townsend, Charles. *San Antonio Rose: The Life and Music of Bob Wills*. Urbana: University of Illinois Press, 1986.

Wills, Rosetta. *The King of Western Swing: Bob Wills*. New York: Watson-Guptill Publications, 1998.

Texas Tidbit

In the recording of his final album, *For the Last Time*, in 1973, Bob Wills's actual voice only appears on a few tracks. He had a stroke during the production and never recovered. His musicians completed the album, and Hoyle Nix used his own voice to add Bob's famous "ah-ha's" during the songs.

Texas Tidbit

Look for the image of the legendary Bob Wills in unexpected places. In Lucky's Café on Oak Lawn in Dallas (3531 Oak Lawn), there are several large and colorful pictures of Bob staring down at the restaurant patrons.

BUDDY HOLLY AND THE CRICKETS

Sir Paul McCartney once commented that the first forty songs he and John Lennon wrote for the Beatles were inspired by Buddy Holly. They had gone to see him when he performed in London and immediately went back to their homes and spent hours and hours trying to mimic Holly's guitar playing and singing style. It was also the first time they saw a four-person configuration for a rock group. Not only did they model their new group after this setup, but they also patterned their name, "the Beatles," on Holly's group, "the Crickets." It is clear that without the influence of this West Texan on the Liverpool Four, there might never have been any Beatles or British Invasion of the '60s.

The Holley family took music seriously.

Charles Hardin Holley (better known as Buddy Holly; the change of the spelling of Buddy's last name from Holley to Holly came about as a result of a misspelling on a contract he signed) appeared on the scene on September 17, 1936; as the last of four children, his parents expected him to learn music like all the other children. They only needed to discover what he could play well. Buddy started with the violin at five. He entered a local Lubbock contest with his older brothers and won five dollars playing "Down the River of Memories." But Buddy's performance didn't come up to par, and the brothers soon dropped him from the group. Buddy kept trying for a while, but he didn't have the knack for the fiddle.

He switched to piano lessons at age eight and didn't do much better. For the third time, he tried something new. He took lessons for the steel guitar. That didn't work out either. Finally, he picked up an acoustic guitar and taught himself to play. This time, magic happened.

At thirteen, Buddy joined up with a school friend, Bob Montgomery, and formed a country music duo. "Buddy and Bob" were good enough to be featured on some local radio stations in the Lubbock area, including KDAV, which happened to be America's first all-country radio station.

A few years later, the duo became a trio with the addition of a bass player, Larry Welborn. They got gigs as opening acts for some well-

known country artists performing in Lubbock. After opening for Elvis Presley and seeing loose hips in action, Buddy knew he wanted to play that new sound called rock-and-roll. When Buddy's trio opened for Bill Hailey, an agent named Eddie Crandall liked what he saw and signed Buddy to a recording contract with Decca Records. In 1956, Buddy (without Bob or Larry) recorded several country songs that were released but failed to pick up steam. As a result, Decca dropped Buddy from the contract.

That'll Be the Day

Buddy regrouped by partnering with Don Guess playing bass and Jerry Allison playing drums. Blending influence from the old Bob Wills style and the new Elvis pizzazz, they recorded the song "That'll Be the Day" on Brunswick Records (the phrase, by the way, was taken from a John Wayne quote in the movie *The Searchers*). This time, his record hit the charts and became a worldwide hit. In 1957, another transition took place with the group. Niki Sullivan came on board as rhythm guitar and Joe B. Mauldin replaced Don Guess on bass. Jerry Allison remained as drummer. Using the four-man configuration, the group, now called the Crickets, recorded their first album at the Clovis, New Mexico studio owned by Norman Petty. The album, named *The Chirping Crickets*, included the hits "Oh Boy," "That'll Be the Day" and "Maybe Baby."

In early 1958, with success under his belt, he teamed up with other up-and-coming rock stars Paul Anka and Jerry Lee Lewis and toured Australia, playing at Sydney Stadium, Brisbane and Melbourne. The next month, he toured Britain and Wales and performed twenty-six times in thirty days. It was on this trip that Paul McCartney and John Lennon got their glimpse of the man who would change their lives and was already changing the sound of rock-and-roll. After the European trip, Tommy Allsup replaced Niki Sullivan on guitar.

Back in the United States, the Crickets appeared on *American Bandstand*, *The Arthur Murray Dance Party* and *The Ed Sullivan Show*.

The rising star of Buddy Holly seemed to have no end; however, his relationship with the Crickets ended abruptly. After his quick whirlwind marriage to Maria Elena Santiago in 1959 (after only one date), he split from the Crickets (who continued to record without him) and went out on a new tour with other young rock-and-roll artists, including Richie Valens,

Buddy Holly statue in Lubbock. *Photo by author.*

Waylon Jennings, J.P. Richardson (the Big Bopper), Dion and the Belmonts, Tommy Allsup and Charles Brunch.

On February 2, 1959, the troupe performed in Clear Lake, Iowa, for an evening billed as "The Winter Dance Party Tour." After the concert, the snow swirled in the bone-chilling winter wind. A rented tour bus waited to take the performers to their next show 430 miles away, but Buddy, tired of bus travel in the cold weather, chartered a plane to fly him and a few of his friends to the next stop. On that fateful night, Holly, Valens, Richardson and the pilot, Roger Peterson, took off in the stormy weather. Only 8 miles into the flight, the plane dove toward the ground. A wing hit the ground, and the plane corkscrewed over and over. All aboard were killed.

In Holly's short-lived career, from 1957 to 1959, he changed rock music forever. His innovative use of a four-man group that included a lead and bass guitar as well as drums set a standard for hundreds of groups to come. His top hits, either solo or with the Crickets, were "That'll Be the Day," "Peggy Sue," "Rave On," "Oh Boy," "Maybe Baby," "It's So Easy," "Think It Over," "Everyday," "Words of Love," "Not Fade Away" and "True Love Ways." Many of these are still played on oldies radio stations today.

The Buddy Holly Legacy

Besides the accolades given Buddy Holly by the Beatles, this musically innovative and original Texan influenced a number of other rock artists, including the Rolling Stones, Bob Dylan and many others. Paul McCartney said of Buddy Holly, "It all came out of this idea of three chords; a group standing up there playing your instruments.…You can see echoes of Buddy Holly and The Crickets in The Beatles." Keith Richards of the Rolling Stones said of his legacy, "Holly passed it on via the Beatles and via us. He's in everybody.…This isn't bad for a guy from Lubbock, right?" Jerry Allison of the Crickets once said about one of Paul McCartney's comments,

"When someone like Paul McCartney says 'If it wasn't for the Crickets, there wouldn't be any Beatles,' I say, 'Excuse me? I'd like to hear that again!'"

Over ten years after Buddy's death, in 1971, Don McLean recorded "American Pie" as a tribute to Buddy Holly and his impact on rock music. Recalling the bleak February day of the plane crash, he penned the lyrics (copyrighted by Don McLean) that said (paraphrased) that he couldn't remember if he cried when he heard about the "widowed bride" and that something touched him "deep inside" on the day "the music died."

Since his death, over forty million Buddy Holly songs have been sold, and they keep on selling. The movie *The Buddy Holly Story* came to the screen in 1978, promoting a revival of his popularity. His hometown finally got the message and, in 1979, erected a bronze statue of its most famous son at Buddy Holly Plaza. The statue is located in front of the Lubbock Memorial Civic Center at Eighth and Avenue Q (U.S. 84). In 1986, Buddy Holly was in the first class inducted into the Rock and Roll Hall of Fame in Cleveland. In 1990, *Buddy*, a musical play, opened in London and later played on Broadway in New York.

In 1997, Lubbock opened the Buddy Holly Center in the historic Lubbock Train Depot. It contains memorabilia from Buddy's life, including a documentary film, and artifacts from rock history. Appropriately, the gallery is shaped like a guitar. It is located at 1801 Avenue G in downtown Lubbock. It's a little hard to find, but here are some directions. From I-27, take the Nineteenth Street exit west. The center is located on the northeast corner of Nineteenth Street and Avenue G. Hours are Tuesday through Friday, from 10:00 a.m. to 6:00 p.m., and Saturday, 11:00 a.m. to 6:00 p.m. The center is closed on Sunday and Monday.

Tours at the Buddy Holly Center are available for groups of twenty or more. Call the center at 806-767-2686 to schedule group tours. For the latest information, go to the www.mylubbock.us website and look under the visitors menu.

References

Mann, Alan. *The A-Z of Buddy Holly*. New York: Music Mentor, 2009.

Norman, Phillip. *Rave On: The Biography of Buddy Holly*. New York: Simon & Schuster, 1996.

Spence, Richard. *The Real Buddy Holly Story*. West Long Branch, NJ: White Star, 2004. DVD.

Texas Tidbit

In the front row of the Winter Dance Party on January 31, 1959, in Duluth sat a young Bob Dylan, enthralled at Holly's performance. That night as he watched Holly, Dylan imitated Buddy's every move and sound. After Buddy's death, Dylan put his musical career on fast-forward and never looked back.

SMOKIN' WILLIE NELSON

Don't confuse Texas with Nashville. Not only are they miles apart, they are worlds apart. In Nashville, country music is governed by a strong corporate business model (some performers lovingly refer to it as the "Nashville Mafia"), while in Texas, country music is governed by beer. The lure of Nashville is great to be sure. Many a Texas up-and-coming country star has paid his or her dues in that "fit the mold or go away" town. Many eventually wrestled themselves away and returned to the heartland to make their own kind of Texas music.

Willie Nelson is one of those Texas prodigal sons. In fact, no other modern Texas performer has impacted country music more than this product of Abbott, Texas. Willie Hugh Nelson popped into this world in 1933, the son of Ira and Myrtle. His dad died early and his mother flew the coop, leaving Willie and his sister Bobbie in the care of his grandparents. Life in the small Texas town near Hillsboro meant football, farming and playing his mail-order guitar beneath a pecan tree. Willie and his musical sister cut their teeth on the radio music of the Grand Ole Opry, New Orleans jazz and the western swing of fellow Texan Bob Wills.

As he sweated in the local cotton fields, he learned the working songs of the African Americans and Mexican Americans he labored alongside. Guided by their granddad, Willie and Bobbie first performed gospel music as children. Willie's first professional musical performance occurred at the age of ten when he played with John Raycjeck's Bohemian Polka Band.

After graduating high school, Willie did a brief stint in the U.S. Air Force and then returned to Texas. He entered a part-time farming program at Baylor University. But the sounds of country music on the radio called to him. By the 1950s, he had become a steady performer playing gigs at local bars and honky-tonks. He found work as a DJ at radio stations in Texas and Washington State and experimented with a few self-released songs. By this

time, he'd written some of his early songs that would later be considered classics, including "Night Life" and "Family Bible."

In 1964, Willie received an invitation to become a regular at Nashville's Grand Ole Opry. There was no bigger or better venue for a country entertainer than performing at the center of the music universe. Or so Willie thought. He tried hard and played the game for a number of years, producing hit songs for some of Nashville's finest, including "Crazy" (for Patsy Cline), "Funny How Time Slips Away" (for Billy Walker) and "Hello Walls" (for Faron Young). He scored a couple of personal hits in 1962 with "Willingly" and "Touch Me," both recorded as duets with his wife, Shirley Collie.

But something about Willie's style clashed with the expectations of the Nashville establishment. His cockeyed singing style punished the ears of the country purists (to put it mildly). He used a conversational singing technique where words landed just off the beat of the music. The Nashville folks couldn't figure out how to sell Willie's sound. In 1965, they even cast him as a co-star on an Ernest Tubb television show, but it wasn't Nelson's cup of tea, and he soon bailed out.

Willie was a Texan after all, born to be independent, to think for himself and find his own niche. To innovate.

In 1973, Nelson broke from the Nashville mold and produced a couple of albums, *Shotgun Willie* and *Phases and Stages*, that stretched country to a new level of energy and originality. The project was risky. But it worked. The albums received an impressive audience. To follow up on his new sound and image, Willie held a July Fourth "Willie Nelson Picnic" in Dripping Springs, Texas, featuring the likes of Loretta Lynn, Tex Ritter, Kris Kristofferson, Waylon Jennings and others. Although the show lost money, this watershed event earned a reputation as the "Woodstock South of the Brazos." From that beginning, a new era of Texas music emerged called progressive country.

Finally, the enchilada hit the fan. Willie and Nashville parted company. He changed his image from that of a clean-cut hee-haw country bumpkin to a longhaired Texas cowboy hippie. (Yes, Willie used to be clean cut.) As fate would have it, there was a venue waiting for him in Texas. It had been there since 1970, when, in the mellow air of Austin's music scene, Eddie Wilson opened a joint called the Armadillo World Headquarters. This laidback club attracted everyone from hippies to rednecks. Willie had played at the Armadillo in 1972, and when he moved to Austin, it became his musical headquarters.

The Red-Headed Stranger

Back in his native state, Willie recorded the album *Red-Headed Stranger* in 1975. He had to fight long and hard to get it produced the way he wanted. It broke all the Nashville rules for radio-friendly and highly produced albums. The corporate logic said it wouldn't sell. It did, and it established Willie as a formidable country star. Because of his departure from Nashville, Nelson earned the title "outlaw." Wearing it with pride, he teamed with a fellow Texas iconoclast, Waylon Jennings (and others), and recorded *Wanted: The Outlaws*. This album included the hits "Good-Hearted Woman" and "Mamas Don't Let Your Babies Grow Up to Be Cowboys." Willie and Waylon won a Country Music Award for best duet from the album. In fact, the superstar team would see additional action from the successful follow-up album, *Waylon and Willie*, in 1978.

Texas, Willie and Austin became the hub of progressive country, and a number of other Texas musicians joined the bandwagon. Numbered among them are Waylon Jennings, Kris Kristofferson, Michael Martin Murphy ("Cosmic Cowboy"), Jerry Jeff Walker, Kinky Friedman, Steve Fromholz, B.W. Stevenson and others.

Country Music Gone Awry

This "country music gone awry" phenomenon broke through to the national scene thanks to a Public Broadcast Service (PBS) series called *Austin City Limits* (*ACL*). Founded by Bill Arhos, the show debuted in 1974 and featured many of the same "Redneck Rockers" based at the Armadillo Club. The early shows featured Nelson and Stevenson. As more artists gathered 'round the movement, the show even influenced the future direction of Nashville. By its third year, *ACL* attracted country music stars including Chet Atkins, Merle Haggard, Garth Brooks, Roy Orbison and many others.

The influence that *ACL* had on modern country music is similar to the radio influence during the 1930s and '40s with past greats like Bob Wills, Gene Autry and Ernest Tubb. Young country musicians such as Lyle Lovett, George Strait, Nancy Griffith, Stevie Ray Vaughan, Sheryl Crow and others cut their wisdom teeth by listening to and then appearing on *ACL* in the 1980s and '90s.

By 1980, the tornadic up-swell of progressive country had petered out a bit, and many of the original Austin Armadillo stars found new musical

paths to follow. Nevertheless, Pandora had been let out of her box, and the face of country music would never be the same.

Nelson cannot simply be pigeonholed into a country music sub-category. Like many of the influential Texas musicians of the past, he adapted his music (country) with other genres (honky-tonk, rock-and-roll, western swing, jazz and others) to form a new sound. His 1978 album *Stardust*, which contained pop standards including "Georgia on My Mind," "Blue Skies" and "I Can See Clearly Now," is a testament to the diversity of Willie's music, his originality and his willingness to sell what he liked. As a result, other musicians followed his lead and led country (and other styles of music) into new territory that is still being explored.

Like the singing cowboys of the past, Hollywood eventually called. Willie appeared in the movie *The Electric Horseman* in 1979 and in *Honeysuckle Rose* in 1980. These were followed by appearances in *The Songwriter* with Kris Kristofferson in 1984, *Red Headed Stranger* in 1987 and several others. In 1993, he was elected to the Country Music Hall of Fame.

Ever mindful of his roots, Willie produced a series of concerts called Farm Aid beginning in 1985 to help the plight of the dwindling family farmer. At the age of seventy-one, he started the company Willie Nelson Biodiesel as a way to help farmers and protect the environment. Appealing to truck drivers who are also music fans to start using this alternative energy supply, he hopes not only to provide a new venue for farmers but also to reduce America's dependence on foreign oil. At last count, Nelson continues to tour and produce albums that reflect his particular Texas flavor of country.

References

Davis, John T. *Austin City Limits*. New York: Billboard Books, 2000.

Koster, Rick. *Texas Music*. New York: St. Martin's, 2000.

Nelson, Willie. *Willie: An Autobiography*. New York: Simon and Schuster, 1988.

Richmond, Clint. *Willie Nelson: Behind the Music*. New York: Pocket, 2002.

Texas Tidbit

Willie got a notice from the IRS in 1990 that he was slightly behind on his taxes—to the tune of $16.7 million. As a result, he lost much of his

property and assets. He released an album titled *The IRS Tapes: Who'll Buy My Memories?* to help pay off his IRS bill.

Texas Tidbit

In December 1998, Willie Nelson was honored at the Twenty-first Kennedy Center Honors for his talents and lifetime achievements as one of the world's best performing artists. Honored that night with him were Bill Cosby, John Kander and Fred Ebb (songwriters for *Zorba*, *Chicago*, *Kiss of the Spider Woman*, etc.), Andre Previn and Shirley Temple Black.

STEVIE, ROCK ON!

Stevie Ray Vaughan adored the guitar. Inspired by his older brother Jimmie, he picked up a guitar at the age of seven and (seemingly) never put it down again. Classmates remember him as far back as elementary school (Lenore Kirk Hall Elementary in the Oak Cliff section of Dallas) walking the halls and playing an air guitar.

On September 18, 1970, during Stevie's junior year at Dallas's Kimball High School, news flashed on the radio reporting that Jimi Hendrix, the super-sonic electric guitar rock superstar, had died in London. At the news, Stevie Ray's world crumbled. He made his way to the principal's office, upset and angry, and asked that a memorial assembly be held to honor Jimi. According to Stevie, the principal called Hendrix a dope head, refused the suggestion and ushered Stevie out of his office.

After leaving high school without graduating, Stevie devoted all of his time to his music and moved to the musical heartbeat of Texas (Austin). By 1975, he was playing in a band called the Cobras. The group became well known and popular at local nightclubs, giving Stevie the chance to develop his style in the presence of the Austin music culture.

In 1977, Stevie left the Cobras for a new gig with blues singer Lou Ann Barton in the Triple Threat Revue. They enjoyed local success but were not a break-out band. Stevie tried again. He added a few more musicians and a new name called Double Trouble. In 1979, Barton left the group. (She remained in Austin and became known as one of the "finest purveyors of raw, unadulterated roadhouse blues.") Double Trouble continued to play the Austin circuit with Stevie as the lead singer. In 1982, they received an

Above: Stevie Ray Vaughan. *Photo by Harold Dozier, courtesy Christian Brooks.*

Right: Stevie Ray Vaughan statue in Austin. *Photo by author.*

invitation to appear at the Montreux Jazz Festival in Switzerland, where they played the venue with stars including Charles Lloyd, the Steve Miller Band, Mink De Ville, Dave Brubeck, Jimmy Cliff, David Bowie and Jackson Browne.

After the group's impressive set, David Bowie asked Stevie to play on an upcoming album and Jackson Browne offered free recording time for the group in his Los Angeles studio. Stevie accepted both offers. He played on Bowie's *Let's Dance* album, released in late April 1983. His group then used Browne's studio in L.A. to record their first album, *Texas Flood*.

Double Trouble's *Texas Flood* reached number thirty-eight on the charts and found significant playtime on rock radio stations. With one success under his belt, Stevie tried for two. Double Trouble's follow-up album in 1984, *Couldn't Stand the Weather*, was an even greater success, reaching number thirty-one on the charts and going gold. Their third album, *Soul to Soul*, released in 1985, reached number thirty-four on the charts. The three early efforts by Double Trouble successes catapulted Stevie Ray Vaughan from a regional artist to a national blues star.

Success can be difficult. Stevie buckled under the growing pressure to produce and sank into alcoholism and drug addiction. He pushed himself to produce a fourth album, *Live Alive*, in 1986. In the fall of 1986, he checked himself into a rehabilitation clinic.

After a month in rehab, Stevie emerged with renewed energy. He came out with a conviction to stay straight and even refused drinks containing caffeine, but his creativity remained intact. The album *Step*, released in 1989, quickly soared on the charts and became Double Trouble's most successful effort to date, earning a Grammy for Best Contemporary Blues Recording and going gold in six months.

In 1990, Stevie recorded a new album called *Family Style* (that included his guitarist brother Jimmie, who had played with the Fabulous Thunderbirds) and set out on another American tour. On August 26, 1990, he played a concert that also included Eric Clapton, Buddy Guy, Robert Clay and his brother Jimmie Vaughan. The show ended with a powerful twenty-minute rendition of "Sweet Home Chicago." Buddy Guy would later recall, "It was one of the most incredible sets I ever heard Stevie play. I had goose bumps."

After the concert, Stevie boarded a helicopter bound for Chicago. It crashed seconds after takeoff, killing Vaughan and four other passengers. At age thirty-five, Stevie's stormy ride had come to an early end.

Vaughan's departing album, *Family Style*, soared to number seven on the charts after its release in 1990. Since then, a number of unreleased songs, remastered albums and tribute records have hit the charts honoring the unique Vaughan style that continues to influence blues and rock music today. There is an old saying that "The good seem to die young." Stevie Ray Vaughan's career was cut short, yet this emotional, talented, determined and passionate Texas guitar plucker is now considered to be one of the most influential guitarists of the twentieth century. Stevie was posthumously inducted into the Rock and Roll Hall of Fame in 2015.

A memorial statue of Stevie Ray Vaughan, dedicated on November 21, 1993, is located on Town Lake (now Lady Bird Lake), near the site of SRV's last Austin concert. On the anniversary of his death, fans often place flowers and personal notes of remembrance at the base of the statue. Dallas plans to erect its own statue of Stevie and his brother Jimmie in 2017 in Kiest Park, near their family home.

References

Crawford, Bill, and Joe Nick Patoski. *Stevie Ray Vaughan: Caught in the Crossfire*. Boston: Little Brown, 1994.

Gregory, Hugh. *Roadhouse Blues: Stevie Ray Vaughan and Texas R&B*. Portland, OR: Backbeat Books, 2003.

Hopkins, Craig L. *The Essential Stevie Ray Vaughan*. New York: Epic/Legacy, 2002.

FROM RAGS TO RAGTIME FOR SCOTT JOPLIN

The great ragtime composer Scott Joplin once commented that it would be twenty-five years after his death before he would be famous. It turns out, he was not only an extraordinary musician, but he could also predict the future.

Scott was the second of six children born to Florence Givens and Giles Joplin (sometimes spelled Jiles) in about 1868 in northeast Texas, probably Linden. Florence was a freeborn African American from Kentucky, and Giles had been a slave in North Carolina. Early in his life, Scott's family moved to Texarkana. His mother played the banjo and sang, and his father played violin. Each of the children learned to play the violin, and Scott had the additional opportunity to take piano lessons from several tutors. In particular, he took lessons from Julius Weiss, a German immigrant with a classical music background. Weiss found Scott a talented and serious student. Not only did he teach Scott how to play the piano, but he also instilled in his student the aspiration to study hard, work hard and make something of himself.

By the time Joplin was in his late teens, he was already trying to make something out of his musical talent. He played whenever and wherever he could get a chance, including honky-tonk saloons all around East Texas and bordering states. In 1891, he joined up with a minstrel group (which was a typical venue for black musicians at that time) and caused a bit of a stir in the black community when his group performed at a benefit to raise money to erect a statue of Jefferson Davis (who had been the president of the Confederate States of America). Joplin continued his travels around mid-America and spent a lot of time in St. Louis at a place called John Turpin's Silver Dollar Saloon. He was probably present when his friend (and John's son) Tom Turpin composed what is considered to be the first rag, the "Harlem Rag," in 1892.

In 1893, Scott visited the Columbia World's Fair in Chicago. Historical accounts of this event report that a number of black musicians from all over the country converged and compared musical notes. When these musicians returned to their respective hometowns, they carried with them the new sound of ragtime music.

Joplin returned to Sedalia, Missouri, where he set up house in the place that some called "the musical town of the West." This community was home to about fourteen thousand people but also catered to a thriving populace of traveling businessmen. For the homebodies, there were civic organizations, the Masonic Lodge, auxiliary guilds and churches. For the travelers, Sedalia

boasted a rather active district of saloons and sleazy joints where any type of entertainment could be found. In those saloons, the venue included (among other entertainment) music that would get your heart pumping and your feet moving. Here, particularly at the Black 400 and Maple Leaf Clubs, Scott Joplin plied his trade at the piano.

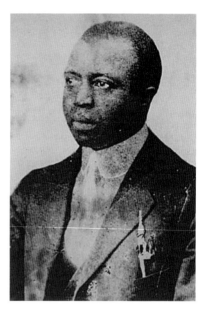

Composer and pianist Scott Joplin, circa 1890.

When he wasn't in the saloons, he remembered his tutoring at the hands of Julius Weiss and continued to improve his knowledge of music by attending the local George R. Smith College (a school created by the Methodist Church to help educate African Americans). Scott also became a member of a local band (playing the cornet) that performed at community events and religious meetings.

Although Scott Joplin did not invent ragtime music, as some think, he perfected it during his time in Sedalia and turned it into a reputable art form. In his expert hands, the rag's lively toe-tapping syncopated rhythms took on an upbeat sound that proved easy to listen to and easy to love.

In about 1895, Scott toured with a group called the Texas Medley Quartette. They toured all over the Midwest and eastern United States. While they were in Syracuse, New York, two of his original songs, "Please Say You Will" and "A Picture of Her Face," were published by local publishers. Another publication came after Scott visited Temple, Texas, to witness the spectacle of a planned head-on collision of two locomotives. The "Crush Collision," as it was billed, was the inspiration for his "Crush Collision March" (copyrighted in 1896). In it, he attempted to imitate the roar of the trains, the whistling for the crossing and the collision itself. (Critics say it wasn't a very convincing piece.) In the same year, he published "Combination March" and "Harmony Club Waltz." In 1898, with encouragement from his friends in Sedalia, he published "Original Rags," his first ragtime piece.

"Maple Leaf Rag"

It wasn't until his seventh song was published in 1899, the "Maple Leaf Rag," that Joplin scored his greatest hit. In a publishing deal better than most contracts with black musicians in that era, Scott's publisher paid him one cent for each copy sold. That modest royalty yielded him about $360 a year. The proceeds didn't make him rich, but they did give him a steady and respectable income. Although there had been more than one hundred rags published before the "Maple Leaf Rag," Scott Joplin's masterful touch brought a unique type of sophistication and esteem to the genre. As a result, Joplin became a best-selling composer of his time, and his "Maple Leaf Rag" became the most popular ragtime piece ever published.

Joplin continued to produce other popular rags, but his most ambitious project, the ragtime opera titled *Treemonisha*, never enjoyed the same kind of success as his individual pieces. Only performed once during his lifetime, in 1915, *Treemonisha* would not be discovered again until years after his death. After its rediscovery, this unique and important opera earned the status of a masterpiece work. It tells a sophisticated and thoughtful story of an African American community's emergence from slavery. The people of the town are led by a young woman named Treemonisha, who helps them reject superstitions and teaches them the value of hard work and education. Scholars believe that the message of *Treemonisha* echoed the lessons taught to Scott by his longtime friend, piano instructor and mentor Julius Weiss.

Time and lifestyle caught up with Joplin.

By 1916, when Joplin was only forty-eight years old, the long-term effects of syphilis took a toll on his health, and he fell into states of dementia and paralysis. He died in 1917 in New York. The local newspaper, absorbed at the time in covering the events of World War I, never carried his obituary. Joplin's star, which had shined for a bright moment, fell quickly from the public's notice. Rag was out. Jazz, a derivative of rag, took center stage as the new popular black music art form. Joplin was buried at St. Michaels Cemetery, East Elmhurst, Queens County, New York.

From Obscurity to Notoriety

For the twenty-five years following his death, the music of Scott Joplin fell into obscurity. In the late 1940s, after World War II, a brief nostalgic revival of ragtime took place because it reminded people of a happier

era. A more significant revival took place in 1973 with the release of the movie *The Sting*, featuring a Scott Joplin–inspired soundtrack. The movie's rendition of Joplin's "The Entertainer" climbed to number three on the Billboard Magazine Top 100. Joplin's star rose again as musicians all over the world rediscovered his genius. From its beginnings in sleazy honky-tonks, Joplin's music found a respected place in the venues of large city symphonies.

Today, in Joplin's childhood home of Texarkana, you can find a Scott Joplin mural at Third and Main Streets depicting the life and accomplishments of the "King of Ragtime." In 1976, Scott Joplin's once forgotten opera *Treemonisha* received the coveted Pulitzer Prize. In 1983, the U.S. Postal Service issued a Scott Joplin stamp as a part of its Black Heritage commemorative series.

Reference

Berlin, Edward A. *King of Ragtime: Scott Joplin and His Era*. New York: Oxford University Press, 1994.

Texas Tidbit

Although Joplin made no direct recordings, he did record several piano rolls in 1916; these have since been rerecorded onto CDs to give the world an idea of his musical genius (although the quality is expectedly marginal).

QUEEN SELENA

On the afternoon of March 31, 1995, the streets of downtown Dallas filled with slow-moving cars. They passed around the Kennedy memorial, down Commerce and up Elm Street. Around and around, more and more cars gathered. At the wheel of each car, a shocked and distressed driver looked as if he or she was searching for something, for some answer. Scrawled on the windows of almost every car was a message, hastily written in white and purple paint—the name Selena. In Houston, San Antonio and other Texas cities, similar people in similar cars gathered in search of answers. Even the *New York Times* ran a first-page story about the tragedy.

The young and beautiful Queen of Tejano Music, Selena Quintanilla-Perez, had been murdered.

At only twenty-three years old, Selena's charm, determination and winning personality had already influenced an entire music genre. Born in Lake Jackson in 1971, Selena was the third child of Abraham and Marcella Quintanilla. Her father played with a band called Los Dinos (The Guys) as a youth, and as his children grew up, he revived the group, teaching each of them music and giving each a part to play in the band. A.J. played guitar, Suzette played drums and little Selena sang. In the Hispanic culture, many parties and celebrations include a live band, and soon Selena y Los Dinos appeared at events all around the Lake Jackson and Corpus Christi areas.

The Quintanilla band, like hundreds of other South Texas Hispanic bands, played a type of music called Tejano. This style of music began in the early days of Texas when Spaniards and Mexicans moved north into Texas and became Texians. Historians called the root of Tejano music *conjunto*, which is a Spanish word meaning a combination or blend. Mostly developed in South Texas, Tejano music is a blend of many kinds of music, including elements of orchestral music, mariachi, bolero and polka (among others). It also featured a blend of instruments, including various types of guitars, fiddles, trumpets and the accordion. Its early years were influenced heavily by the polka and brass sounds of Texas German and Czech communities. In the 1940s, Tejano music drew on the western swing style of Bob Wills. All of these elements blended together to create an upbeat, lively type of music suitable for parties, special events and dances.

However, not everyone liked or respected Tejano music. Like the blended Tex-Mex language that many Hispanic Texans spoke, it was neither American nor Mexican. "Pure" Hispanic groups including Mexicans, Puerto Ricans and Cubans rejected the corrupted South Texas Tejano music and refused to play it or listen to it. Nevertheless, it flourished in Texas under pioneer stars that included Narciso Martínez, Don Santiago Jimenez Sr. (*El Flaco*, the Skinny One), Tony de la Rosa, Paulino Bernal, Estaban Jordán, "Little" Joe Hernandez of Temple and the true King Band de Johnny Moa.

Conjunto Music

Narciso Martínez is often called the "father" of *conjunto* music. He was born in Mexico in 1911 but moved to La Paloma (just outside Brownsville) as a

child. In the late 1920s, he played the accordion at parties and dances with a style influenced by Texas German and Czech music. In 1935, he teamed up with Santiago Almeida, a twelve-stringed bass guitar (*bajo sexton*) player, and created the basics of what would become Tejano music. Although he recorded a number of moderately successful records, he never hit the big time and had to supplement his music by working as a laborer. When Tejano music came into wider popularity, his fellow musicians recognized his contributions and inducted him into the Conjunto Music Hall of Fame in 1982. Martínez also received a National Heritage Award in 1983 from the National Endowment for the Arts for his contributions to the nation's cultural heritage, the highest honor ever presented to a Hispanic folk musician. The Narciso Martínez Cultural Arts Center opened in San Benito (near Brownsville) in 1991 honoring the father of conjunto music.

Until the 1940s, conjunto music was only instrumental. Valerio Longoria (born in Kenedy) introduced trap drums and words to the music first, using flowery Spanish lyrics and a more romantic style. The lyrics were modified from strictly Spanish to Tex-Mex in the 1950s by musicians such as Isidro Lopez. Other changes occurred in the 1970s groups by adding keyboard and orchestral sounds to the mix.

Don Santiago "El Flaco" (the Skinny One) Jimenez Sr. recorded a number of songs in the 1930s and '40s and became known for his two-row button accordion influence on Tejano music. His sons Don Santiago Jimenez Jr. and Flaco (née Leonardo) carry on his father's traditions as popular Tejano musicians.

The music played by the Quintanilla family band came from this talented line of Texas music history. However, something set the Quintanilla band apart from the hundreds of other small Tejano bands. That something was Selena. Her fame in the Tejano music scene became apparent when she was only thirteen years old. A bubbly child in elementary school, Selena made friends readily and participated in a variety of school activities. Her smile and vivaciousness captured the heart of everyone she met. Each time she stepped out on stage, that same winsome and charismatic personality won the hearts of her audience. She made her first recording in 1983, and her first big television experience came the next year on the Spanish-language *Johnny Canales Show*. Although her star was rising, the Quintanilla family continued to struggle to make a living as a Tejano band. They traveled the armadillo-lined back roads of Texas in a bus held together with bailing wire and slept on mattresses in the cramped rear of the bus.

The Little Girl with the Big Voice

With each passing month, Selena's fame grew. As it did, she accomplished something that no Tejano star had done before. Through her recordings and appearances, Selena's popularity spilled out of the Texas borders and into Hispanic groups that had been historically hostile to the Tejano style of music. In 1984, she took her show into northern Mexico, where Tejano music had previously been all but banned. To everyone's surprise, a crowd of over fifty thousand fans mobbed her performance. They loved Selena. She broke the barrier no other artist had been able to breach. In that same year, she won the Female Vocalist of the Year award at the Tejano Music Awards in San Antonio.

The Quintanilla family purchased a new bus, and Selena continued to take Tejano music into new Hispanic venues as well as into the (English) American music scene. Interestingly enough, like many Texas Hispanics, Selena grew up speaking only English. She learned Spanish phonetically from the songs her father taught her.

In 1992, Selena married guitarist Chris Perez, who had played in the family band for two years. In 1993, she held a concert at the Houston Astrodome that attracted sixty-seven thousand fans (the largest concert crowd ever at the 'Dome). In 1994, she won a Grammy for Best Mexican-American Album for *Live* and released the hit single and album "Amor Prohibido." With Tejano music now becoming popular all over America, Selena was asked to describe Tejano. She answered, "It's got polka in it, a little bit of country, a little bit of jazz. Fuse all those types of music together. I think that's where you get Tejano."

By 1995, even though Selena enjoyed icon status, she retained the same warm friendliness and charm of the little girl from Lake Jackson. A line of clothes was named after her, and she opened a series of Selena boutiques in South Texas. She appeared in the movie *Don Juan DeMarco*, starring Johnny Depp and Marlon Brando. With growing popularity in the English-speaking world, everyone had high expectations for a breakthrough English-language album. She even had a fan club.

The president of her fan club, Yolanda Saldívar, managed two of Selena's boutiques. Selena trusted Yolanda with managing the fan club dues but soon learned that much of the money was being pocketed by Saldívar. The family tried to get the bookkeeping records from Saldívar that would show if the fan club and boutique money had been properly accounted for, but Saldívar refused to give them up. After a series of disagreements about the situation,

Saldívar asked Selena to meet her at a Days Inn in Corpus Christi to give her the records. Selena went alone to the meeting. Just before noon, a maid heard screaming coming from room 158. A young lady ran from the room, pursued by an older woman. A shot cracked through the air. Selena made it to the motel lobby before collapsing in a pool of blood. Although paramedics arrived minutes later and rushed her to a hospital, they could not save her. She died at 1:05 p.m. on March 31, 1995.

The news of Selena's death sent the Texas Hispanic community into shock. Major networks on both Spanish and English news stations broke into programming to announce the news. Calls from Spain, Mexico and other countries around the world flooded Corpus Christi City Hall asking for information.

Saldívar was captured, charged and convicted of the murder. At Selena's funeral, sixty thousand fans mournfully remembered the brief life of one who had done so much for Texas music. The once vibrant Selena now rests at the Seaside Memorial Park in Corpus Christi.

In the six months following her death, ninety-eight babies in Houston were named Selena. There were seventy-two in Dallas, fifty-five in San Antonio and hundreds more in other cities across the world (over six hundred in Texas alone).

In 1996, then governor George W. Bush declared April 16 (her birthday) as "Selena Day." In 1997, Warner Brothers produced the movie *Selena* starring Jennifer Lopez. In 1998, Selena's father, Abraham Quintanilla, opened a museum in Corpus Christi to honor his daughter's life. It displays dresses designed and worn by Selena and includes other Selena memorabilia, including her Porsche. It is located at 5410 Leopard Street in Corpus Christi. Call 361-289-9013 or go to the www.q-productions.com website for more information. A memorial tribute concert in Houston called ¡Selena Vive! was held in 2005 and attracted over fifty thousand fans. Even in death, Selena continues to reign as the queen of Tejano music.

References

Mavis, Barbara J. *Selena*. Hockessin, DE: Mitchell Lane Publishers, 1997.
Richmond, Clint. *Selena!* New York: Pocket Books, 1995.
Selena. *Selena—Dreaming of You*. Milwaukee, WI: Hal Leonard Corporation, 1996.
Silva, Rosemary. *Remembering Selena: A Tribute in Pictures and Words*. New York: St. Martin's Griffin, 1995.

Texas Tidbit

The ¡Selena Vive! tribute concert in 2005, which lasted for almost four hours and was attended by more than fifty thousand fans, holds the record for the highest-rated Spanish-language show in American television history.

BACH TO TEXAS

If Bach, Beethoven or Mozart had only known about Texas, they would have packed up their harpsichords and pianofortes and headed straight to the Lone Star State. As history happened, their music had to be imported into Texas sometime after their deaths. However, even though classical and stage music wasn't invented in Texas, a number of Texans have influenced its direction in the modern world.

Music associated with the Old World certainly came to Texas along with the early pioneers. Performed by individuals and small groups rather than orchestras, it wasn't until the turn of the twentieth century that cities in Texas supported local symphony orchestras. The Dallas Symphony started in 1900, Austin in 1911, Houston in 1913 and San Antonio in 1939.

Opera appeared in Texas as early as 1875 (Field's Opera House in Dallas), and an early Texas opera star from that city was Leonora Corona, born Lenore Cohron in 1900. She attended Oak Cliff High School (now W.H. Adamson) and moved to Seattle while she was still a teenager. She made her operatic debut around 1924 in Naples and sang extensively in European theaters before signing with the Bracale Opera Company and touring Havana and Puerto Rico. She sang at the Metropolitan Opera (starting in 1927) for eight seasons in Italian operas, including *Tosca*, *Aïda* and *Don Giovanni*. She also performed at Carnegie Hall and at the Opéra Comique in Paris. Another opera star grew up in San Saba in 1928. Thomas Stewart attended Baylor and Juilliard. He debuted at the Met in *Falstaff* and also appeared in *Carmen*, *Othello* and many others.

Texas spawned several musicians who influenced Broadway as well. They included two University of Texas grads, Harvey Schmidt and Tom Jones (not the Welsh Tom Jones), who are responsible for the musical hits *The Fantasticks* and *I Do! I Do!* Joshua Logan, born in Texarkana, won a Pulitzer Prize (1950) for *South Pacific*. Larry King (no, not the talk show host) wrote the 1970s smash hit *The Best Little Whorehouse in Texas*. The incredible Tommy Tune, born in Wichita Falls, has won nine Tony awards (in four

different categories) as a Broadway actor, dancer, singer, choreographer and director—plus Drama Desk awards, Obie awards and a *Dance Magazine* Lifetime Achievement Award in 1990, among several others.

However, when you mention Texas and classical music in the same sentence, you have to include the name Van Cliburn.

Tall, Lanky and Talented

Born in 1938 in Shreveport, Louisiana, Harvey Lavan Cliburn Jr. (shortened to Van Cliburn) came from a Lone Star family tree longer than a country mile. The booming oil business had taken his father out of the state temporarily, but they would return to Kilgore in a few short years.

While his father worked in the oil business, Van's mother, Rildia Bee O'Bryan Cliburn, taught piano lessons. As a toddler, Van watched with interest the succession of his mother's students come in and out of their house. He delighted to hear his mother practice and listened with intense curiosity. He also watched carefully as students learned their daily lessons. One day after his mother left the room, Van sat on the piano bench and started playing the music that the last student had been practicing. When his mother returned, she knew he had a musical talent but was determined that he would be properly trained.

At the age of three, Van started learning piano from his mother— daily lessons without fail. And these weren't lessons from the typical *Hal Leonard Method* books for young fingers. Not from Rildia Bee! His mother had studied under Arthur Friedheim, a student of the famous pianist Franz Liszt, and could have been a successful concert pianist if the door had been open for young women in that era. From his mother/teacher, Van learned how to read music, how to sit correctly, how to caress the keys and how to interpret music. She made sure he didn't develop any bad musical habits.

Music tutoring in the Cliburn household went beyond piano lessons. His mother and father drove Van from Kilgore to so many concerts in Dallas and Shreveport that once, when asked where he lived, he said, "On Highway 80." Van played for his school choirs, community events and church functions. All the while, he took lessons from a piano teacher who told him, "While you are taking lessons from me, I am not your mother." She demanded significant daily practice, and Van, with few reservations, met her demands with enthusiasm. By the time he was in junior high school,

Van stood almost his full height of six feet, four inches, and his large hands gracefully and skillfully covered any reach the music required.

By the age of twelve, Van had won a statewide Texas piano competition and played with the Houston Symphony. At the age of fourteen, he won a National Music Festival Award and played in Carnegie Hall. The awards kept mounting up for young Cliburn. He hurried to finish high school at the age of sixteen so he could get on with a professional piano career. At seventeen, he entered the prestigious Juilliard School of Music in New York.

His mother carefully selected a teacher who could take Van to a higher level of professionalism. That teacher, Madame Rosina Lhevinne, had graduated from Moscow Conservatory with the highest honors, and some consider her the most influential piano teacher of her generation. When she first met Van, she refused to take him on as a student, saying that her schedule was too full. Then she heard him play. She rearranged her schedule, and Van grew into her most promising pupil. Under Lhevinne's inspired tutelage, Van won several national competitions and gained the experience to compete internationally.

To understand the significance of what happened next, you need to know about the events of October 1957. Ever since the end of World War II, the United States and Russia (then the Communist Soviet Union) had both stockpiled a large number of nuclear weapons. The fear on each side led to a "cold war" of high tension, fueled by spy versus spy intrigue and inflammatory political rhetoric. This increasing anxiety drew the "free west" and the "communist east" to the brink of mutual annihilation. By 1957, although each country had a massive arsenal of nuclear weapons, the delivery of them to the enemy was a crude proposition. Each country knew that the next move was conquering space, where weapons could be dropped on the enemy from above.

All hope of a peaceful future depended on developing space technology before the Soviets. The United States tried to fire rockets into space several times, and each one blew up in failure. Then, in a crushing blow, America lost the space race on October 4, 1957. On that day, the Soviets successfully sent the world's first satellite, Sputnik, into space orbiting the earth. Americans were frozen in fear. Could (and would) the Russians drop atom bombs on the United States from space? Schools practiced atomic bomb drills. Suburban Americans dug fallout shelters in their backyards in a desperate search for safety. Geiger counters (to locate radioactivity) could be purchased at any American department store.

From Russia with Love

Six months after the Russian launch of Sputnik, with tensions on both sides edging toward a breaking point, a young Van Cliburn entered the First International Tchaikovsky Piano Competition in Moscow. Unaware of what role his participation would have in world affairs, he played his way through the preliminaries and worked his way into the final competition.

In a series of performances that were the first live concerts ever televised in the Soviet Union, Cliburn played Tchaikovsky's "Piano Concerto No. 1" and Rachmaninoff's "Piano Concerto No. 3." The Russian people were spellbound by the lanky Texan. He didn't fit the Communist Party's description of the evil American. In fact, he looked rather friendly. They watched as he played the pieces (composed by Russians) with a passionate and spontaneous flair.

With the last note still reverberating, the Russian audience exploded into applause and gave Cliburn a standing ovation lasting eight minutes. The Soviet judges had to ask Premier Nikita Khrushchev for permission to award Cliburn the top prize. How could he be denied? The premier gave

Van Cliburn's adoring fans. *Courtesy Van Cliburn Foundation.*

Van Cliburn at the New York ticker tape parade. *Courtesy Van Cliburn Foundation.*

his permission. Van Cliburn not only became an instant celebrity in Russia, but this Texan's southern graciousness and friendly demeanor thawed the relations between the two superpowers.

Upon his return to the United States, Van Cliburn received a huge ticker-tape parade in New York City—the only classical musician ever to earn that prestigious honor. *Time* magazine featured him on its cover and called him "The Texan Who Conquered Russia." He signed a recording contract with RCA, and his recording of Tchaikovsky's "Piano Concerto No. 1" became the first classical album to sell over one million copies. It remained the worldwide best-selling classical album for over a decade.

For the next twenty years, Van Cliburn reigned as the superstar of classical music. In 1962, he and other Texas music lovers and community leaders established the Van Cliburn International Piano Competition in Fort Worth and put Texas on the classical music map. This prestigious "super bowl of piano competitions" is held every four years and attracts the best musicians from around the world.

Van Cliburn passed away on February 27, 2013, at the age of seventy-eight. He is remembered as an effective, influential and respected Texan ambassador. His support for the growth of the arts in Texas, his nourishment of young talent and his influence on arts and educational causes around the globe will remain a lasting legacy. For information about "The Cliburn," visit www.cliburn.org.

References

Alexander, Patricia, and Darren Alexander. *Van Cliburn: America's Musical Hero*. Fort Worth, TX: Bluebonnet Classics, 2001.
Chasins, Abram. *The Van Cliburn Legend*. Garden City, NY: Doubleday, 1959.
Reich, Howard. *Van Cliburn*. Nashville, TN: Thomas Nelson Publishers, 1993.

Texas Tidbit

Kilgore was such an oil boomtown that residents even drilled through the floor of the National Bank to find more of that liquid gold.

Texas Tidbit

Van Cliburn made his television debut on the January 19, 1955 edition of the *Tonight Show* and played Ravel's "Toccata" and a Chopin etude. He brought down the house.

TEXAS SPORTS

READY, SET, INNOVATE!

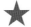

The backbreaking, dust-snorting work needed to eke out a living in the early days of Texas made cowboys want to kick up their heels every once in a while and enjoy a bit of competition. Local horse races and roping competitions led to rodeos. Kids growing up in the wide-open spaces of Texas banded together, found an empty lot or field and played ballgames. As Texas public schools formed in counties across the state, they channeled students' extra energy into sports. In many communities, sports gatherings for local schools developed into an integral part of a community's social life because they offered a welcome escape from the grinding work of Texas oil fields and farms. The Friday night lights of football stadiums in the fall still serve as the focal point of many Texas towns and cities.

Scads of books have been written about Texas sports and its heroes. This book doesn't intend to duplicate that achievement. Instead, it presents an overview of Texas sports and looks at a few of the individuals and organizations that made unique and innovative contributions to sports that reached beyond our state boundaries.

Before the Texas revolution, the Mexican territory of Texas enjoyed ranch-oriented sports including bull fighting, horse racing and rodeos. Bull fighting was outlawed in 1891, but rodeos and other horse sports continue to this day. These activities were at first informal and local. Eventually, they evolved into more formal county and state events. Anglo, Native Americans (particularly Comanche), Mexicans and African American cowboys all competed against one another in rodeo sports. Horse racing flourished

until betting was outlawed in 1937 and revived again when wagering was reinstated in 1987.

The Germans also introduced nine-pin bowling to the state, and it still remains popular. (It's ten-pin bowling these days.) Shooting sports sprang from the necessity to own and know how to use a gun. Gun clubs formed in many communities, and contests were staged all across the state. Germans and Czechs brought gymnastic clubs to Texas in the 1850s (some still exist today). Gymnast Mary Lou Retton, a Texas transplant at age fourteen, when she came to train with Bela Karolyi in Houston, became America's sweetheart at the 1984 Olympic Games in Los Angeles. She won five medals, inspired a generation of gymnasts, was named the *Sports Illustrated* Athlete of the Year and became the first woman on a Wheaties cereal box.

Organized league sports found their way to Texas, particularly baseball, around the time of the Civil War. Originated back east in about the same year that Texas became a state, firm baseball rules were adopted in 1857, and by 1868, there were one hundred known baseball clubs in the United States. In Texas, the Houston Baseball Club started in 1861. By the 1880s, almost every town of any size sponsored a baseball team. The first professional sports in Texas came in 1888, when John J. McCloskey, "the Father of the Texas League," formed the Texas League of Professional Baseball Clubs. Two of the most successful teams were the Houston Buffaloes and the Fort Worth Panthers. Because of the Jim Crow laws that followed Reconstruction, many towns actually had three teams: white, Hispanic and African American. The Texas Negro League was formed in 1867, and these clubs lasted until the 1960s. The popular and successful Texas League dominated Lone Star baseball until the Houston Colt 45s (now Astros) brought major-league baseball to the state in 1962.

FOOTBALL COMES TO TEXAS

Football got started in the United States back east in 1869 when two colleges, Rutgers and Princeton, staged a competition based on rules from the London Football Association.

By 1876, an American set of rules for football had been established by Walter Camp. Football got started in Texas with community and sandlot teams during the late 1800s, and organized teams started in public schools at the turn of the twentieth century. The University of Texas fielded its first football team in 1893 and beat the Dallas Foot Ball Club (a city

amateur team) at Fair Park by a score of 18–16. The Texas UIL (University Interscholastic League) was formed in 1913 to regulate school sports. As a sign of the times, separate white and black organizations operated until they were combined in 1965. The first professional football team in Texas was the NFL's Dallas Texans, which went broke in 1952. In 1960, professional football tried again (more successfully) with the creation of the Dallas Cowboys in the NFL and the Houston Oilers in the AFL.

Texas coaches and athletes have contributed significantly to the game of football both in the way the game is played and in its national popularity. For example, SMU coach Ray Morrison (1915–16, 1922–34) invented the "Statue of Liberty" play and the five-man defensive line. Baylor coach Frank Bridges (1920–25) pioneered the spread formation, the hidden-ball play, the end-around and the tackle-around. Dutch Meyer of TCU (1934–52) improved on the spread formation by using the double wing with two split ends and two or three wingbacks. Texas A&M coach Homer Norton (1934–47) was the first to use a tower to observe practices. Texas native Bob Neyland served as the Tennessee coach from 1926 to 1952 and was the first to capture plays on film for review and to communicate with coaches in the press box with a telephone wire.

Texans also played a hand in promoting football. Oilman J. Curtis Sanford created the Cotton Bowl postseason college matchup in 1937, pitting Texas Christian University against Marquette. (The Cotton Bowl game was originally played in the Fair Park Stadium in 1937 and got its own stadium in 1938.) A&M coach Joe Utay elevated the Cotton Bowl to national prominence in 1940 when he helped organize the Cotton Bowl Athletic Association, which started the tradition of the Southwest Conference champion appearing in the Cotton Bowl. In the professional ranks, Tex Schramm, general manager of the Dallas Cowboys, helped introduce innovations such as sudden-death overtime, instant replay, wireless microphones for referees, the wild-card playoff system and moving the goal posts to the back of the end zone.

Three recent Texas innovators who had a particularly lasting impact on the game are Lamar Hunt, Tom Landry and Darrell Royal.

Lamar Hunt was born in Arkansas, the son of the Dallas oil tycoon H.L. Hunt. After graduating from Southern Methodist University in 1959, he attempted to bring an NFL team to the metroplex but was turned down. Like any good Texan, he decided if the big boys didn't want to play his way, he'd start his own league. And he did. In 1960, he gathered up seven like-minded investors and formed the American Football League (AFL),

which included the Dallas Texans. The Texans moved to Kansas City in 1962 and became the Chiefs. In 1966, the AFL agreed to merge with the NFL, and the first official championship playoff between the two leagues occurred on January 15, 1967. Hunt's Kansas City Chiefs fell to the Green Bay Packers 30–15. A few years later, Lamar Hunt coined a new name for the championship bout. He called it the Super Bowl, and the name stuck.

Hunt was inducted into the Pro Football Hall of Fame in 1972 and the Texas Sports Hall of Fame in 1984. The championship trophy presented to each year's best AFC team is named the Lamar Hunt Trophy in his honor. He was also instrumental in the promotion of tennis and soccer and has been honored as an innovator in those sports as well. Hunt died on December 16, 2006.

THE CLASS ACT

Another Texan who influenced the game on the field was Tom Landry. Tommy Landry learned football in Mission, Texas, as a part of the Mission High School team under Coach Bill Martin, including a spectacular 1941 championship season. After World War II, Tom played on the University of Texas Longhorns team and then went on to play and coach for the New York Giants in the National Football League. His reign as the Dallas Cowboys' coach from 1960 to 1988 is filled with innovation in both defense and offense that changed football forever.

His creation of the "Flex defense" came from the fact that his early teams lacked the power and youth of other teams of the day. To counteract this, Landry positioned his right tackle and left end a few feet behind the line of scrimmage to give the line a better chance at pursuing a runner. Each defender had an assignment to control one or more gaps, and this gave his players a chance to match up to the more powerful defense of the day. As the quality of his players increased over the years, the Flex became known as the "Doomsday Defense." The defense helped the Cowboys achieve NFL titles by 1966 and a Super Bowl win by 1971.

Landry also perfected the "shotgun formation." Originally a running formation used by San Francisco, Landry refashioned it into a passing formation. The formation gave the quarterback the opportunity to view the entire field as the play unfolded. The famous "Hail Mary" pass from Roger Staubach to Drew Pearson in the 1975 playoffs was made possible by the shotgun formation. Today, every professional football team includes

the shotgun in its playbook. Landry died on February 12, 2000. A section of Interstate 30 between Dallas and Fort Worth was named the Tom Landry Highway in 2001.

TEXAS INNOVATIONS

Another innovative Texas football coach was Darrell Royal. In twenty-three years as head coach at the University of Texas, he never had a losing season. He is also credited with two innovations that have been used by many other teams. One is the "Flip-Flop Winged-T" (1962), which allowed the offensive line to flip right or left and simplified the blocker's assignments. Along with assistant coach Emory Bellard, Royal created the Wishbone offense, which utilized a running formation with a wide receiver, a tight end and three running backs behind the quarterback. This setup allowed the quarterback to run an option on either side of the line. Many other coaches, players and administrators contributed to Texas football, making Texas the premier state for playing and enjoying the game from high school to the pros.

Basketball is another Texas sport that fills the stands all across the state. Invented in 1891 in a Springfield, Massachusetts YMCA by Dr. James Naismith, basketball was designed as a sport that could be played indoors. By 1900, it was popular in Texas with both men's and women's teams playing at public schools and colleges, as well as in community leagues. In fact, businesses often recruited high school basketball stars to improve a company team. In many communities in Texas, women's basketball games drew larger crowds than the men's teams.

Professional basketball arrived in Texas with the creation of the American Basketball Association (ABA) franchise the Dallas Chaparrals (also known as the Texas Chaparrals), a team that played from 1967 to 1973. The Chaparrals were transplanted to San Antonio in 1973 to become the Spurs. The ABA Houston Mavericks played from 1967 to 1969. In 1971, the Houston Rockets became the first Texas NBA team. In 1973, the Spurs joined the NBA, and the Dallas Mavericks were formed in 1980. Professional women's basketball came to Texas with the creation of the National Women's Basketball Association Dallas Diamonds and Houston Shamrocks in 1984, but the league only lasted one season. In 1996, the National Basketball Association board of directors announced the formation of the WNBA, the Women's National Basketball Association. Sheryl Swoopes was the first WNBA player signed to a contract, and their inaugural season began in June 1997.

One Texas coach who influenced women's basketball was Harley Redin of Wayland Baptist College (1946–73), who promoted rule changes such as the five-player full-court game and the thirty-second shot clock.

With so many opportunities for sports and with so many talented Texans participating, it is no wonder that Texas and Texans have made significant contributions to the sports world. For example, Jack Johnson broke the color barrier in national boxing competitions by becoming the first African American to win the world heavyweight championship. Rodeo superstar Bill Pickett invented bulldogging at the turn of the century. Babe Didrikson Zaharias, perhaps one of the greatest athletes the world has known, helped bring professional women's golf into the mainstream of U.S. sports. To add icing to the cake, the Kilgore Rangerettes changed halftime entertainment forever (and for the better). Even playing facilities were changed by Texas ingenuity. The Astrodome inspired an entire slew of stadiums that brought sports into venues that had previously been hampered by weather. These people and innovations are described in detail in upcoming stories.

To learn more about other Texas sports heroes, here are some sports museums you should visit:

The Texas Sports Hall of Fame is located at 1108 South University Parks Drive in Waco and is open Monday through Saturday, 9:00 a.m. to 5:00 p.m. It is open on Sunday from noon to 5:00 p.m. Call 800-567-9561 for more information, or visit www.tshof.org.

For rodeo sports figures, visit the Texas Cowboy Hall of Fame in Fort Worth at 128 East Exchange Avenue. It is open Monday through Thursday from 10:00 a.m. to 6:00 p.m., Friday and Saturday from 10:00 a.m. to 7:00 p.m. and Sunday from noon to 6:00 p.m. For more information about the Texas Cowboy Hall of Fame, visit its www.texascowboyhalloffame.com website or call 817-626-7131.

Babe Didrikson Zaharias and the Rangerettes also have museums (as mentioned in the upcoming stories).

In addition, most major Texas universities have on-site sports museums or exhibits featuring their own sports history and heroes.

Reference

Holmes, John. *Texas Sport: The Illustrated History.* Austin: Texas Monthly Press, 1984.

JACK JOHNSON BREAKS BARRIERS

When John Arthur Johnson was born on March 31, 1878, in Galveston, Texas, the Civil War had only been over a few years, and African Americans had few opportunities other than doing common labor. Starting at a young age, Jack (as he was called) went to work painting milk wagons, exercising horses, baking bread, unloading ships at the Galveston dock and whatever odd jobs he could find.

When he took a job as a janitor at a local gym, the place intrigued him. He watched the others work out and then tried it himself. The exercises were exhilarating. Every workout technique he saw others doing, he learned and did himself. One particular activity at the gym that he admired was boxing. Soon, he knew that boxing was what he wanted to do.

Buying two pairs of gloves, he recruited local black friends to fight him. As a sparring partner with the other blacks, he entertained white spectators for donations. He quickly gained a reputation as the best black boxer in Galveston, but that title was less than what he wanted. While training with Joe Choynski, a professional boxer known as the "California Terror," the two were jailed in 1901 for boxing (which was illegal in Galveston) after Choynski defeated Johnson. Choynski continued training Jack while they were in jail, and when they were released, Jack left the island in search of opportunity. Traveling around the country making a living taking on odd jobs, Johnson looked for opportunities to box. He fought anywhere there was a challenge: on ship docks, at circuses, in gyms. In 1897, Johnson made a decision. He would turn pro.

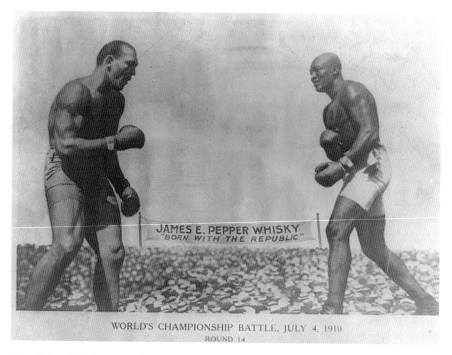

JAMES E. PEPPER WHISKY
"BORN WITH THE REPUBLIC"

WORLD'S CHAMPIONSHIP BATTLE, JULY 4, 1910
ROUND 14

Prize fighter Jack Johnson, circa 1910. *Courtesy Library of Congress, LC-USZ62-91059.*

During that era of American history, black people were not welcomed in most sports. Boxing was no different. Johnson not only had to know how to fight in the ring, but he also faced a seemingly insurmountable barrier to get into the professional ring in the first place. He kept fighting for the opportunity. Although there were white groups that tried to keep him out of the fight, Jack Johnson did get into the ring, and when the bell rang to start the round, he was good. Trumped-up claims by the popular media that a black man could not fight were soon dispelled. Jack won fights and made more money than most black men of the era had ever seen.

Jack liked having and spending money. He wasn't ashamed to let people know he was rich. He wore smart clothes, hired a maid to tend his wardrobe, drove fancy cars, hobnobbed with European royalty and owned his own nightclub. To some in the white establishment, Jack went too far when he dated white women. Interracial dating was frowned on by much of society, and in some states it was illegal. Jack spent time in jail for his indiscretions, but that didn't stop his career. Little by little, he fought his way toward respect in the ring.

In 1903, he won the Negro heavyweight championship. It was not enough. He lacked the ultimate prize. The current reigning heavyweight champion of the world was James J. Jeffries, but he refused to fight Johnson. Johnson didn't give up. When Tommy Burns became champion in 1906, Johnson chased Burns across the world and eventually intimidated him into signing a contract to fight. However, Burns only agreed when he was guaranteed a purse larger than any fighter had ever received. No matter. Johnson took his shot.

FODDER FOR THE PRESS

Once the contract was made public, Johnson became fodder for the press. Racially bigoted newspapers ridiculed him with every racial slur available in the English language. Nevertheless, in Rushcutters Bay, Australia, on December 26, 1908, Jack Johnson had the opportunity to prove himself in the ring. Over twenty thousand people crowded into the stands and watched as Johnson came out swinging. Before the first round was over, the spectators realized that Burns had met his match. Movie cameras that had been set up to chronicle Burns's success were shut down when it became apparent that Johnson would win. Johnson tore into Burns with a continuing barrage of uppercuts and hooks. The contest became so one-sided that the police stepped in and stopped it. Johnson was declared the winner.

Some in the press called the fight with Tommy Burns a fluke. They wanted revenge. Many couldn't accept the fact that a black man held the championship; some looked for a new fighter to take on Johnson. They called on former heavyweight champion Jim Jeffries to win back the title. They called Jeffries "The Great White Hope." As recounted in Rex Lardner's *The Legendary Champions*, a *New York Herald* writer lamented after the Burns fight:

> *The fight! There was no fight. No Armenian massacre could compare with the hopeless slaughter that took place to-day. It was not a case of too much Johnson, but all Johnson. A golden smile was Johnson's....Burns was a toy in his hands. For Johnson it was a kindergarten romp. "hit here Tahmy" he would say exposing the side of his unprotected stomach...then would receive the blow with a happy, carefree smile...But one thing now remains, Jeffries must emerge from his alfalfa farm and remove that golden smile from Johnson's face. Jeff, it's up to you!*

Johnson proved that the Burns fight was no fluke. He defeated five more challengers in quick order. Jeffries responded to the calls to fight Johnson for the title, and the bout was scheduled for July 4, 1910. Newspapers billed it as the fight of the century.

The Great White Hope

Although the fight was originally planned for California, there was so much opposition to it that it was moved to Reno, Nevada. A huge crowd came to the event, including over five hundred reporters. Preparations of both fighters were covered in the press. Johnson was in his prime. Jeffries, the Great White Hope, was not.

As Johnson walked to the ring, he was met with insults. When Jeffries entered the room, he was met with cheers of elation. The betting odds were in his favor, ten to six. The fight began. For the first two rounds, the opponents danced around each other. In the third round, Johnson opened up, landing several menacing blows to Jeffries. The Great White Hope struck back and landed a punch in the fourth round, opening an old wound in Johnson's lip and drawing blood. The crowd went wild for Jeffries. Jeffries was one tough opponent. But Johnson proved to be tougher. In round after round, Johnson wore down the old prizefighter. In the fifteenth round, Jeffries's coach threw in the towel. The fight was over. Johnson had defeated the Great White Hope.

Johnson celebrated his championship, but many people were not ready to give him respect. With Johnson living a high-profile life and flaunting his wealth, white authorities looked for ways to punish him. When he dated a white woman in 1912, he was convicted of violating the Mann Act by transporting a woman across state lines before marriage and was sentenced to a year in prison. To escape the sentence, he fled to Canada and later to Europe.

Jack Johnson stayed out of the United States for seven years, defending his heavyweight championship three times in Paris. In 1920, he returned to serve his sentence. While at Leavenworth Prison, he served as the athletic director. After his release, Johnson never regained his success as a fighter and lived the rest of his life fighting to make ends meet. In his remarkable boxing career, he fought 114 fights and won 80 matches, 45 of them by knockouts.

Jack Johnson opened a door that would allow future black athletes to compete in the same leagues as the white players. In 1926, Tiger Flowers

became the first black middleweight boxing champion, defeating Harry Greb in fifteen rounds. In 1936, Jessie Owens became a national hero for his performance at the Summer Olympics held in Berlin, Germany (dispelling myths of Adolf Hitler's claim of a superior German race). In 1945, Jackie Robinson became the first black player to sign a major-league baseball contract (with the Montreal Royals).

In 1948, Alice Coachman became the first black woman to win an Olympic Gold Medal. In 1950, Althea Gibson became the first black woman to play at the U.S. Nationals Tennis Tournament. Many other athletes of all races can look to the contribution of Jack Johnson as one who fought his way past prejudice to pave the way for future generations. Jack Johnson died in an automobile accident in 1946. During his lifetime, he wrote two memoirs: *Mes Combats*, published in 1914 (in French and hard to find but reprinted in English in 2007 as *My Life and Battles* by Praeger Publisher), and *Jack Johnson in the Ring and Out*, first published in 1927 and republished in 1993.

References

Farr, Finnis. *Black Champion: The Life and Times of Jack Johnson*. New York: Scribner, 1964.

Fradella, Sal. *Jack Johnson*. Boston: Branden Publishing Company, 1990.

Johnson, Jack. *Jack Johnson in the Ring and Out*. London: Proteus, 1977.

Lardner, Rex. *The Legendary Champions*. New York: American Heritage Press, 1972.

Roberts, Randy. *Papa Jack: Jack Johnson and the Era of White Hopes*. New York: Free Press, 1982.

Ward, Geoffrey. *Unforgivable Blackness: The Rise and Fall of Jack Johnson*. New York: Knopf, 2004.

Texas Tidbit

Jack Johnson also patented a wrench. It was recorded as U.S. patent number 1,413,121 on April 18, 1922.

BILL PICKETT, THE TEXAS BULLDOGGER

If that angry longhorn steer hadn't gotten loose, the entire sport of the western rodeo would be a lot less interesting. On a hot summer day in 1903, that steer did get loose and refused to enter the corral. Young Bill Pickett, who was trying to get the steer to behave, got downright ticked off. He rode up beside the steer on his horse, jumped onto its head, grabbed its horns and wrestled it to the ground, all the time biting the steer's lower lip.

Pickett was born in 1870 in Travis County as the second of thirteen kids. His parents, Thomas Jefferson and Mary Virginia Pickett, were both former slaves. From the front porch of his house, he could hear the thunderous roar of thousands of hooves as cowboys on tall, strong horses drove herds of cattle across the dusty prairie. He watched these rugged cowboys riding high in their saddles. He paid attention to every detail when the cowboys worked as a team to control the herd and to lead it this way and that. Sometimes he waved at them, and sometimes they tipped their hats back at him.

After Bill completed fifth grade, he took a job at a local ranch and quickly earned a reputation as an expert cowpoke. While working on a ranch one day, he noticed something that would not only change his life but would impact a national sport as well. The story goes that young Pickett noticed that cattle-herding dogs, which happened to be of the bulldog breed, would bite the lip of a steer to get its attention. He wondered what would happen if he did the same thing. He'd find out soon enough.

The Pickett family moved to Taylor, Texas, when Bill was eighteen. He started a horse-breaking business there with his brother, joined the National

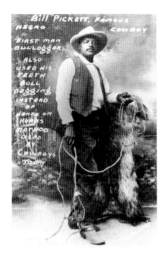

The inventor of bulldogging, Cowboy Bill Pickett.

Guard and became a deacon of the local Baptist church. In 1890, he married Maggie Turner.

When that aforementioned wayward steer got loose in 1903, Bill thought about how those bulldogs bit the lip of the steer to control it. Just to see if he could do it, he rode up beside the errant steer, jumped on it, grabbed it by the horns and bit the animal's bottom lip. The beast yielded to Bill's strength and was wrestled to the ground. Everyone who saw what happened was amazed as well as amused. Word got around, and people wanted to see it done again. Sometimes they'd throw some loose change in a hat to pay Bill for the exhibition. Bill enjoyed the attention and the money. He called this new sport of bull wrestling "bulldogging" after the bulldogs that had inspired him to give it a try.

Over the years, the wrestling-the-steer-to-the-ground part of the bulldogging sport has remained, but cowboys don't bite the lip of the steer anymore.

In Only Eight Seconds

The sport of bulldogging eventually adopted specific rules. In a few words, the rules are this: a four- to five-hundred-pound bull is released into a rodeo ring, and a split second later, the bulldogger begins the chase. A "hazer" is also sent out on the left side of the bull to keep it going straight ahead. In a feat of exact timing, courage and skill, the bulldogger jumps from his horse, grabs the steer by the horns and digs the heels of his boots in the ground to stop the beast. He then wrestles the steer to the ground, with time called when the steer is on its side with all legs pointed the same direction. A good bulldogger is able to accomplish this amazing feat in about five to eight seconds.

Pickett performed this type of exhibition at hundreds of rodeos around Texas and other western states. In 1905, he performed at Madison Square Garden in New York City, where none other than Will Rogers rode as his hazer. At that event, the steer got rambunctious and ran up into the stands with Pickett and Rogers in hot pursuit. Together, they finally got it back into the arena.

Pickett's popularity (he was sometimes billed as the "Dusky Demon") made him a featured attraction in the nationally known Miller Brothers 101 Ranch Wild West Show, where he performed bulldogging exhibitions from 1905 to 1931.

Bill Pickett died in 1932 and was buried at the site of the former 101 Ranch near Ponca City, Oklahoma. Historians say that if African Americans had been able to compete in the all-white rodeos at that time, he would have been a superstar. Nevertheless, Bill did gain a lot of fame during his lifetime, and he is remembered as the inventor of the popular rodeo sport of bulldogging. Pickett was inducted into the National Rodeo Hall of Fame in 1972. In 1989, he was inducted into the Pro Rodeo Hall of Fame and Museum of the American Cowboy at Colorado Springs, Colorado. The United States Postal Service honored the memory of Pickett with a 1994 U.S. postage stamp. Unfortunately, the original USPS stamp pictured his brother Ben instead of Bill. They corrected the mistake, called back the misprinted stamps and issued a corrected version (making the incorrect Bill Pickett stamps collector's items).

Bill Pickett is remembered each year at the Bill Pickett Invitational Rodeo in Oklahoma, the only yearly African American rodeo in the world. At the National Cowboy and Western Heritage Museum in Oklahoma City, where Bill Pickett is honored as the originator of bulldogging/steer wrestling, these words (coined by his friend Colonel Zack Miller) are inscribed to Pickett's memory:

> *Like many men in the old time West*
> *On any job he did his best*
> *He left a blank that's hard to fill*
> *For there will never be another Bill.*

Nowadays, the closest you can get to seeing Bill Pickett in action is to visit the bronze statue of him bulldogging a steer in the Fort Worth Cowtown Coliseum (unveiled in 1987). A bronze marker was installed in the Stockyard "Texas Trail of Fame" in 1997 to honor Pickett. There is also a Bill Pickett historical marker at 400 North Main Street in Bill Pickett's hometown of Taylor (east of Round Rock and northeast of Austin).

References

Clements, Andrew. *Bill Pickett: An American Original, Texas Style*. Boston: Houghton Mifflin Company, 1997.

Dickinson, Malcolm. *Bill Pickett: Bulldogging King of the Rodeo*. Austin, TX: Eakin Press, 2003.

Hancock, Sibyl. *Bill Pickett: First Black Rodeo Star*. New York: Harcourt Brace Jovanovich, 1977.

Landau, Elaine. *Bill Pickett: Wild West Cowboy*. Berkeley Heights, NJ: Enslow Publishers, 2004.

McDowell, Bart. *The American Cowboy in Life and Legend*. Washington, D.C.: National Geographic Society, 1972.

Pinkney, Andrea Davis. *Bill Pickett: Rodeo-Ridin' Cowboy*. San Diego: Voyger Books, 1999.

Sanford, William R. *Bill Pickett: African-American Rodeo Star*. Berkeley Heights, NJ: Enslow Publishers, 1997.

Scarbrough, Clara Stearns. *Land of Good Water: A Williamson County, Texas History*. Georgetown, TX: Williamson County Sun Publishers, 1998.

Schlissel, Lilian. *Black Frontiers*. New York: Simon & Schuster Books for Young Readers, 1995.

Texas Tidbit

Bill Pickett was featured in a 1923 silent film titled *The Bull-dogger*. Advertising for the movie described Pickett as the "Colored Hero of the Mexican Bull Ring in Death Defying Feats of Courage and Skill."

WORLD'S GREATEST ATHLETE

Many sportswriters and historians consider Babe Didrikson Zaharias the best female athlete in the world, and some consider her the greatest modern-day multisport athlete, male or female, bar none. The muscular Babe took on virtually every sport during her lifetime. She not only played but excelled at basketball, track, baseball, tennis, swimming, diving, boxing, volleyball, handball, bowling, billiards, skating, cycling— and oh, yes, there was golf. She was once asked if there was anything she didn't play, and she said, "Yeah, dolls." People talk about looking into Babe's eyes and seeing nothing but determination. She was focused on her life's goals and avoided distraction. Tough on competitors, she was adored by her fans, and she gave them plenty to cheer for.

Born Mildred Ella Didrikson in 1912 in Port Arthur, Texas, she was the sixth of seven children born to Norwegian immigrants Ole and Hanna Didrikson. The family moved in 1915 to Beaumont, where the children played on homemade gymnasium equipment built by Ole in their backyard. Of all the children, Mildred excelled the most at sports. While playing baseball one summer, she hit five home runs in one game, and people started calling her "Babe" after the great home run king Babe Ruth. The nickname stuck.

As a teen, Babe excelled in high school basketball. (Back in those days, women's basketball was one of the most popular Texas high school sports.) When she graduated, she was recruited not by a sports team but by an insurance company in Dallas (Employers Casualty) to strengthen its company

women's basketball team. Between 1930 and 1932, she led the company team to two national titles and was named an all-American each year. In 1932, she entered the Amateur Athletic Union Championships (track and field) and came away with five first-place medals and a slew of other awards and broke four world records. In the 1932 Summer Olympic Games in Los Angeles, she won gold in the eighty-meter hurdles and the javelin throw. On her return to Texas, Babe discovered that the Texas public had been following her exploits closely, and she received an enthusiastic welcome home.

WHEN GOLF BECAME GOLD

With everything going her way, she ran into a temporary roadblock. She lost her amateur athletic status by appearing in an automobile commercial. Times called for innovative thinking. She looked for ways to use her talents to help provide for her parents. She tried anything and everything. She even appeared in a vaudeville act running on a treadmill while playing a harmonica at the same time. But it was sports she desired. She needed a professional sport that would accommodate women and finally decided on golf. After taking lessons in California, she played her first tournament in 1934 at the Fort Worth Women's Invitational. On her second try, at the Texas Women's Amateur Championship in 1935, she won first place, but other players complained that she should not be allowed to compete as an amateur. As a result, she went back to barnstorming her talents in exhibitions around the country. On one of her trips in 1938, she met a popular wrestler and sports promoter named George Zaharias. Something clicked between them, and they fell in love. Babe and George were married shortly thereafter, and he became her manager.

In 1943, she was able to regain her amateur standing in golf and went on to win seventeen tournaments and become the first American to win the British Women's Amateur Championship. In 1945, she qualified for the Los Angeles Open, a men's Professional Golfers' Association tournament, and made the thirty-six-hole cut. (This accomplishment would remain unrivaled until Annika Sorenstam was invited to compete in the Fort Worth Colonial in 2003. She missed the cut by four strokes.)

Babe turned professional in 1947. In 1948, she, along with several other women golfers (Hope Seignious, Betty Hicks, Ellen Griffin, Peggy Kirk, Betty Mims Danoff, Patty Berg, Louise Suggs, Marilynn Smith and Betsy Rawls) helped make the newly minted Ladies Professional Golfers

Association (LPGA) into a success. Babe was the leading LPGA money winner between 1949 and 1951, and the Associated Press named her Woman Athlete of the Half-Century in 1951. She also became one of the first four inductees into the LPGA Hall of Fame in 1951.

Babe's Biggest Challenge

At the height of her rise to fame, Babe was struck with cancer. She underwent a colostomy in 1953, and the doctors said she'd never return to professional sports. Babe didn't listen to them. Her prayer became, "Please God, let me play again." And play she did. In 1954, she struggled back to the course with incredible determination and won five tournaments, including the United States Women's Open. The Golf Writers of America presented her with the Ben Hogan Trophy as comeback player of the year. However, the cancer caught up with her again in 1955. Heroic treatments would not stop the spread of the disease.

After a year of fighting off the inevitable, Babe died in 1956. It was front-page news around the world; one paper carried the headline "Death of the World's Greatest Athlete."

Babe Didrikson Zaharias won every woman's golf title available to her during her career, including the world championship (four times) and the United States Women's Open (three times). Her talent, strength of character and excitement for sports helped create a national audience for women's golf. In 1955, the Babe Didrikson Zaharias Trophy was established to honor outstanding female athletes.

Babe should not be remembered only as a superb athlete. She was an example of how hard work, determination, tenacity and the conviction to meet every challenge head-on are the keys to success. One of her favorite sayings was, "You can't win them all—but you can try." She admitted she had some luck along the way but then said, "Luck? Sure. But only after long practice and only with the ability to think under pressure." When asked about her life goals, she remarked, "Before I was even in my teens, I knew exactly what I wanted to be when I grew up. My goal was to be the greatest athlete that ever lived." You made it, Babe, you made it.

Babe is buried in Forest Lawn Memorial Park in her adopted hometown of Beaumont. The city honored its prize athlete with a museum (opened in 1970) and park located at 1750 I-10 and MLK Parkway (exit 854). The museum and visitors' center is open daily from 9:00 a.m. to 5:00 p.m. (except

Christmas Day). For more information, call 409-833-4622 or 1-800-392-4401. Admission to the museum is free. About a third of Babe's trophies and many articles from her personal life can be seen at the museum. Some of her other trophies and memorabilia are at the Babe Zaharias Golf Course and Country Club in Forest Hills, Florida (once owned by Babe).

In 1975, a Babe Didrikson Zaharias women's athletic scholarship was established at Beaumont's Lamar University. In 1976, she was elected to the National Women's Hall of Fame in New York. A made-for-TV movie about the life of Babe Zaharias, titled *Babe* (not to be confused with the movie about a pig), was broadcast in 1975, with Susan Clark playing the role of Babe and Alex Karras playing George. (Interesting footnote: these two actors met while filming the movie and later married.)

In 2004, the United States Golf Association (USGA) "Golf House" in Far Hills, New Jersey, honored Babe with a yearlong exhibit called "Let Me Play Again" to honor her heroic comeback after cancer surgery. For more information, visit the babedidriksonzaharias.org website.

References

Cayleff, Susan. *Babe: The Life and Legend of Babe Didrikson Zaharias*. Urbana: University of Illinois Press, 1996.

Didrikson, Babe. *This Life I've Led*. Boston: Barnes, 1955.

Freedman, Russell. *Babe Didrikson Zaharias*. New York: Clarion Books, 1999.

Johnson, Thad, with Louis Didrikson. *The Incredible Babe: Her Ultimate Story*. Lake Charles, LA: Andrus Printing and Copy Center, Inc., 1996.

Johnson, William O., and Nancy P. Williamson. *Whatta-Gal!: The Babe Didrikson Story*. Boston: Little Brown & Company, 1977.

Stamberg, Susan. *Babe Didrikson: The Greatest All-Sport Athlete of All Time*. Berkeley, CA: Conari Press, 2000.

Texas Tidbit

One of the more interesting "trophies" in the Babe Didrikson Zaharias museum in Beaumont is a 250-pound, fifteen-foot-long gold key. This "key to the city" was presented to her by the people of Denver, Colorado (where she was living at the time), when she returned in triumph in 1947 after becoming the first American to ever win the British Women's Amateur Tournament since it began in 1893.

HIGH-STEPPING RANGERETTES

Texas guys like football. At halftime, they like beer. That combination leads to a pretty rowdy crowd. At least that was the case in 1939. At Kilgore Junior College, President B.E. Masters had an idea. He reasoned that the only thing that could compete with a beer in the mind of a young whippersnapper was a pretty gal. He took his idea to Gussie Nell Davis, who, up to that time, headed up the Greenville High School all-girl Flaming Flashes drum and bugle twirl-and-dance team. Masters asked Miss Davis to see what she could come up with to keep the people entertained "without the drums and bugles." Miss Davis came up with a gem of an idea, something no one had done before.

In 1940, Miss Davis recruited freshman and sophomore women at Kilgore Junior College and formed a precision dance-drill team she called the Rangerettes. With the assistance of a choreographer, Denard Hayden, she put together a show that wowed the halftime audience (to the consternation of the food vendors).

The Rangerettes were an instant success. They not only provided a new kind of exciting halftime entertainment but also put Kilgore Junior College "on the map" and attracted a steady stream of new students. The entire concept could have all been a flash in the pan except for the passion Miss Davis had for her newly minted organization. She immediately established a vision of excellence for the team and demanded performances designed to dazzle every audience. And perform they did, but not only at football games; they performed first nearby, then all over the country, then around the world.

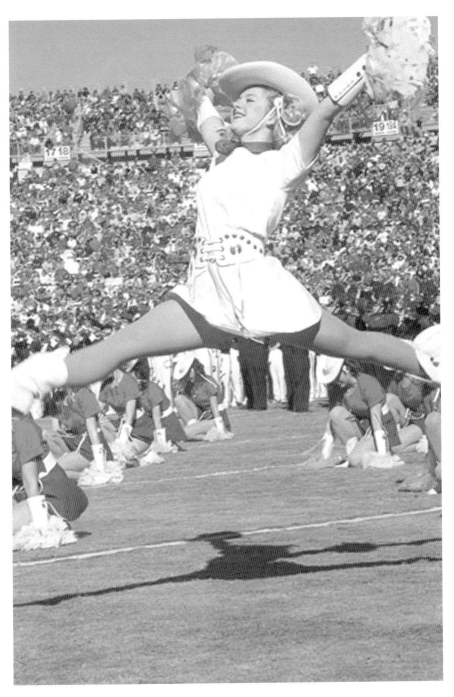

A Rangerette at the Cotton Bowl. *Courtesy Rangerette Gallery.*

In 1940, they were featured at the Lions International Convention in New Orleans. By 1946, they were invited to their first bowl game, the Junior Rose Bowl in Pasadena. In 1949, they made their first appearance at the Cotton Bowl in Dallas. Except for 1950 (when they appeared at the Sugar Bowl in New Orleans), they have entertained at every Cotton Bowl halftime show.

They also performed at the All-Star Game from 1951 to 1955, President Eisenhower's inauguration in 1953, the International Rotary Convention in 1959 in New York, Macy's Thanksgiving Day Parade (1967–69) and the list goes on and on. Their fame reached across the nation's borders when they appeared for the National Convention of Chambers of Commerce in Venezuela in 1972. They have subsequently been Texas ambassadors in Romania, Hong Kong, Macao, Korea, Nice, Paris, Cannes, Tokyo and Ireland. In 2001, they strutted their stuff at the inauguration of President George W. Bush.

THE SWEETHEARTS OF THE GRIDIRON

These talented performers from Texas owe their reputation to one of the most demanding and beloved women in Texas: Gussie Nell Davis. Gussie Nell grew up in Farmersville, the daughter of Robert and Mattie Davis. She received a BA in physical education from the College of Industrial Arts (now Texas Woman's University) in 1927 and a master's from the University of Southern California in 1938. Between degrees, she worked as a PE instructor and pep squad director.

It seems that "no good deed goes unpunished," and Miss Davis had her fair share of detractors. The Rangerettes were brought to task by feminists in the 1970s for their emphasis on physical attractiveness, but Miss Davis continued to do as she had always done. She instilled pride in her team and held them up to the highest standards of respect, self-confidence, discipline, cooperation and the ability to perform with precision and professionalism. Through her skill and determination, the Rangerettes gained a reputation for their distinctive high kick and earned the nickname "Sweethearts of the Gridiron." As the popularity and fame grew, pictures of the Rangerettes in their distinctive red, white and blue uniforms appeared on the covers of many national magazines, including *Newsweek, Saturday Evening Post, Life, Southern Living* and (yes) *Sports Illustrated*.

Although each Rangerette smiles while "on stage," the act of being the best is not easy. They've had to perform in the toughest circumstances,

from Texas heat to icy weather. Each time, they remember Miss Davis's motto: "Beauty knows no pain." And if they have pain, they don't show it.

Not satisfied with creating one great original organization, Miss Davis teamed up with Irving Dreibolt (then retired director of the SMU Mustang Band) in 1958 to create the American Drill Team Schools, Incorporated, which now provides instruction for drill teams all across the country.

Miss Davis retired in 1979, but her innovative legend continues. Mrs. Deana Bolton Covin led the troupe until 1993. Mrs. Dana Blair took over the reins and continues to expect and produce the highest-quality performances possible. Mostly because the Rangerettes inspired drill teams all over the country, estimates in 1983 claimed that over seventy-five thousand high school college students participate in drill teams each year. (That number today must be in the hundreds of thousands.) In 1975, the Houston Contemporary Museum of Art honored Gussie Nell Davis for creating a "living art form."

With over seventy years of precision, pride, discipline, dedication and that high kick embedded into their memories, the alumni Rangerettes Forever organization keeps the spirit of the early years alive in the hearts of the new recruits. They also support the Rangerette Showcase and Museum on the Kilgore College campus that houses costumes and memorabilia from the colorful history of Kilgore's most famous performers. A sixty-seat-theater shows films and slides of Rangerette performances. It is open from 9:00 a.m. to 4:00 p.m. on weekdays and from 10:00 a.m. to 4:00 p.m. on Saturdays. For more information about the Rangerette Showcase, call 903-983-8265. If you are about to enter college and want to become a Rangerette, call 903-983-8273. Visit the official Kilgore Rangerette website at www.rangerette.com.

Texas Tidbit

In 1999, with the Rangerettes performing at halftime for the forty-ninth time, Gussie Nell Davis was inducted posthumously into the Cotton Bowl Hall of Fame. She died on December 20, 1993, but is remembered forever.

THE INSIDE STORY OF THE ASTRODOME AND ASTROTURF

Whew. Those scorching summer days in Houston can get so hot and humid that you have to take a shower to cool off after walking twenty feet from your car to your house. Imagine playing a baseball game (or watching one) in weather like that. There are always a few loyal fans who will come out and watch a game in any weather, but to get a professional stadium full of fans, Houston knew that it had a problem.

In 1956, three Houston businessmen—George Kirksey, William Kirkland and Craig Cullinan—got together to figure out what it would take to bring a major-league baseball team to the Bayou City. To that end, they began the Houston Sports Association (HSA) and started pleading their case to the Major League Baseball (MLB) owners. After all, Houston was one of the largest cities in the United States. Skyscrapers were sprouting up downtown like weeds after a rain. It was growing, had wealth and vision and had that "Think Big" Texas mentality but lacked a major sports franchise. The MLB leaders were interested in Houston's proposal and gave them marching orders: "Build a stadium and we will come."

By 1959, the HSA had launched an effort to find a place for a stadium. To bolster its chances of success, the HSA brought in former Harris County judge and Houston mayor Judge Roy Hofheinz. Under his guidance, they had a revelation. They reasoned that although it had never been done before (when did that ever stop a Texan?), the best bet was to create a fully enclosed and climate-controlled indoor sports and event facility. With plans in hand, the group returned to the MLB owners and presented their idea

of a spectacular and unique domed stadium, along with evidence that the people of Houston were behind the venture. The National League saw the future and awarded the franchise.

Now the real work began. Dirt began to fly for the construction of the Harris County Domed Stadium (its official name) in 1962. At the same time, because the new Houston Colt 45 franchise had to have a place to play, a quickie thirty-two-thousand-seat stadium was constructed in a corner of the land where the dome was rising. As expected, attendance at that temporary stadium remained low due to the stifling Texas heat and pesky mosquitoes. Nevertheless, the franchise played three seasons in Colt Stadium while the dome rose across the parking lot.

When the new stadium opened in late 1964, it was named the Astrodome in honor of the popular U.S. space program because NASA was headquartered in Houston. During that time, the Mercury single-person capsule flights were mesmerizing the world, and NASA was about to embark on the Gemini program. For the same reason, the team was also renamed from the Colt 45s to the Houston Astros.

The first pitch of the first game played in the Astrodome was tossed out by then president Lyndon B. Johnson on April 9, 1965, in an exhibition game between the Houston Astros and New York Yankees. In that game, Mickey Mantle hit the first homer in the stadium, but the Astros won 2–1 in twelve innings. The press called the Astrodome the "eighth wonder of the world." Its modern amenities included a constant seventy-two-degree temperature and 50 percent humidity. The inside air was purified through a charcoal filter system. The stadium spanned 642 feet, and the inside height soared a nose-bleeding 205 feet from playing field to the dome. An eighteen-story building could fit inside the dome. Although its Lucite roof made use of available daylight, the stadium was also illuminated by powerful lights measuring 300 feet for night games. It sported five restaurants—in short, it was a spectator's heaven. Taking advantage of the stadium's popularity, the Houston Oilers football team left Rice Stadium and began playing its home games in the Astrodome starting in 1966.

However, all was not perfect with the stadium. With the roof consisting of a mesh of clear plastic panels, outfielders complained that the glare from light coming through the panels made it difficult to see fly balls. The stadium tried painting some of the panels. That stopped the glare but killed the grass. That's where Texas ingenuity stepped in again. In 1966, the Astrodome installed an artificial grass (dubbed Astroturf) that solved the problem. Although there have been complaints that the artificial turf causes more

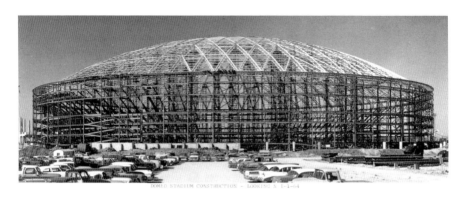

Astrodome construction. *Courtesy of Harris County Sports and Convention Corporation.*

injuries, it has been adopted at other indoor and even a number of outdoor stadiums (with some modification over the years). The Astros and Dodgers played baseball's first game on synthetic grass on April 8, 1966.

All good things come to an end. The Oilers moved from Houston in 1996, losing their final game at the Astrodome 21–13 to the Cincinnati Bengals. The Astros played their last game at the Astrodome in 1999 when Houston defeated Los Angeles, 9–4. The stadium was renamed in 2000 as the Reliant Astrodome and continues to be used for a variety of entertainment venues. The long-term future of the dome remains unclear. In 2014, the 'Dome was listed in the National Register of Historic Places, and Harris County continues to look for new uses for its historic structure.

Reference

Doherty, Craig A., and Katherine M. Doherty. *The Houston Astrodome.* Woodbridge, CT: Blackbirch Press, 1997.

Texas Tidbit

In 2005, the Astrodome was used to house thousands of evacuees from New Orleans after Hurricane Katrina.

INDEX

Index

ABOUT THE AUTHOR

Alan C. Elliott, born and bred in Texas, is the author or co-author of over twenty books, including *Currents in American History*, *Images of America: Oak Cliff* and *A Daily Dose of the American Dream: Stories of Success, Triumph and Inspiration*. He is co-writer with Leon McWhorter of the movie *Angels Love Donuts* and is the author of several children's books, including the Texas Christmas story *Willy the Texas Longhorn*. For the latest information, go to www.texasingenuity.com.

Visit us at
www.historypress.net
...

This title is also available as an e-book